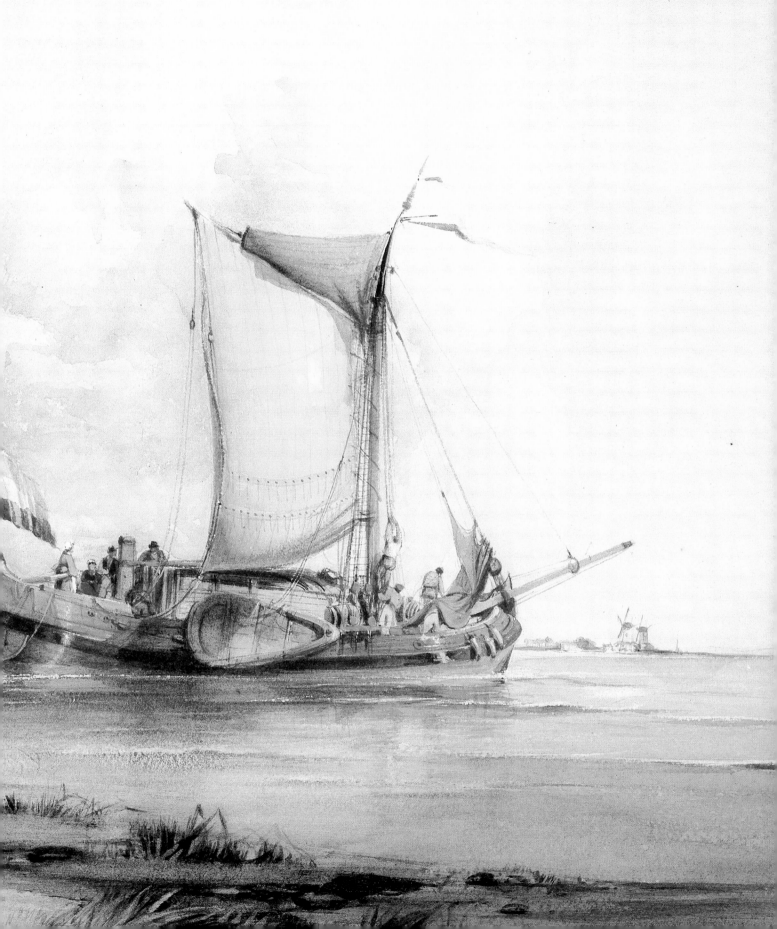

GEORGE CHAMBERS

1803-1840

His Life and Work

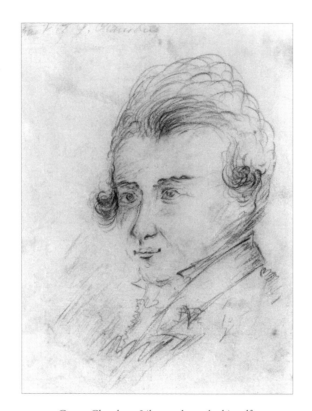

George Chambers. Likeness drawn by himself.
Pencil 8 x 6in. (20.5 x 15.5cm). Royal Academy of Arts, London.

GEORGE CHAMBERS

1803-1840

His Life and Work

The Sailor's Eye and the Artist's Hand

Alan Russett

*with extracts from the 1841 biography
by John Watkins*

ANTIQUE COLLECTORS' CLUB

FOR ALEXANDRA AND GEORGINA

ISBN 1 85149 233 X

British Library Cataloguing-in-Publication Data
A catalogue record for this book is available from the British Library

Printed in England by the Antique Collectors' Club Ltd., Woodbridge, Suffolk
on Consort Royal Satin paper supplied by the Donside Paper Company, Aberdeen, Scotland

ANTIQUE COLLECTORS' CLUB

The Antique Collectors' Club was formed in 1966 and now has a five figure membership spread throughout the world. It publishes the only independently run monthly antiques magazine, *Antique Collecting*, which caters for those collectors who are interested in widening their knowledge of antiques, both by greater awareness of quality and by discussion of the factors which influence the price that is likely to be asked. The Antique Collectors' Club pioneered the provision of information on prices for collectors and the magazine still leads in the provision of detailed articles on a variety of subjects.

It was in response to the enormous demand for information on 'what to pay' that the price guide series was introduced in 1968 with the first edition of *The Price Guide to Antique Furniture* (completely revised 1978 and 1989), a book which broke new ground by illustrating the more common types of antique furniture, the sort that collectors could buy in shops and at auctions rather than the rare museum pieces which had previously been used (and still to a large extent are used) to make up the limited amount of illustrations in books published by commercial publishers. Many other price guides have followed, all copiously illustrated, and greatly appreciated by collectors for the valuable information they contain, quite apart from prices. The Antique Collectors' Club also publishes other books on antiques (including horology and art), garden history and architecture, and a full book list is available.

Club membership, open to all collectors, costs little. Members receive free of charge *Antique Collecting*, the Club's magazine (published ten times a year), which contains well-illustrated articles dealing with the practical aspects of collecting not normally dealt with by magazines. Prices, features of value, investment potential, fakes and forgeries are all given prominence in the magazine.

Among other facilities available to members are private buying and selling facilities, the longest list of 'For Sales' of any antiques magazine, an annual ceramics conference and the opportunity to meet other collectors at their local antique collectors' clubs. There are over eighty in Britain and more than a dozen overseas. Members may also buy the Club's publications at special pre-publication prices.

As its motto implies, the Club is an organisation designed to help collectors get the most out of their hobby: it is informal and friendly and gives enormous enjoyment to all concerned.

For Collectors — By Collectors — About Collecting

**The Antique Collectors' Club, 5 Church Street, Woodbridge,
Suffolk IP12 1DS, UK
Tel: 01394 385501 Fax: 01394 384434**
——————— *or* ———————
**Market Street Industrial Park, Wappingers' Falls, NY 12590, USA
Tel: 914 297 0003 Fax: 914 297 0068**

CONTENTS

LIST OF COLOUR PLATES

FOREWORD

George Chambers deserves recognition as one of the outstanding marine artists of the early nineteenth century. He worked in all the major genres of marine art; battle pictures; seaport views; ship portraits; storms and shipwrecks; and general scenes of shipping. He was equally adept in oil and watercolour; he could design on an epic scale, and paint intimate and exquisite vignettes. His feeling for the elements of sea and sky, for ships running before the wind, and the turbulent swell of waves, for luminous colours, and the transparency and fluidity of water, is always unerring.

There is a clarity of light and feeling for the vagaries of atmospheric effect, arising from close observation of nature, that links him to the best of the romantic painters of his generation. Chambers draws you into his scenes to experience the reality of the things he saw and transcribed, without making you aware of the conventions of his art. For several years a picture of a Dutch boeier (Colour Plate 53) hung in my office, and the wonderful freshness of the scene, the transparent light on the waves, the cumbersome barge heeling to leeward, was always a source of delight.

Chambers is more than simply a naturalistic sea painter. He depicted many of the events and places of his day, and his pictures are an important historical record beyond the purely aesthetic. The Bombardment of Algiers which was commissioned by Greenwich Hospital must rank as one of the outstanding battle pictures of the early nineteenth century, powerful and majestic in composition, cool in tone, brilliant in colour, and wonderfully observed in detail. His peaceful views of Greenwich and Portsmouth are important topographical records of familiar places as well as beautiful works of art.

Chambers is much less well known than his contemporaries. From a humble background in Whitby he first went to sea in a Humber keel at the tender age of ten to experience the rigours of seafaring. He was diminutive in stature, and his fellow sailors declared that he was just big enough to go into the bung-hole of a blubber cask. As an artist he was largely self-taught, and he had to make his way without powerful connections and the advantages of education and class. Like his contemporaries, Clarkson Stanfield and David Roberts, he found employment as a scene painter, rising slowly by way of the theatre to the realms of fine art. Life remained a struggle despite the acclaim which his exhibited pictures brought him. He died at the early age of thirty-seven before he had time fully to establish his reputation and receive proper recognition.

Marine art often suffers by comparison with landscape painting because it is regarded as a specialist and subservient genre. There have been recent monographs on Nicholas Pocock, Clarkson Stanfield and Samuel Walters, another on E.W. Cooke is in preparation, but other artists like J.T. Serres, J.C. Schetky, N.C. Condy, Thomas Whitcombe and William Huggins remain unresearched and unsung. Against this background of relative neglect, it is a stimulating sign of enterprise on the part of author and publisher to launch a book on George Chambers. Drawing on the *Memoir* by John Watkins, published soon after the artist's death, it charts the course of Chambers' career, illustrates many of his most significant works, and ends with an important check-list of exhibited pictures and the sale catalogue of the artist's studio. It is an important contribution to the study of marine art, and a highly readable account of the life of an unusual artist and character.

RICHARD ORMOND

INTRODUCTION

For many years 'Britannia entering Portsmouth' (Colour Plate 31) has seemed to me to be the most serene of all marine paintings. Closer acquaintance with its painter led to 'Dutch boeier in a fresh breeze' (Colour Plate 53) and 'The Bombardment of Algiers' (Colour Plate 34) and a realisation that George Chambers was an artist of exceptional talent and deep sensibility. Further enquiry revealed a series of watercolours of breath-taking lucidity and colour displaying a quality and emotional content which had been little known and appreciated. Turning to the pages of John Watkins' *Life and Career of George Chambers,* privately published in 1841, for more detail of his background, opened up a remarkable life story, beginning in the utmost poverty as a sea-going boy at Whitby and ending, after a tragically short life, as a nationally-acclaimed marine painter in London. Fighting ill-health throughout and without education or formal artistic training, he emerged as a person of fierce determination who overcame all his disadvantages, including an inherent diffidence resulting from his unprivileged origins, to reach the highest levels of artistic achievement.

Pursuing research into his pictures and into further biographical detail soon acquired a momentum of its own and the idea of producing a book which would make the artist and his work more accessible to a wider public grew into an objective that seemed to be worth while. In this, Roger Quarm, Curator of Pictures at the National Maritime Museum, Greenwich, gave me much encouragement and help, for which I am most grateful.

The biographical *Memoir* produced by John Watkins, a close friend of Chambers, immediately after the artist's death to help raise money for the widow and orphans, is almost unique of its kind. The narrative of Chambers' early life repeats a previous version Watkins had published in 1837, the text of which was approved by Chambers himself. Its accuracy may therefore be accepted, and has been largely confirmed by further research. Watkins himself wrote in an engaging, almost Dickensian, style and the extracts from his *Memoir* are therefore quoted directly in smaller indented type in order to help maintain the contemporary atmosphere of the narrative. Watkins also relied heavily on his correspondence with Chambers as well as other letters to the artist, which he obtained from the widow. Many of these he quoted verbatim and are similarly reproduced in this volume.

The picture research has been a fascinating pursuit, revealing many of Chambers' known works but which has equally left many tantalisingly obscure. No account book or diary of Chambers is known, so one cannot be certain that any catalogue of his works would be complete. Paintings have sometimes lost their titles over the intervening years or had them changed. The work of George William Crawford Chambers, his elder surviving son, discussed in the text, is another complicating factor. It is to be hoped that, by bringing the artist into greater prominence, the present publication will help to reveal the whereabouts of more of his works.

The decade of the 1830s was critically important in terms of political, economic and social history in Britain, yet it has remained a somewhat unconsidered, transitional period in art history. This is largely because the working lives of leading artists of the time often extended from the preceding Romantic period to the succeeding Victorian, and art appreciation has tended to incorporate these years within the scope of their total output. The 1830s have therefore been left as

something of a hiatus in this artist-oriented art historical approach. It has been, perhaps, part of George Chambers' misfortune that he was probably the only important painter who flourished in this decade alone.

Chambers was in no sense the product of any stylistic 'school' or movement and cannot therefore be readily categorised. Being self-taught, he painted what he knew and understood, the sea, ships, weather and light. The need to establish himself in a highly competitive environment, as well as the financial demands of a wife and growing family, obliged him to accept commissions from valuable patrons for conventional subjects which were popular at the time, such as public festivities, water-side landscapes and naval battles. These he executed with skill and success but his driving ambition was to achieve a more painterly interpretation of the varied light and colour effects of the elements, using ships, boats and people as a means to this end. Although, perhaps unusually, he began by painting in oils, it was in watercolours that he seemed to feel best able to achieve the true impressions he sought. In this he resembled R.P. Bonington, who was an evident influence on him, and, like Bonington, expressed a genuinely romantic spirit. Early romanticism consisted largely in the return to nature, to capture the feeling of the moment and to acknowledge the individual's place in the total scheme. This sensibility imbued Chambers' most expressive work when he was not constrained by the limitations of the commission. He was among the last painters to exemplify this tradition before the advent of more sophisticated artistic practices and sentimental content in Victorian times.

This concentrated determination on the part of Chambers qualifies him to be considered strictly as a marine painter or, more accurately, a sea-painter. For, during the nineteenth century, marine painting had been extended to cover a wide range of shore-side landscape views in which the water was itself far from the most important element. Sea-painting had thus lost much of the identity it had preserved since its beginnings in Dutch seventeenth century painting. At the more practical, or pragmatic, end of the scale, ship portraits proliferated in response to Britain's growing maritime prosperity and came to be regarded as an important segment of marine painting. Within this wide spectrum Chambers, having graduated from ship portrait painting, pursued his own dedicated course to achieve the highest level as a painter of the sea.

The appraisal of Chambers and his place in nineteenth century art history is carried further in the text and his relationship with other artists examined. A diverting picture emerges of Chambers' circle of friends, their personalities and their life at work and play. In considering this group of friends and contemporaries, whose lives were usually at least of normal length, the tragedy of Chambers' early death is highlighted. Had he lived longer he could well, as contemporaries observed, have scaled the highest pinnacles of recognition.

Chambers exhibited at all the major societies in London, as well as some in the provinces, and the records of his submissions to these have inevitably formed one of the starting points for the picture research (Appendix 2). In order to avoid encumbering the text, their titles have sometimes been abbreviated as follow: Royal Academy: RA, British Institution: BI, Society of British Artists: SBA and Old Water-colour Society: OWS.

All the illustrations are reproductions of works by George Chambers unless otherwise stated. Dimensions are given with vertical height first followed by horizontal width. Details of the title references in the footnotes will be found in the Bibliography.

ACKNOWLEDGEMENTS

The gracious permission of Her Majesty The Queen to reproduce George Chambers' 'View of Dover' (Colour Plate 15) is gratefully acknowledged, together with the generous assistance of Christopher Lloyd, Surveyor of the Queen's Pictures, Charles Noble, the Hon. Mrs. Roberts, Curator of the Print Room in the Royal Collection, Lady de Bellaigue and Miss Pamela Clark of the Royal Archives and the staff of Royal Collection Enterprises.

I have also greatly appreciated the help and support of Viscount Dunluce, the Hon. Randal McDonnell, Lady Charlotte Dinan, Major General and Mrs. H.W.R. Pike, Mrs. Sidney M. Waddington, Dr. C. and Dr. K. Draper, Dr. Roderick Howell, Mrs. Sheila Benzie, E.H.H. Archibald, Stuart Boyd, Colin P. Bullamore, Mr. and Mrs. F.B. Cockett, A.S. Davidson, Robert Dinsdale, W.H. Galleway, Ralph Hyde, John Munday, Bernard Reed, Ian Warrell, John Wallrock and Meryl Beamont at the Fishmongers' Company.

The volume owes an immeasurable debt to the National Maritime Museum, Greenwich, and I am most grateful to members of the staff who have been so helpful in many aspects of the research for and the production of the work. In particular I wish to thank Richard Ormond, the Director, for writing the Foreword, Roger Quarm and Pieter van der Merwe for much helpful advice during preparation and constructive comment after reading the typescript, Caroline Hampton for professional help on Chambers' painting techniques, Lindsey Macfarlane with picture research and Christopher Gray for providing transparencies and photographs for reproduction as illustrations. The staff of the Caird Library at the Museum have been unfailingly helpful, as have many others, too numerous to mention. My heartfelt thanks to them all.

In Whitby, Jacqueline Price, Hon. Curator of the Pannett Art Gallery, Harold Brown, Hon. Librarian of the Whitby Literary and Philosophical Society, and the Whitby Archives Heritage Centre have provided invaluable assistance in my search for knowledge and understanding of Chambers' birthplace and his life there.

Members of the staff of the various libraries used and other institutions consulted have all given ready service and willing help, for which I am grateful. These include: National Art Library, Victoria and Albert Museum; Library of the Royal Academy of Arts; London Library; Westminster City Archives; Public Record Office, London and Kew; Greater London Record Office; Genealogical Society; Guildhall, London; St. Bartholomew's Hospital; Manchester City Art Galleries; National Gallery, London and West Sussex Record Office.

In the search for works by Chambers and, where appropriate, reproductions of them, many public art galleries and museums have been approached. I should like to thank curators, curatorial and photographic staff at the following galleries and museums for their generous help: Beaverbrook, Fredericton, New Brunswick; Birmingham; Bristol; Department of Prints and Drawings, British Museum; Scottish National Portrait Gallery; Royal Albert Memorial, Exeter; Guildhall, London; Ferens, Hull; Greenwich Borough; The Huntington, California; National Gallery of Ireland; Leeds City; Museum of London; Whitworth, Manchester; Margate; Merseyside; Montreal, Quebec; Newport; Castle Museum, Norwich; Castle Museum, Nottingham; Art Gallery of Ontario, Toronto; Portsmouth; Harris, Preston;

Rotherham; Seattle, Washington; Sheffield; Southampton; Glynn Vivian, Swansea; Tate Gallery; Theatre Museum, V&A; Toledo, Ohio; Victoria and Albert; Wakefield; National Library of Wales; National Museum of Wales; Wisbech and Fenland; Witt Library, Courtauld Institute of Art, University of London; Yale Center for British Art; Paul Mellon Centre for Studies in British Art; York.

I am also most grateful to auction houses and fine art dealers for their helpful support in searching for paintings, drawings and reproductions of them, and allowing me to use them as illustrations: Agnew's, Bonhams, Christie's Archives, Christie's Images, David Cross, Dowmunt, Martyn Gregory, Hahn, Phillips, and Sotheby's. For additional photography, I am indebted to Bryan Rutledge and the Sutcliffe Gallery.

I wish to express my warm appreciation of the support of my publisher, who has been a tower of strength in drawing everything together and producing the final work.

Last, but by no means least, I thank my wife for her unstinting help with typing and all those other modes of support which are indispensable in such an enterprise.

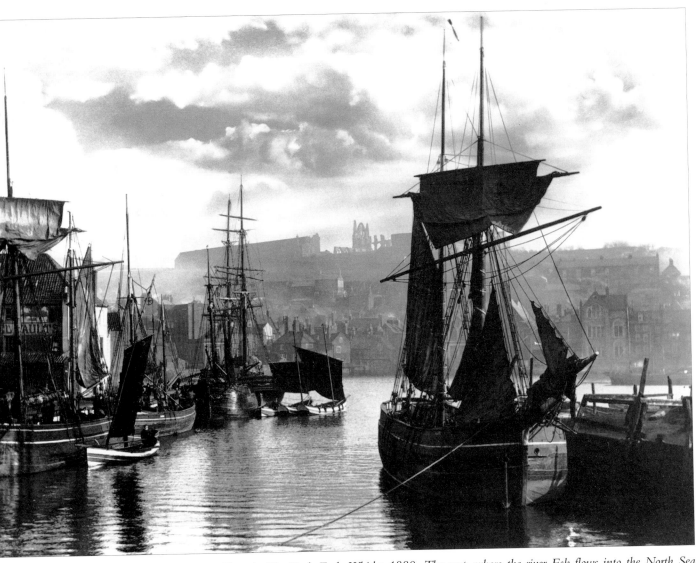

Plate 1. The Dock End, Whitby 1880. The port, where the river Esk flows into the North Sea after its descent from the Yorkshire moors, with the Abbey ruins on the hill behind.

Photograph Frank Meadow Sutcliffe, copyright The Sutcliffe Gallery, Whitby

Chapter 1

CHILDHOOD AND ADOLESCENCE IN WHITBY
and AT SEA 1803–25

George Chambers was born on 23 September 1803 in Whitby, the ancient fishing and trading port where the river Esk flows between high cliffs into the North Sea at the end of its descent from the North Yorkshire moors (Plate 1). Entries in the family Bible show that his parents, John Chambers and Mary Appleby, had married in Whitby on 28 August 1794. Their first child, Ann, was born on 6 October 1795 and Sarah, the second, on 24 September 1798. John, the eldest son, was born on 19 September 1800, followed by George and then Thomas on 8 December 1808.

John was a mariner, an ordinary seaman, whose wages might have amounted to £3 per month. Mary, his wife, was allowed to draw half the wages at home, and made up as much as she could by taking in washing and letting lodgings.

Writing in 1841 after the artist's death, John Watkins, his close friend and ardent supporter, described the family home and George's upbringing in the following words:

> The humble tenement in which George was born is situated in a court or yard leading to the old Methodist Chapel, or first Wesleyan meeting-house in Whitby, where the founder of the sect once preached.

This particular court (Plate 2) no longer exists as it was replaced by the present enlarged Wesley Hall chapel on Church Street, which was opened on 25 July 1901. Other similar courts, however, opening off the street on either side of the chapel under the steep East Cliff, below St. Mary's Church and the ruins of the Abbey, give a good idea of what it would have been like (Plate 3). The yards are now picturesque and quaint but at that time they were probably crowded, smelly and noisy. Located just above New Quay, the fish pier, the entrance to the yard would, in the days of Chambers' childhood, have been across the cobbled street from the water's edge. The area between Church Street and the harbour has since been filled in and built on.

> The wages of a common labourer, whether on sea or land, are insufficient for the maintenance of himself and family, unless his wife be a helpmate. And in times of sickness, or failure of employment, or when service in his old limbs 'lies lame', parochial relief is now rendered indispensable, but cannot be obtained except upon very degrading and distressing conditions. Happily, however, for the parents of young Chambers, these times had not yet arrived; and by industry and frugal care they were enabled to maintain themselves and an increasing family without being beholden to the parish. Those parents who did not themselves receive any instruction, are generally the most anxious that their offspring should receive it, for the mental curse of ignorance is deeply deplored by those who feel it. Besides, children at school are considered to be out of the way both of moral and physical harm – they are kept from idling in the street, or from troubling their industrious parents at home. There is a free school in Whitby –

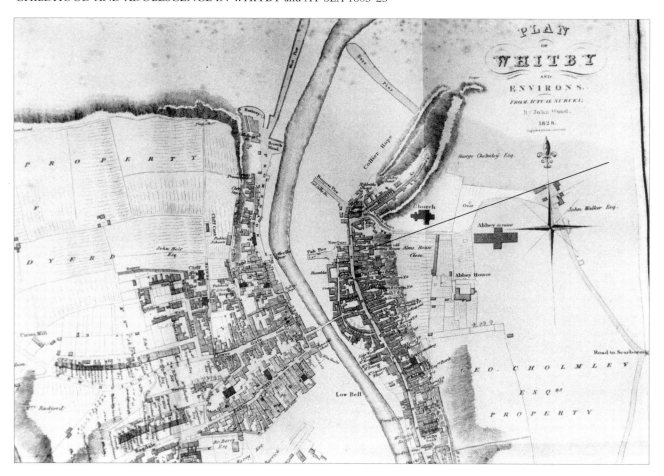

Plate 2. Detail from John Wood's Plan of Whitby, 1828. The yard in which Chambers was born and brought up can be found beside the Methodists' old Meeting House (arrowed).

not so free, however, as to exempt the scholars from incidental expences, and a charge of a penny per week each. A penny per week seems a small sum for education, but it weighs heavy on those whose bread is taxed, and who have not a penny to spare. Chambers' mother could not afford to double this sum, and George was obliged to take turns with his elder brother John, week about, at school. Imperfect as such an alternating course of instruction must have proved, it was soon cut short – young Chambers was taken from school at the early age of eight years, to earn his own subsistence – his mother being much burthened with a large family.

The family was further increased, at about the time George was taken from school, by the birth of another daughter, Mary, on 16 November 1811. A fourth son, William, followed on 23 January 1815 and an eighth child, Jane, on 12 November 1817.[1]

The first employment of our future artist was sufficiently humiliating. Whitby is supplied with coals brought from the north in old sloops. Porters carry bags full to purchasers, and the little Chambers was engaged, in concert with another boy, to hold the mouth of the bag open until it was filled by the shovel-men on board. Two shillings and the sweepings of the coal-dust from off the deck, was the recompence he received per week. Methinks I see him, black as a chimney-sweep, carrying this present proudly home to his mother.

Whitby's principal sea-faring activity at this period was whaling in Arctic waters. The annual summer campaign was the central feature in the life of the whole community and one upon which its prosperity depended. Mrs. Gaskell set her romantic tragedy *Sylvia's Lovers,* published in 1863 but based on earlier actual events, in Whitby, giving it the name of Monkshaven. The story captures much of the atmosphere of the town at that time.

1 Bullamore p.14

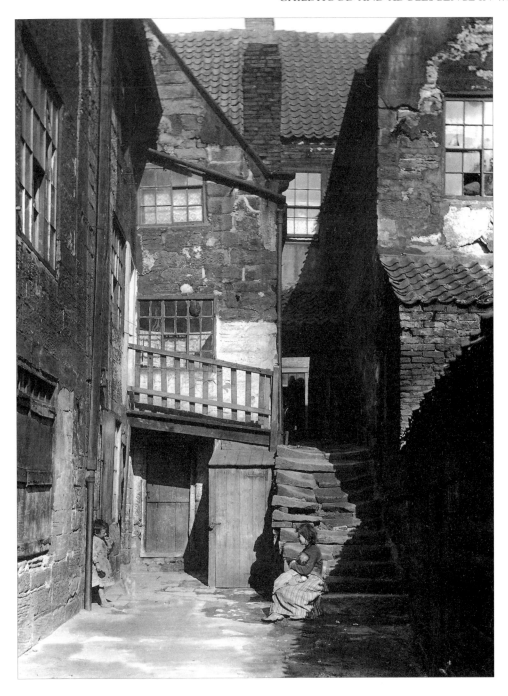

Plate 3. Argument's Yard, Whitby, c.1895. The yard where Chambers lived as a boy would have been very similar.
Photograph Frank Meadow Sutcliffe, copyright The Sutcliffe Gallery, Whitby

It would have been no accident that the first whaler, or Greenlander, home in the novel, eagerly awaited, was named *Resolution*. The name was already famous as that of one of the Whitby-built ships of Captain James Cook, the greatest mariner from the north Yorkshire coast. A *Resolution* was also the ship of William Scoresby (1760-1829), the most successful of Whitby's whaling captains. A part-owner of the new 291-ton ship built in 1802, he sailed as her master every year until 1810, when he resigned command to his son William Jnr. (1789-1857). In May 1806 he took *Resolution* to latitude 81 degrees 30 minutes, which remained for many years the highest latitude ever reached. On the same voyage he completed his cargo of twenty-four whales in thirty-two days. In ten consecutive years the *Resolution* brought home a total of 249 whales which yielded 2,034 tons of oil. The elder Scoresby bought the teak-built ship *Fame* in 1817, taken as a

prize from the French, and sailed her himself as master for further profitable campaigns from 1819 to 1822 (see page 109). The net profits of Scoresby's thirty voyages as captain have been estimated at £90,000, a return of 30% on capital.[2]

> At the premature age of ten, young Chambers, following the footsteps of his father, both from inclination and necessity, or rather, excited by the current talk of his companions, went to sea in a humber-keel, called the *Experiment,* better known as 'Jose Andrew's Ketch'. His uncle was both owner and captain – a man of whom he that sailed with him might say – 'I have great comfort from this fellow: methinks he hath no drowning mark upon him; his complexion is perfect gallows.' [Shakespeare *The Tempest* I.1.] He lived in storms both at sea and on shore. His vessel was so small that he only required a single shipmate; and when he took young Chambers 'off his mother's hands,' he did not know where to find a berth for him. But the boy being, like his father, of small stature, there was the less difficulty, and he actually consigned him to one of his sea-boots for his bed-place.

Crew muster rolls of the *Experiment* for the years Chambers was aboard have not been found, but from 1802-06 they show that Andrew's crew consisted of a mate and a seaman.[3] By 1813 he may have dispensed with the seaman in normal trade.

> Once when the vessel was taking in a cargo of oil, the robust Greenland sailors, joking upon the contrasted form of our manikin, declared him just big enough to go into the bunghole of a blubber-cask. I make no apology for the insertion of these anecdotes – he himself made no scruple to relate them for the amusement of his friends; and nothing can be more to the honour of a little man than for him to do the deeds of a great one. When telling these things he used to laugh as heartily as his hearers.
>
> For one who was younger than his years, tender as they were, and who required unstinted food, and play, and sleep, there could not be a situation of greater hardship, privation, and discomfort, than that in which Chambers was weaned from home. Without sufficient clothing to protect him from the wet and the cold, to which he was exposed, and to the injurious effects of which his tender age rendered him particularly liable – his food of the coarsest and most unpalatable kind – tasked beyond his strength in labours and watchings by night and by day, and subject to the tyranny of men whose senses had been too much steeled for sensibility, and who desperately assisted the storms that almost smothered the deep-laden old sloop – it was now that his previous hard training proved a benefit to him; for no one nursed in the lap of ease could have endured what he then had to endure, and what many boys are now enduring. Having been cobbled about in the *Experiment* for two years like the round stones that sometimes formed her cargo, his father, then in the employ of Messrs. Chapman, got them to take him apprentice, and he was bound to Captain Storr, of the new transport brig *Equity,* on board of which he launched [in 1816].

The *Equity,* a snow of 195 registered tons, was built in Whitby by W.S. Chapman and Co. She was initially owned by Captain J. Storr and Peacock, the Chapmans coming into part-ownership in 1824. Crew muster rolls show that Storr sailed with a crew of eight or nine, but its members are not named. For the early years of Chambers' service the vessel was employed in coastwise trade, probably making round trips from the north-east to London. But between 1818 and 1820 she was trading from London to Trieste in the Adriatic. This then changed to Elsinore and it must have been on one of the first of these trips into the Baltic that she called at St. Petersburg, where the encounter with Captain Braithwaite took place

2 Weatherill pp.389-90
3 Public Record Office BT98
Folios 105, 173 and 194

which ultimately led to the termination of Chambers' indentures. After the Baltic, the *Equity* returned to the Trieste run.[4]

It was now that his genius for painting began to develop itself. Doubtless it had been gathering strength in his growing mind; but stronger than life itself must that genius have been which could force itself into action in such a repressible sphere!

Chambers was a willing workman, of an active disposition, and quiet temper. He was very muscular, and could climb like a cat, by which means he saved himself from the blows of the seamen, when they were drunk, or disposed to treat him as a ship-dog. But nothing did he take delight in as in drawing – he recurred to it at every opportunity – seldom going on shore when in a harbour, except on a Sunday to church, to see the pictures in it; and though his hours for repose at sea must have been very welcome to him, he devoted them when they happened in the day-time, to his favourite pursuit; for it soon grew to be more than an amusement to him. 'Genius,' says Southey, 'first shows itself in imitation, and necessarily must do so.' Chambers did not possess any works to copy; but his master was accustomed to draught the headlands as they passed them, that he might know their appearances again, as well as bearings and distances; and rude as those draughts were, they were not bad patterns for the first rough attempts of our future artist. He loved to draw ships – particularly the *Equity;* and as his small size rendered him unequal to heavy tasks, and seemed to unfit him for the sea, he was chiefly employed in jobs of painting. The crew of the *Equity* were pleased with Chambers' pictures, and used to furnish him with paper and pencil, that he might draw them something. They were proud of him, and sometimes took him on shore with them to share in their recreations.

His captain was not so considerate as the crew. Many a night did he keep Chambers anxiously waiting for him in a boat half starved to death, while he himself was carousing in a warm public house. Once having fallen asleep on the side of the boat, he was so suddenly awakened by the harsh and fearful voice of his master, that in the confusion of the moment he fell overboard, and narrowly escaped being suffocated in the mud. In the same thoughtless spirit Captain Storr used to boast that he had a cabin-boy who could creep into a cat-hole; and he once laid a wager with a fellow-captain, named Willis, that Chambers could coil himself up in the binnacle, or box where the ship's compass is kept.

Cat-holes were openings in the afterpart of a vessel through which warps were passed for mooring or hauling astern. Although small, these could have been, like the binnacle, large enough for a very small person to enter.

Chambers must have injured himself by such feats, which gained him nothing but the uproarious applause of the drunken captain, who betted bottles of wine on his success. Better would it have been had his master attended more to his comfort and improvement; for poor Chambers was compelled to lay the whole of a severe winter without bed or bedding – his clothes having been stolen from him in the London docks by a runaway seaman. He became so subject after this sad neglect to cramps and rheumatism, which frequently afflicted him in after life, and disabled him from the use of his pencil, that when he had to 'go aloft' he was obliged to carry a loadstone in his hand' [the magnetic properties of which were judged to be curative]. For want of proper care to shift his wet clothes he contracted a fever, which caused his skin to come off; so that, as he said, he got a new face by it. In short, rough usage was considered as the best method to make a good sailor of him.

Watkins' account of the hardships of Chambers' early years may contain

4 Public Record Office BT98
Folios 182 and 272

exaggerations in order to enhance the artist's subsequent achievements. None the less, he was evidently a close friend and it seems reasonable to accept that he had a good recall of what he was told and recorded it faithfully. Chambers' own memory may, of course, have embellished some of his earlier hardships. In 1837 Watkins wrote a Memoir on Chambers, published in Whitby and London, which gave much biographical information. Watkins records later in the biography that the draft of the Memoir was sent to Chambers for comment but that he proposed only one minor amendment (see page 94). It seems indisputable, therefore, that Chambers had a very hard upbringing and that his health was probably irreparably damaged as a result.

In this manner he continued till five of the seven years for which he had been bound had expired, when a circumstance occurred which led to the gratificaton of his secret aspirations. He had displayed such skill in the difficult art of decoration, that his master frequently employed him to paint the ship's stores, and the ship itself, which appeared to great advantage among other vessels, and excited the pride of the envied captain. Visitors on board could not help remarking how beautifully the buckets, etc., were ornamented; and, enquiring who the person was that showed such a taste for painting, Captain Storr would reply – 'It's all the work of my little cabin-boy.' 'What, little Chambers!' his friends would exclaim. 'Yes,' the captain would say, 'you would be astonished to see what a fine inclination he has for painting and sketching. And he is so quiet, too. Why, bless you, he never asks me for anything, except it be for a few pence to buy paper, or paints and pencils, with.' 'Well,' they would say, 'if you will allow him to come on board of us, and to paint our buckets in this way, he shan't want for money to buy paints and pencils with.'

Captain Braithwaite, of the *Sovereign,* of Whitby, happening to be at St.Petersberg when Captain Storr was there, the two kindred countrymen were drawn together by that bond of fraternity which is scarce acknowledged at home, but felt to be very binding in a strange place. Captain B. had bought a quantity of tubs, cheap articles at St.Petersberg; and having heard of young Chambers' proficiency in painting, he employed him to ornament them, a task which he executed so much to that gentleman's satisfaction that he begged Captain Storr to manumit his apprentice, and allow him to follow the dictates of nature, which plainly prompted him to be a painter. Captain Storr made a favourable promise, but forgot it till some time afterwards, when the *Equity* being accidentally laid alongside of the *Sovereign,* in London Docks, and Captain B. having more wine on board than the customs, on clearing, would permit, he invited Captain S. to a drinking-bout. In the course of conversation over the bottle, the subject of Chambers' discharge was renewed, and Braithwaite extracted an oath from Storr, that he would let him go.

Storr accordingly went into the city to enquire what steps would be necessary to be taken in the affair, when he learnt that an affidavit of the consent of his apprentice's parents would be required. There was not time to procure such a document, for the *Equity* was shortly to sail. Fortunately, however, for Chambers, he had a letter in his pocket written by his mother, in answer to one on this subject, in which she said that she could procure for him a place in a painter's shop. Here was sufficient evidence of her consent, and Storr now took his apprentice to the offices of one or two notaries, to get the indenture cancelled; but no notary was in attendance. The truth is, Storr had repented of a promise made in the liberality of wine; the slightest obstacles in the way of its performance were represented by him as insuperable. He was selfishly fond of his apprentice, and he now told him that he must get a new rig-out for a voyage up the Mediterranean; adding, that he would see about his discharge when they

returned home. This was not very equitable conduct in the master of the *Equity,* who, still hesitating between the opposite desires of breaking and keeping his word, called at the office of his brokers and part-owners, the Messrs. Chapman, and mentioning to them his fruitless errand in search of a notary. They told him that they could cancel the indenture, and they did so. Chambers was now free; but, like a ship parted from her anchor, he was adrift without home or harbour. How to get to Whitby was his first care. He sought a passage in one of Lord Mulgrave's traders [see page 127], and offered to work his way, but the wharfinger to whom he applied could not permit this without the consent of the proprietor at the other end. It was agreed at last that, if required to pay anything, he should pay thirteen shillings, instead of a guinea, the usual fare. The vessel happened to sail down the river on the same day that the *Equity* sailed, and his old shipmates gave him three cheers as he passed.

It was late 1821 or early 1822 and Chambers was eighteen years of age.

After a very stormy passage, he arrived at Whitby; and, not being asked for the passage money, he bought a new hat with it. A widow named Irvin, who carried on her deceased husband's business of 'house and ship painter,' agreed to take Chambers for three years, and to pay him five shillings a-week the first year, six shillings the second, and six shillings and sixpence the last year; and that the three years should be specified in the indentures as seven years, the usual term. The widow employed a foreman, named John Younghusband, who soon saw reason to bless the dutiful and diligent behaviour of the new apprentice, as he quickly surpassed the older ones.

Younghusband was probably the 'master' referred to in the following account in Roget of an anecdote, related by Alfred Clint (1807-1883), the watercolourist, in October 1857. He 'took lodgings in a house, when he was staying at Whitby, in which there was an imitation marble mantelpiece painted by Chambers. His landlady informed him that she sent for the housepainter, with whom little Chambers was employed, to have the mantelpiece grained, stating that she wanted it done in the best way possible. The man said he would send someone who could do it better than any one in Whitby, and sent Chambers to do the work. When he presented himself, the lady expressed her surprise to the master that he should send a mere boy, as she wanted it done by a first-rate workman. "Let him alone", said the master, "and see it when it is finished. He will do it better than any man that I know of". And to the surprise of every one the sailor boy did it to admiration'.[5]

They were much employed among the Greenland ships, and Chambers' superior skill in lettering the whale-boats attracted much attention, and brought a great increase of custom to his mistress's shop, so that a rival in the trade, named Trueman, offered him double wages if he would leave her and come to him. But Chambers had an indulgent mistress, who allowed him more leisure to pursue his darling schemes than he could have found under a master. He resigned himself to common labour, for the sake of the fine art on which he meditated in secret.

Noting his quick and clever workmanship, the Greenland captains showed him sketches made in the country of their ships, among icebergs, with the crews in boats, harpooning whales, and requested him to copy them on millboards. These orders increased, and with them increased the little sums which he received for executing them, until, from a few shillings, his prices actually rose to a guinea.

His services were not alone had in requisition by owners and captains of ships, they were likewise desiderated by old wives and young maidens. The former employed him to paint their pails, or water-skeels; and the latter slyly entreated him to invoke

5 Roget II p.225

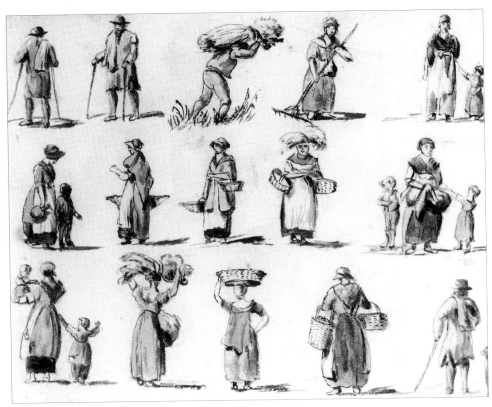

Plate 4. Rustic Figures. Chambers' exercises copying from W.H. Pyne's Etchings of Rustic Figures for the Embellishment of Landscape, *page 16. Pencil and some watercolour 4 x 5½in. (11 x 14cm). Chambers could not afford to buy Pyne's book so, with the help of the bookshop assistant, borrowed it overnight, copied the drawings and returned it in the morning.*

Royal Academy of Arts, London

the goddess of painting, while they invoked the god of love, to unite their propitious powers; in a word, he was employed to paint Valentines!

Neglecting the amusements common to youth, and hearkening only to the spirit within him, Chambers devoted every spare moment to the indulgence of a painter's propensity. With all the ardour of youthful genius, he made drawings of every object that took his fancy and frequently depicted his marine recollections. His desire for improvement progressively increased, and became the momentum of his mind. So urgent was he to obtain prints to copy, and yet so devoid of means, that he used to borrow at night, of a bookseller's boy, a drawing-book, which he copied, and returned in the morning, that it might not be missed during the day by the master of the shop, a Mr.Bean.

In the library of the Royal Academy of Arts in London is a collection of sheets of drawings by Chambers which may be the result of these clandestine efforts with the borrowed drawing book. Most of these drawings (Plates 4-11) are copied from William Henry Pyne's (1769-1843) *Etchings of Rustic Figures for the Embellishment of Landscape*. This work, like Pyne's better-known *Microcosm* (1803), and other drawing books of the period, was a collection of engravings of figures alone and in groups at typical daily tasks and with domestic animals. They were intended as exercises in drawing and to provide examples of 'staffage' to fill the foreground of pictures such as landscapes by artists who were not perhaps so adept at figure drawing. Pyne's *Rustic Figures* consists of an introduction and sixty pages of these illustrations. It was published by Ackermann in London in 1815 and, according to the title page, 'sold by all the Book and Print-sellers in the United Kingdom'. It is

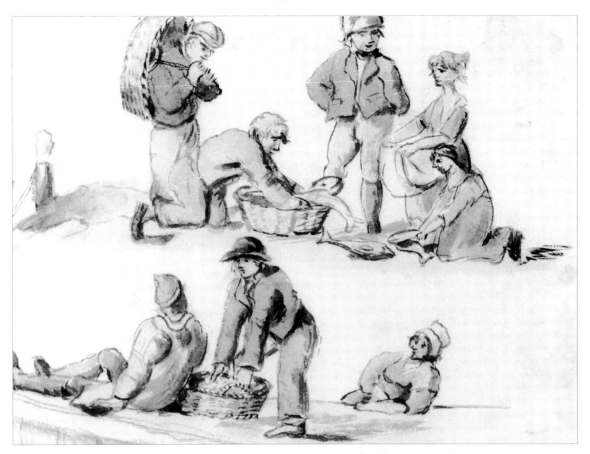

Plate 5. Chambers' copies from Pyne's Rustic Figures, *page 17. Pencil and some watercolour 4 x 5½in. (11 x 14cm) (verso Plate 4). The practice included groups as well as single figures.*

Royal Academy of Arts, London

entirely possible, therefore, that the book was in stock at Mr. Bean's bookshop in about 1820 when Chambers had returned to work in Whitby.

The sheets of drawings by Chambers are of odd sizes and shapes, on paper without water-mark and, while the figures generally follow the lay-out of Pyne's book, the pages are in some cases incomplete copies of the original. Chambers' copies are accurate representations if at times more free in treatment. Although Pyne contains only black and white line drawings, Chambers coloured several of his copies with watercolour, adding soft tones and bright touches which demonstrate that his sense of colour was formed early. As his style developed he was able to handle figures with confidence and naturalism. Those which invariably appear in the foreground of his waterside pictures are skilfully portrayed, both in form and colour, and contribute strongly to the composition. The 'View of Dover' for Queen Adelaide (Colour Plate 15) is a good example. The occupants of foreground boats in his seascapes always provide an effective focus of interest, often with a highlight in red, and distant figures on board ship are delineated with lively accuracy. A direct transposition of figures from Pyne to any of Chambers' pictures has not been traced. He evidently learnt the lessons from the primer well and absorbed them so that they became an integral part of his technical accomplishment.

The sheets at the Royal Academy were assembled by a private collector and may have been bought at the posthumous sale of the contents of Chambers' studio which took place at Christie's auction rooms on 10 February 1841. Several lots (numbers 15 to 21) consisted of sketches and studies of figures (Appendix 3).

Plate 6. Chambers' copies from Pyne's Rustic Figures, *page 19. Pencil and some watercolour 8 x 6½in. (21 x 16cm). He did not always complete all the drawings on each page of Pyne's manual.*

Royal Academy of Arts, London

Plate 7. Chambers' copies from Pyne's Rustic Figures, *page 20. Pencil and some watercolour 8 x 6½in. (21 x 16cm). (verso Plate 6). Although Pyne's engravings were in black and white Chambers often tinted his copies with watercolour.*

Royal Academy of Arts, London

Baffled by his limited time and means, although his indulgent mistress frequently allowed him both, he often sat up all night to execute extra work, by which he earned an extra shilling, and this was immediately given for an hour's lesson, to a Mr. John Bird [1768-1828], a drawing master in Whitby. These were the only lessons which he received, nor could they have been of much service to him, except in improving his knowledge of colour, for the subject of them was a scriptural piece, (Jacob meeting Rachel) which is now in the possession of his elder brother. Bird's forte was landscape; Chambers' was marine, in which he could receive little or no assistance from Bird, who, however, told him to stick to it, and virtually acknowledged his superiority by condescending to receive instruction from him, by commissioning him to do a few drawings, and recommending him to the notice of his own patrons.

Mr. Bird was making a good living as a teacher, when all his prospects were blighted by an unlucky partnership with Dr. Young, in a book-speculation, the failure of which bowed him with grief to the grave.

Bird had collaborated with the Rev. George Young on several works, including the *History of Whitby* (1817) and *A Picture of Whitby* (1824). The title page of the *Geological Survey of the Yorkshire Coast,* published in 1822 with hand-coloured engravings, accords the authorship equally to 'Rev. George Young, A.M. and John Bird, Artist'. This participation by his early teacher may have been an added reason why Chambers possessed a copy of the book (see page 153). The precise nature of the speculation which hastened Bird's demise in 1828 is not clear.

[Chambers'] best efforts were little oil paintings of vessels at sea; not painted to look 'fine', but actually sailing, and their crews engaged in performing some nautical operation, such as reefing, tacking, &c.

Even at this early stage Chambers included people in his paintings, the element of personal interest which was to characterise them throughout his life.

He painted on the panels of his humble home a picture of the *Equity* and a panoramic view. He had much to struggle through, with few helps, and a great lack of materials.

J.J. Jenkins, one of J.L. Roget's sources for his *History of the Old Water-colour Society*, records that on a visit to Whitby in 1865, a Mr Weatherall, presumably George Weatherill, Chambers' artist friend, told him that the subject of the picture on panel over the chimney-piece of the house was a fleet of North

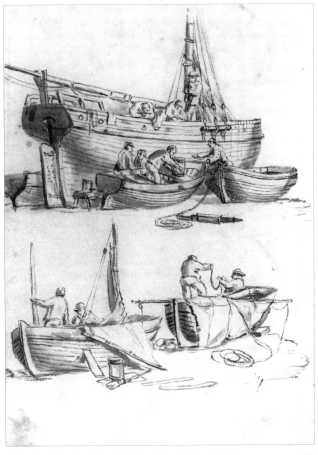

Plate 8. Chambers' copies from Pyne's Rustic Figures, *page 26. Pencil and some watercolour 8½ x 6in. (22 x 15.5cm). Chambers felt most at home with boats and boatmen. His copying of Pyne's originals was very accurate, if at times a little more free.* Royal Academy of Arts, London

Plate 9. Chambers' copies from Pyne's Rustic Figures, *page 29. Pencil and some watercolour 8½ x 6in. (22 x 15.5cm) (verso Plate 8).* Royal Academy of Arts, London

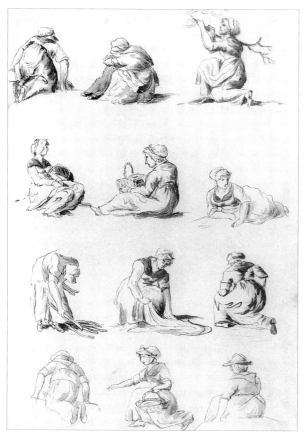

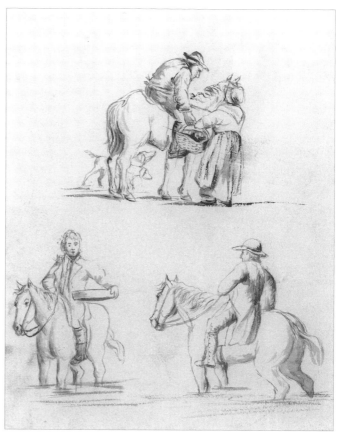

Plate 10. Chambers' copies from Pyne's Rustic Figures. *page 52. Pencil and some watercolour 8½ x 6½in. (22 x 16cm). Chambers frequently portrayed figures in the foreground of his pictures.* Royal Academy of Arts, London

Plate 11. Chambers' copies from Pyne's Rustic Figures, *page 53. Pencil and some watercolour 7 x 6in. (18 x 15.5cm). Horses, however, were not often to appear in his subsequent works.* Royal Academy of Arts, London

Country vessels in a calm off Flamborough Head. This picture had been cut out and was then in the possession of a Mr.Corner.[6]

Chambers also used his talents to record the spectacular events of the time in Whitby. 'On the 25th. July 1823, between three and four o'clock in the morning, the Town Bell was rung, as an alarm for fire in the Theatre, Skate Lane (now Brunswick Street), the inside of which was completely burnt out, together with the apparatus of the strolling company of Pantomime performers, the chief of whom was Mr. Scott, who performed the part of swallowing three or four steel swords 2½ feet in length. This painting is the representation of the above by George Chambers, who rose to such eminence as a marine painter.' Such is the inscription on the reverse of a painting on millboard owned by Dr. Thomas English, author of *Whitby Prints,* published in 1931. The picture was reproduced by W. King as a wood-cut and published in the *Whitby Repository* in 1866. Dr. English wrote: 'The painting is not only strong and brilliant, but very much more of a picture than the engraving, especially in the grouping of the figures.' The original painting has not been traced but the black-and-white reproduction from the *Repository* (Plate 12) gives an idea of its quality.[7] The Whitby Literary and Philosophical Society was founded in 1823, with John Bird as its first curator, and has since then been a continuing and vital force in preserving Whitby history. The wood-cut of the theatre fire was reproduced on the front cover of its Annual Report for 1992.

6 Roget II p.226
7 English I K1

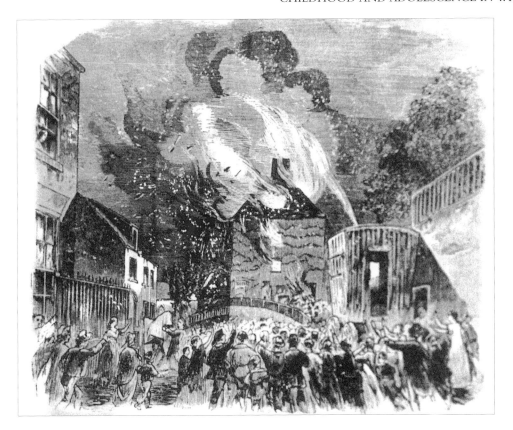

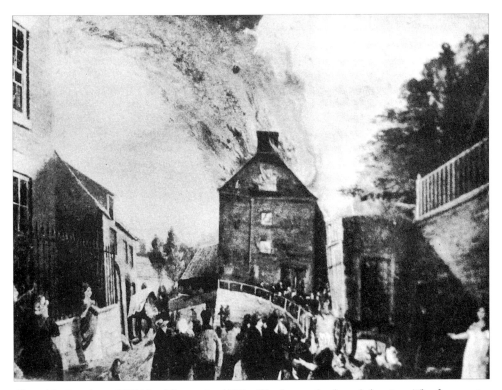

Plate 12. Burning of Whitby Theatre in 1823. Woodcut and coloured drawing. The fire was too spectacular an event to ignore. The wood-cut was produced later from the drawing.

Whitby Literary and Philosophical Society Library

Our young artist grew strongly desirous to paint a view of his native port from the sea. Accordingly, one Christmas holiday, he rowed with two companions in an old coble off to the roadstead, and made his first sketch from nature. He had scarcely completed it when a storm arose – the sea was thrown into immediate agitation, and the waves threatened to overthrow the crazy coble – tumbling it about and dashing their spray upon the inmates, who kept pulling the oars with all their might, without being able to stem the combined forces of wind and water. They were obliged to keep the coble end on, as it is termed, lest it should upset, and they could not spare a hand to bale out the water which poured in. The inland objects began to rise to their view, as they drifted nearer to the colliers that were passing in the offing, a-reefing of their topsails. No one saw them from the shore, and it seemed that they would be seen no more, for no mercy could be expected from the merciless waves, whose fury kept increasing. They were falling into despair when, providentially, the wind or the tide changing, they were enabled to go ahead; and by dint of that superhuman exertion which is prompted by fear, they reached the harbour in a sinking state. Poor Chambers had pulled harder than any of them; so hard, indeed, that the blood had run down from his hands upon the oars.

Sketches, such as that Chambers made at the beginning of this outing, before the weather broke, furnished him with the material for the views of Whitby which became an essential part of his output in the following years (Colour Plate 1 and page 32).

Five weeks elapsed before Chambers recovered from the effects of this ill-omened and yet providential adventure. Mr. Allan, the surgeon employed to dress his festered hands, possessed a taste for drawing, which he had cultivated with success. Several clever sketches of his, together with a few engravings, he lent to his patient, whose confinement was thus relieved, in a manner most agreeable to him. Mr. Allan not being a native of Whitby, purchased one or two little oil paintings done by Chambers, and gave him one or two letters of introduction to friends in London, which, however, his diffidence prevented him using.

Our young aspirant had now completed the term of his servitude; and, a consciousness of his powers giving him confidence in their successful exercise, he grew wishful to leave the narrow limits of his native town, and to seek encouragement in a more extensive sphere. He had saved a few pounds for this purpose, by the sale of a few pictures, but this money was unfortunately needed to defray the expenses of his mother's funeral, which took place about this time. Her death, however, removed his last desire to remain at home. He had grown 'sick and tired' of Whitby, for he had now arrived at that degree of excellence when his merit became his enemy, or made him enemies. He had soared above the low taste of the town.

He got a run up to London in a new ship called the *Valleyfield,* Captain Gray [built at Whitby, completed in 1825 and owned by the Chapmans]. For his services, he was paid two pounds. This sum formed the greater part of his finances.

Chambers was past his twenty-first birthday, when, like many young men before and since, he arrived in London to face the exciting but daunting challenge of making a living and a name for himself.

Chapter 2

'HIS FIRST, AND BEST FRIEND, CRAWFORD' LONDON 1825-27

Chambers had neither friend nor relative in London, except a married sister, who was more needful of support than capable of affording it. Accordingly he rented a bedroom of her, and boarded with her. He had now risen above the occupation of a common painter; but it seemed likely that he would have to return to it, or to the sea, which he dreaded. [He was offered employment as a journeyman painter for thirty shillings a week but turned it down.] The continual exercise of his skill was his sole dependence; but this kept improving that skill. Luck befriends the laborious. He might long, however, have laboured in vain had not Providence raised him up the very friend he needed.

Christopher Crawford had been a comedian at Whitby, and a doctor in a Greenland ship – both somewhat eccentric pursuits, and not unlikely to be coupled in one person. Wishful at length to settle in life, and on shore, he married, and commenced busines as a publican, at the sign of the Waterman's Arms, 22 Wapping Wall, near St. James's Stairs. Having a comfortable house in a convenient locality – Wapping being the Whitby of London – and possessing the indispensable recommendation of hailing from the 'old town', Crawford soon found himself, like Matthew, seated at the receipt of custom. Those captains especially who 'carry coals', and are therefore called colliers, found the accommodation which they more especially needed. Crawford provided them with coal-whippers – (Irishmen, who most expeditiously hoist out a cargo) and nearly all the Whitby vessels, and many of the north country ships, accordingly 'worked out of Crawford's house'.

Crawford was likewise very useful as an agent, or arbitrator, or general man of business and information on all affairs of shipping – his house became a rendezvous for sailors wanting ships, and captains wanting sailors – it was better known to the postman than any other house in Wapping: and when the destination of a letter in that district was doubtful – 'Try Crawford's' – generally put it into the right channel for delivery. But the chief charm of Crawford's house consisted in the companionship which the owners, the captains, and seamen found there; for all persons belonging to Whitby, and wishful to meet their fellow-townsmen, to tell and hear news, resorted to Crawford's as to 'Change'. [The Royal Exchange, at this time still on Cornhill in the City, was surrounded by coffee houses and bars and had always been a great centre for news and gossip.] The worthy host himself, an honest, hearty, blunt and bluff John Bull, was ever to be found seated in his great armchair in the bar, smoking cigars, and surrounded by parrots and other exotic things, presented to him by sailors from some far foreign land.

It should perhaps be mentioned that Crawford's public house was not the 'Prospect of Whitby' which has remained famous up to the present day. This was an older hostelry at 57 Wapping Wall, on the waterside near Pelican Stairs, dating back to the sixteenth century. It took its name from a Whitby ship which habitually tied up there. The existence of both houses, however, serves to confirm that Wapping was the traditional London home of Whitby ships and their sailors.

Class distinctions obtained in Crawford's house, as they do everywhere in this land of castes. There was a room up stairs kept sacred to the use of owners, and called the House of Lords – another below for captains, and a third for common seamen. The debates in the Lords were chiefly about freights – the gentlemen in the lower house frequently indulged themselves in critical comments on the conduct and character of those in the Upper House – while the people told their wrongs or hardships to each other, or drank forgetfulness of both, to awake in the morning with the remorseful consciousness that most they wronged themselves, and increased their own hardships.

Crawford's lords were wishful that their room should be adorned with a picture of the 'good old town', more endeared by its absence; and Huggins (see page 85), a somewhat noted marine artist, was applied to to paint one. Huggins had never seen Whitby, and required a sum of money for travelling expences, to take a sketch. The lords demurred at this additional expence; and rather than incur it they were ready to forgo the gratification of their wishes – the affair came before the commons; but they could do nothing but talk about it; at length it reached the ears of the unpriviledged people.

'Is it a picture of Whitby that the gentlemen want?' enquired one of the Jacks belonging to the *Valleyfield*. – 'There's little Chambers that came up with us would paint one for them better than any body, I'll be bound.' Crawford overheard this genuine burst of one of Neptune's sons. 'What's that?' he exclaimed. And learning the necessary information, away he went to seek 'little Chambers'.

Poor Chambers was at this period suffering under that depression of spirits which isolation and anxiety naturally occasion. Unfortunately, the zeal of his Whitby sister was not such as to encourage, but to depress him further. He was regarded by her in too humble a light. Crawford found him very shy and very diffident – he could not draw him into conversation, much less into companionship. Chambers did not pretend to be an artist – scarcely a common painter. In vain Crawford tried to lure him to his house, by telling him that he would find his old associates there. Crawford returned disappointed; but hearing our painter's praises reiterated, he was induced to pay him another visit. Fortunately, he found Chambers finishing a little mill-board piece, which he had promised to do for a shipmate. Several others were placed around the room, and among them was one of a larger size, which Crawford immediately recognized as a portrait of the *Equity,* coming through the Downs, with a view of Ramsgate in the distance. Crawford took it up, and said – 'Why, this is the brig you belonged to when you came to my house with Captain Storr!' Chambers replied – 'Yes – I remember well coming to your house with a bundle of slops [sailors' clothing], which Captain Storr had been buying for me at a shop in Ratcliff Highway, where he had great difficulty in finding a suit small enough to fit me.' 'Yes,' said Crawford, 'you were always noticed as being very small; and that is perhaps the reason why you are so shy; but come to my house, and I'll take care that no one molests you. I want you to do something for the gentlemen's club-room. Will you allow me to take this to show them?' Chambers feared to give his consent; but made Crawford a half-promise that he would come. He accordingly mustered courage, and went shortly afterwards.

Crawford shewed him a view of Whitby, which he himself had been attempting to paint. Chambers muttered 'It is quite out of drawing,' and that he could do a better one himself. Crawford immediately took him at his word, and prevailed on him to go with him into the city, where he purchased a prepared canvas for him, which was a delightful novelty to Chambers, he having never painted on anything but wood panels and mill-boards. As soon as they arrived with this prize at Chambers' lodgings, he began to chalk a view of Whitby upon it – the protruding cliffs, the fine pier, and other well-remembered objects, rose like a vision,

'As from the stroke of the enchanter's wand'

and filled Crawford's eyes with rapture. It was considered what ships would be best to put in, and here the native shrewdness of our young artist suggested that if he put in one man's ship, and left another's out, he would give offence to the party to whom he did not give a preference. Gladly would he please all, but he was afraid that he should please none; and at length it was decided that only Greenland ships should be admitted, and those only in which Crawford had sailed – namely, the *Resolution* [of Scoresby fame – see page 19], the *Esk,* and the *Volunteer;* an old veteran, built upon an obsolete model. They were represented as being towed out to sea in a calm. Fishing-boats and cobles filled up the intermediate parts of the scene.

Crawford kept the work a secret from those whom he intended to surprise with it; and when it was done, he desired Chambers to take it to the Messrs. Chapman of Leadenhall-street. But Chambers durst not carry it through the streets, whether covered or uncovered; nor durst he accompany Crawford with it. At length, it was agreed that he should follow in the wake of his sturdy friend, keeping him in sight as he bore along the prize. Crawford entered the office of the Chapmans, leaving Chambers at the door. 'Now,' exclaimed Crawford, with honest warmth, holding up the picture, 'what think you of this?' 'Upon my word,' said Mr. Chapman, 'it's a grand thing – pray who did it?' 'Why, it's all the work of your late apprentice, little· Chambers, whom you were so kind as to liberate.' 'Is it possible! – where is he now?' 'He is in the passage,' said Crawford, 'he durst not come in.' 'Oh! call him in by all means.' Crawford immediately introduced his bashful protege, saying, 'Here is the artist!' 'Well, Chambers,' said Mr. Chapman. 'Will you do us one?' 'I'll try, if you wish me, sir.' 'Oh, certainly!' said Mr. Chapman. 'Crawford, get him to paint us one; but I should like to have our ship the *Phoenix* put in, and she had better be done returning home with a full cargo, her boats at her quarters – the crow-nest and the garland up – just as she appears in the country.'

The *Phoenix* was one of the Chapmans' most successful whalers, remaining in their ownership from 1816, when new, until 1837. She was in 1831 and 1832 the only Whitby ship to undertake a whaling campaign. Wrecked on Whitby Scar in 1837, she will figure again later in the Chambers story (Colour Plate 1 and page 151).

Crawford promised to attend to Mr. Chapman's wishes, and said he intended to adopt Chambers as his son, to keep him out of the picture dealers' hands, who would merely make a tool of him for their own profit.

The picture was placed in the frame-maker's window, where it drew forth the admiration of all who saw it: but more particularly of Whitby folks, who came full-mouth'd to Crawford's, telling him to go and see a splendid view of Whitby, done by some great artist, and the very thing that he wanted. It was now Crawford's time to triumph. 'Gentlemen,' said he, 'that picture's mine! – it was painted for me by little Chambers – it will be brought here and hung up in this room.'

Watkins refers to Chambers' 'depression of spirits at this period' and it may have been this sense of loneliness and insecurity which encouraged the young artist to pursue an affair of the heart.

Chambers had not been in London two weeks when he was standing at his sister's door, with his hands in his sailor's jacket looking at a club-funeral, that was passing in procession. A girl happened at the same time to be going to the post with a letter for a sweetheart in the country. Chambers' sister, who had lodged with her grandmother, saw her, and called her to them. Our hero was then very strongly feeling the want of that sympathy which men, isolated by their genius, can only find from the softer sex,

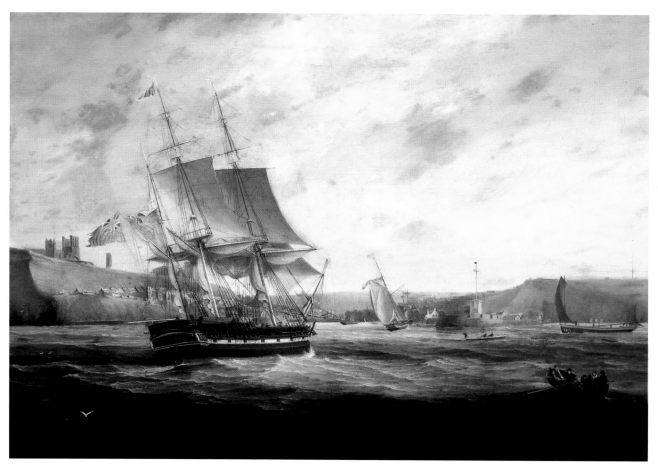

Colour Plate 1. Phoenix *and* Camden *running into Whitby harbour. Oil on canvas 25 x 36in. (63 x 91cm). Signed and dated 1825. Chambers' early sketches of Whitby from the sea were soon put to good use in this painting of two of the Chapmans' vessels running into the port.*

Christie's Images

where youth and nature prompted him to seek it. Something in the air and manner of Mary Ann, his sister's young acquaintance, attracted his attention, and ultimately fixed it with a devotion second only to his love of the arts. Love delights in contrarieties. She was volatile – he was sedate.

Chambers loved with the thoughtless generosity of a sailor. He had found one who had a liking for the arts and was never so proud of his pencil [or brush], and so pleased with its performances, as when he first shewed them to his sweetheart. She treated him rather flippantly in the street, where he appeared as a mere sailor-boy, but her feelings grew more respectful towards him when she saw the works of his wonderful skill. The genious of the painter awed her; but the mildness of the man reaasured her. But there was a lion in the way to church.

Crawford, in one of his frequent visits to Chambers, found a lady's garment in his painting-room, and his suspicions being awakened thereby, he bluntly asked what such a thing was doing there. Chambers endeavoured to evade the subject, by starting another; but Crawford would have an answer, and at last extorted an open confession. Crawford thought Chambers was too young to marry, and was strongly desirous that he should first take a tour through Italy, or through some classical clime, where he might both improve his genious and his knowledge of the world. No better advice could be given; but love is stronger than prudence, though not stronger than friendship. Chambers would not marry without the consent of Crawford – that consent was refused, and the poor lover began to pine, and actually became so ill, that Crawford was seriously alarmed, and began to talk with him more sympathetically.

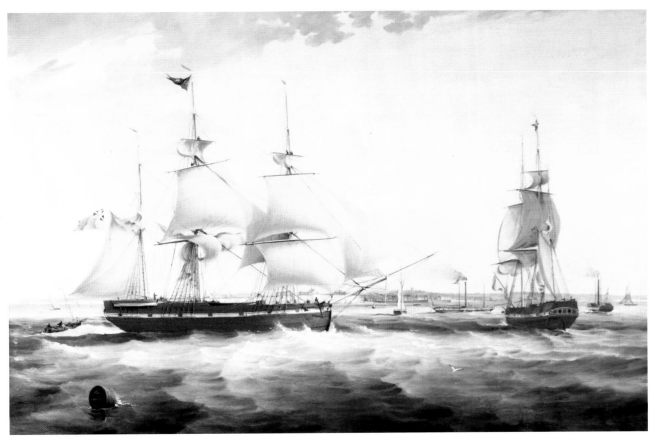

Colour Plate 2. The Crown *and paddle steamers off Folkestone. Oil on canvas 26 x 39in. (66 x 99cm). Signed and dated 1826. The more traditional type of ship's portrait, the background probably having been sketched during Chambers' voyage on the* Runswick. Christie's Images

Chambers owned that what he most wished for in the world was Crawford's consent to his marriage, which he at last reluctantly obtained. Chambers saw that his friend had given but a forced consent, and was fearful that he would hold him in dudgeon afterwards, but Crawford soon became reconciled to him.

Crawford is shown to have had a very sound understanding not only of Chambers' abilities but also of the desirability of foreign travel and study in order to develop those talents. By the middle of the eighteenth century it had become almost obligatory for an aspiring artist to make a European tour, culminating in Rome to study the antiquities, often accompanying young noblemen on the Grand Tour. After the end of the Napoleonic Wars continental travel was again possible and became very popular with a wider range of travellers and artists. In addition to studying the Old Masters, artists were able to produce landscape views of the favourite beauty spots for direct sale and also, increasingly, for the Picturesque Annuals which became popular in the following decades. Crawford was right to advocate a tour as the next proper step in Chambers' development. It would have given him a similar range of artistic experience and companionship to that enjoyed by R.P. Bonington (1802-1828), E.W. Cooke (1812-1880) and William Callow (1812-1908), to mention only three contemporaries. Taking a parallel from the life of Edward Lear (1812-1888), who, with the financial support of the Earl of Derby, went abroad for the good of his health in 1837, it might also even have improved Chambers' health and prolonged his life.

Missing that opportunity and at the same time taking on the additional financial

burden of a wife and, later, children, was thus probably a decisive turning-point in Chambers' life and career as an artist. The debate with Crawford, who was evidently Chambers' main financial support, was probably the reason why George's courtship of Mary Ann lasted two years.

The narrative returns to 1825, shortly after Chambers' arrival in London, and his painting of Whitby for Crawford's House of Lords, which was so much admired in the frame-maker's window.

> The Whitby gentlemen, who had not deigned to notice Chambers at home, began to bespeak pictures (or rather portraits) of their ships; but Crawford stopped them short by telling them that the artist was engaged to paint a picture for Mr. Chapman, and after him they might be served. The picture was done so much to that gentleman's satisfaction, that he consented to its being engraved for the painter's benefit; who, however, received only a few copies from the Messrs. Fisher, the engravers.

Colour Plate 1 reproduces the painting, which passed through a London sale-room in 1991 with an established provenance from Mr. J. Chapman. The print was published by G. Chambers and E. Fisher in London on 2 January 1826 (Appendix. 4).

The name *Phoenix* is delineated both on the pennant and the stern of the ship, but neither painting nor print gives immediate evidence of the crow's nest and garland at the masthead, which Mr. Chapman had specified. As a whole the composition shows how far Chambers had already progressed from the conventional ship's portrait. The leading vessel entering the harbour is the *Camden,* another Chapman ship, and the requirement for a wide panoramic view of Whitby, combined with a recognisable view of known ships, has been achieved with great skill. The result is a more convincing and natural scene than the traditional broadside view of a vessel set against a shoreline.

> Mr. Chapman next bespoke a portrait of the *Recovery,* Captain Fotherly, sailing through the Downs, with Shakspeare's cliff in the back-ground. Chambers had forgotten how the land lies in the Downs, and could not undertake the subject unless he had a view to copy from. This difficulty was soon overcome, by the favour of a gentleman who possessed several marine views, and who kindly permitted our artist to copy them. The picture when painted was sent to Mr. Chapman's brother at Elsinore, whose house it now adorns. Ten guineas were paid for it.

Mr. Thomas Chapman, representing the family trading interests in the Baltic, was the British agent at Elsinore. This painting, too, seems to have been a further version of an earlier one, the *Equity* in the Downs, which Crawford had found in Chambers' studio. Plates 22 and 23, later versions of a similar scene, probably give a good idea of the painting.

Two ship portraits in the traditional manner, both signed and dated 1826, are typical of Chambers' output in this period. They were almost certainly the result of commissions from ships' captains who frequented Crawford's establishment and conform to the conventional pattern of ship portrait, with the vessel shown in two positions, broadside and from the quarter. The ships are accurately portrayed but the sea is depicted with a formality and flatness which is far removed from the freshness he was soon to achieve. The whole effect is dignified but staid and

lifeless. The *Crown* (Colour Plate 2) was a Whitby vessel, built in 1801 and owned by John Barry. The other, 'A frigate and a two-decker off Gibraltar' (Colour Plate 3), retains similar characteristics although two different vessels are portrayed. The Folkestone background to the *Crown* is detailed and suggests that it may have been the result of a sketch on the spot. It could therefore have been produced during Chambers' cruise on the *Runswick* (see below). For Gibraltar, Chambers would have relied on his memory, or perhaps sketches, from the time when the *Equity* was trading into the Mediterranean.

The *Spartan* at Hull, of 1827 (Colour Plate 4), illustrates the impressive advance he achieved in the course of the following year. The painting is more developed and sophisticated in its composition, treatment of ships and background detail. After this Chambers never returned to his early style of conventional portrait.

Chambers' father, whose notion of the value of pictures was derived from Whitby opinion, wondered that gentlemen should give such large sums for paintings that in his eyes did but spoil good canvas. He was too incredulous to believe that a banker's cheque which his son shewed him was genuine, until he saw it cashed. Others of Chambers' friends exemplified by their remarks the satirical lines of Peter Pindar, but without his wicked wit:

'For though the picture I'm compelled to blame,
I'll say most handsome things about the frame.'

Chambers was one day with Crawford in the shop of a picture dealer, when, casting his eye around, he chanced upon a marine painting by Whitcombe, which took his fancy, and admiring the style of colouring, he asked if he could borrow it. The dealer said it was on sale, and could not be lent. He then enquired the price, and was told with a look of scorn that it was too high for him to afford. 'Here,' said the dealer, 'is a thing that would suit you better.' Chambers looked at the thing, and saw that would not suit him at all. Hereupon Crawford spoke up and asked the price of the first picture. 'It would be dirt cheap at ten guineas,' was the reply. 'It's thine George,' said Crawford, 'there's the money – give me a receipt.' Chambers shook his head at his patron's liberality, but Crawford would not be gainsaid, and told him that he should not want for any help that money could buy. But Chambers found that it would not do for him to spend his time copying other men's pictures – he longed to get out to nature – to sketch the Downs himself; and fortune and his friend favoured his wishes.

Thomas Whitcombe (c.1752-1824) had been one of the most eminent painters recording naval engagements during the wars with France. Many of his works were published as prints. His painting was fresh and authentic and Chambers clearly absorbed elements from it into his own technique.

Crawford had a relation a shipowner, whose vessel the *Runswick* was engaged for a voyage to the Isle of Wight, and Chambers' brother-in-law was going master of her at that time. The owner's leave was soon obtained, on the promise of a portrait of his vessel; and Chambers set sail, supplied with money by his kind patron, who begged him not to return in haste, but to take sketches wherever he had an opportunity.

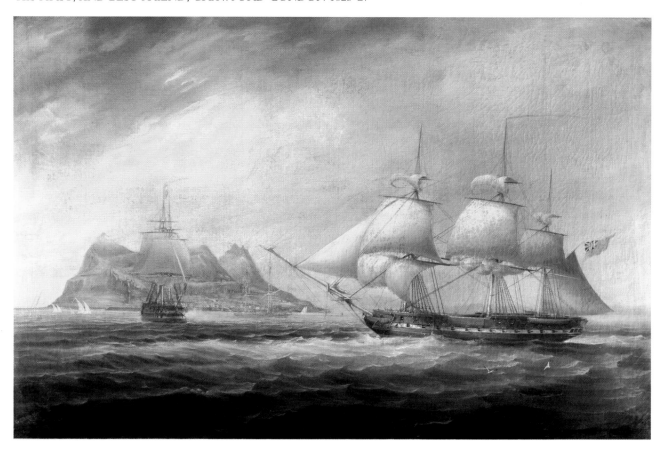

Colour Plate 3. A frigate and two-decker off Gibraltar. Oil on canvas 26 x 39in. (66 x 100cm). Signed and dated 1826. Another ship's portrait in similar mould. Chambers probably remembered Gibraltar from his days sailing into the Mediterranean as a seaman on board the Equity.
Christie's Images

Plate 13. Cottages in Devonshire. Indian ink 8 x 6in. (21 x 15.5cm). Sketches made onshore during Chambers' trip on the Runswick.
Royal Academy of Arts, London

The *Runswick*, a brig of 188 tons, was built in Sunderland in 1819, registered in Whitby and owned in 1826 by John Bovill and William Brown, with the latter as her Master. The sketches illustrated in Plates 13 and 14 of four cottages in

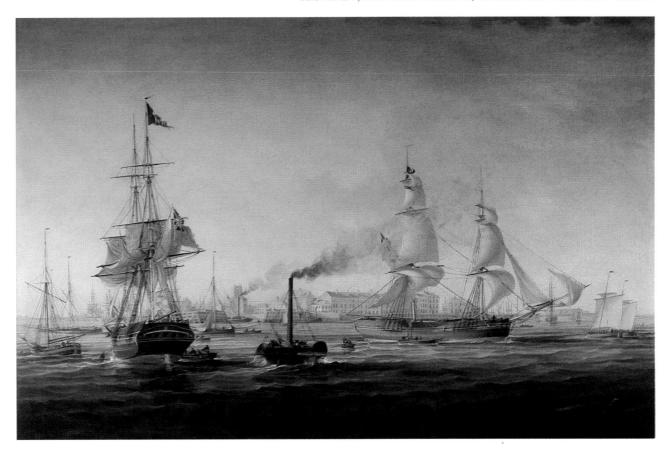

Colour Plate 4. The port of Hull with the brig Spartan *in two views. Oil on canvas 31 x 46in. (79 x 117cm). Signed and dated 1827. Chambers is already developing the ship's portrait into a more sophisticated and painterly waterside view, including the bustling activity on the river.*
Ferens Art Gallery, Hull

A Sloop with a view on the Coast of Devonshire

Plate 14. A sloop with a view of the coast of Devonshire. Indian ink 7 x 6in. (18 x 15cm). A quick sketch of a more familiar subject.
Royal Academy of Arts, London

Devonshire and a sloop off the Devonshire coast were probably among those made on this trip.

A lone sepia drawing at Greenwich inscribed 'Boat at St. Aubin' (Plate 15) is

the only indication, either artistic or biographical, that Chambers visited Jersey. Lot 41 of the studio sale after his death included 'Mont Albin's Tower' which could have been this drawing. Had he made a sketching tour in the Channel Islands a larger body of work would undoubtedly have survived. The drawing therefore presumably dates from his earlier sea-faring days or, more probably, indicates that the *Runswick* made a run across the Channel from the south coast. St. Aubin at the time still rivalled St. Helier as the main port in the island. St. Aubin's Fort, just offshore, dates from the mid-sixteenth century. The scene bears a resemblance to Swansea harbour at low tide (Plate 46) and may have given Chambers some preliminary thoughts for it.

> Chambers' trip was extended beyond what he had thought of at first, and he not only sketched the remarkable headlands southward to the Isle of Wight; but he proceeded northward, sketching the coast-scenes and harbours, particularly the Humber and the Tyne views. He visited his old friends at Whitby, made merry with them for a while, and then returned to London, well stocked with marine sketches. 'No more copying for me', said Chambers; 'I can now paint from my own sketches'.

The use to which one of his sketches was put is illustrated in Colour Plate 4, 'The Port of Hull with the brig *Spartan* in two views'. The vessel was built at Whitby in 1826 by Thomas Brodrick for John Brodrick, a Hull merchant.[1] Although here reverting to the more customary format, perhaps at the request of the client, Chambers again shows his concern to produce a picture which is something more than a simple ship portrait. The shoreline is delineated with care and the waters of the Humber are busy with a variety of river craft going about their business.

> During our artist's absence Crawford had enlarged his parlour. Chambers, looking around, said, 'I think I could do something on these walls that would please.' 'Well, then, sketch away,' said Crawford, and Chambers painted a panoramic view of the coast from Whitby, northward to the Tees, introducing the vessels of various owners that frequented the house, who were highly delighted thereat. This panorama attracted many a visitor to the parlour, much to their own pleasure, and to Crawford's profit.
>
> Chambers was now never at a loss for back-grounds to his marine views; and accordingly commissions for ship portraits poured in upon him faster than ever. Not only pride, but sometimes gratitude to a favouring providence, prompted the captains to desire a pictorial representation of some skilful or fortunate sea-adventure in which they or their ships had figured.
>
> In giving Chambers instructions for these, they found him apt. He sometimes delineated the subject before they could describe it; and having been a mariner himself, no situation in which a vessel could be placed, either by accident or design, but he could depict her, trim, rigging, and occasion all exact. He could also double in a picture, as actors are obliged to do in a limited company – sometimes a captain would wish to have his vessel painted as she appeared before a gale and after it, and both appearances in one picture, for the sake of saving expense.
>
> But the secret aspirations which had made him dissatisfied with his lot, when a common sailor, and also when a common painter, made him now ambitious to relinquish portrait-painting, and become a painter of pictures – portraits being scarcely regarded as pictures, although his portraits were superior to many professed pictures. Portrait-painting is the most profitable, but it is the least pleasing department of the arts, as it certainly is the lowest. The vanity that incites a man to have his own

1 Credland p.161

portrait taken, incites a captain to have the portrait of his vessel painted; and as vanity is very capricious, it is very difficult to be pleased and cannot be always pleased but at the expence of true taste.

This indeed marked a turning point for Chambers, not only in the development of his style and technique but also in the thematic content of his work. Until this time his output consisted largely of ship portraits and coastal views, often on the north-east coast of England at or near his native Whitby. The two were combined for he, and his patrons, were always anxious to have a topographically correct background. His voyage in the *Runswick* resulted in a widening of his range of coastal scenery, but this detail, while still accurately drawn, was by then being relegated to the distance. He was developing, in terms of both themes and style, beyond the conventional ship portrait and concentrating on a naturalistic representation of the elements, where the vessel is part of the interpretation of the light and movement of sky, sea and air, rather than being a subject in itself. Hereafter, Chambers rarely identified the vessels in his sea-pieces, except in cases where they formed part of the required subject matter.

Chambers remained loyal to his north-eastern upbringing by sending work to Newcastle-upon-Tyne for exhibition at the Northumberland Institution for the

Plate 15. Boat at St. Aubin. Sepia 7½ x 13in. (19 x 33cm). Perhaps the Runswick, *unloading at low tide, at Jersey, Channel Islands.*
National Maritime Museum, London

Plate 16. Waterside scene at Chatham. Pencil 11 x 15in. (27.5 x 39cm). Chambers was a tireless taker of sketches and delighted in these groups of figures and boats at the water's edge.

National Maritime Museum, London

Promotion of Fine Arts, the initiative of local artists Thomas Miles Richardson (1784-1848) and Henry Perlee Parker (1795-1873).[2] A 'View of Whitby' was, however, Chambers' first picture to be accepted for public exhibition in London, by the British Institution early in 1827 (No. 77). This was a large picture and might, at least conceivably, have been the one he painted for Crawford. However, it seems more likely that he returned to a successful and familiar subject (Colour Plate 1) and produced a fresh version for submission to the Institution. Thereafter Chambers exhibited at the British Institution every year, with the exception of 1828, 1836 and 1838, until 1840 (Appendix 2).

But, living in London near the Thames, he did not fail to take advantage of the opportunity to witness important local events and to record them. Two drawings at the National Maritime Museum are of the launch of the *Royal George* (120 guns) at Chatham on 22 September 1827 (Plates 16 and 17). Although only sketches made on the spot, these demonstrate that Chambers was living up to his determination to become 'a painter of pictures' by tackling more complex compositions with a variety of content. These drawings were therefore early forerunners of some of his later ceremonial waterside scenes such as the Opening of London Bridge (Colour Plate 14). Even here he already included diverting foreground human interest with the two men perched enigmatically on the buoy.

Christopher Crawford not only patronised Chambers but also helped other members of his family. He procured a berth for John, George's father, as a cook on board a foreign-going ship. Before sailing, John asked Crawford to help

2 Villar p.8

William, one of his younger sons, and a berth was found for him to go to sea with a good master. John died on the passage home and did not therefore live to see the achievements of his sons, in particular George's artistic triumphs.

Chambers' character is described at this time by Watkins as:

> naturally of a mild and unassuming disposition; and the baffling circumstances of his early life had tended to increase his natural humility and diffidence – still, he was not without a confidence in himself, and this could be aroused into indignant pride and scorn. He ever listened patiently to sensible objections, and paid great deference to just criticism; but ignorant and presumptuous fault-finding disgusted him; and humiliating treatment produced an effect contrary to that intended . As he long remembered a kindness, an injury was not soon forgotten by him – his resentment, however, was devoid of malice. Having painted a picture, it was not always he could procure his price; and those who paid him, sometimes thought themselves privileged to be displeased. He deemed himself ordained for a better life than this, and longed to leave it. Fortune soon favoured his wishes.

Plate 17. The Launch of the Royal George *120 Guns from Chatham Dockyard in presence of the Lord High Admiral and the Duchess of Clarence Sketched on the Spot by G. Chambers. Pencil 9 x 16½in. (23.5 x 42cm). An on-the-spot drawing which catches the animation of the scene by careful detail and skilful composition. Preparation for his later formal oil paintings.*

National Maritime Museum, London

Chapter 3

'HERE'S HOUSES': PANORAMA PAINTING
AT THE COLOSSEUM 1828-29

The planning of Regent's Park had begun before the end of the eighteenth century but it was only after the conclusion of the Napoleonic Wars that development began in earnest, to the designs of John Nash and with the support of the Prince Regent. In the south-east corner of the Park, Thomas Horner built a replica of the Pantheon in Rome, designed by the young Decimus Burton, which he named the Colosseum.

Horner (1785-1844), whose early work had been surveying country estates and producing panoramic views of them, had decided to join the current fashion for panoramas by painting a 360-degree panorama of London from the summit of St. Paul's Cathedral. In 1820 he made a large number of drawings from the Bull's Eye Chamber of the lantern but then a wooden scaffolding was erected outside the dome to permit the replacement of the ball and cross which capped it. Horner was given permission to erect a platform and cabin above this, claimed to be 420 feet (128 metres) above street level. From this viewpoint he produced, during 1823, 280 sketches covering a surface of 1,680 square feet (156 square metres).

Horner's original idea had been to produce prints from the drawings but it seems that Rowland Stephenson, a wealthy City banker, persuaded him to undertake the scheme to construct the Colosseum for the display of a panorama based on his drawings. This would be larger than those shown in Robert Barker's original, which had opened in 1793, and the Panorama in Leicester Square. Stephenson was the principal financial backer of the enterprise.

Construction of the Colosseum started in 1824 and was complete by 1826. The panorama was initially intended to cover 24,000 square feet (6,688 square metres) but was later claimed to be over 46,000 (12,820 square metres). The difficulties of projecting the perspective were compounded by the fact that the interior walls of Burton's sixteen-sided building were covered by flat planes of canvas upon which the design was painted. The dome was plastered. Edmund Thomas Parris (1793-1873), who was mechanically minded as well as an artist, was chosen to head the team of painters, working from scaffolding of his own design. His outline, 250 times the size of Horner's original drawing, was finished in April 1826. The whole work was due for completion in 1827 and in August of that year Horner held a press view of what was ready. But progress was slow and there were rumours of financial difficulties, so that in September 1828 Horner felt it necessary to write to *The Times* to denounce his detractors. On Boxing Day 1828 Stephenson disappeared, having absconded to the United States.

Chambers had expressed to Crawford his wish for more challenging assignments.

Plate 18. Burlington Quay, Yorkshire. Engraving by J.C. Bentley after G.Chambers 4¼ x 6in. (11 x 15.5cm). Produced from a drawing by Chambers of a north country port, now known as Bridlington, for inclusion in a series of views of ports and the coast. Although he has, typically, taken the view from seawards with a vessel in the foreground, it was the houses which caught Crawford's eye and prompted him to take it to Horner as an example of the young artist's work.

Going with him one day to see the Diorama in Regent's Park, Crawford made enquiries about the Colosseum then in progress close by, and learned that Mr. Horner, the proprietor and projector, was in want of an artist. Without more ado, Crawford took Chambers to the door and pulled the bell. His modest companion interposed, saying – 'You do wrong – we shall be given in charge to a policeman!' 'Not anything of the kind!' said Crawford. 'I have business with Mr. Horner, the manager.' A servant in laced livery opened the door, and enquired the nature of the application. 'An artist is in attendance,' said Crawford, 'and waits admittance.' A voice within was heard to say – 'Come in!' This proved to be Mr. Horner's, who asked them what was their will. Crawford answered – 'An artist wants employment here, as we understand such persons are needed in this large building.' 'That's correct,' replied Horner. 'Which of you is it?' Crawford pointed to Chambers, and Horner said, 'Your son, I suppose?' 'Not exactly so,' said Crawford, 'but almost, for I have adopted him, and he is quite as obedient to me as a son.' 'Very well,' said Horner, 'I asked the question because many parents come here with their sons, of whose abilities they have formed a partial opinion; but when tried, nearly all have failed. However, I cannot judge until I see specimens. That building, as you call it, requires very proficient artists indeed.' 'Well,' said Crawford, 'will you permit us to call again, and bring specimens with us?' 'I have no objection,' said Horner; and, viewing Chambers somewhat superciliously from top to toe, he added,

'but I think it will be time lost.' 'Not so, I hope,' said Crawford, and with that they departed.

As soon as they got into the street, Crawford reproached Chambers for not answering for himself. Poor Chambers had been thunderstruck by this scene, in which he was so interested and yet so involuntary a party. He now found words to express his astonishment. 'Why', he said, 'I could never for a moment think of undertaking such a thing – it's quite out of my line.' 'Never mind that,' said Crawford, 'we must attend with some sketches, and see what effect they will have upon the gentleman. I think he is a countryman of your's; I am quite certain he is a Yorkshireman'. Chambers felt as if he had been made a fool of by Crawford, and inwardly vowed he would never give him an opportunity to commit him so again.

Crawford waited next day upon Chambers, and desired him to get his sketches ready. Chambers muttered something in reply; but not being wishful to disappoint his old friend, he turned over a portfolio, saying at the same time, 'I know I have no such things as that gentleman wants.' 'Never mind,' said Crawford, 'my word is my bond – hit or miss, we must attend according to promise.' 'I tell you it's of no use,' said Chambers, half provoked to petulance, 'they are not such things as he wants – he wants houses, and I have nothing but ships.'

Looking round the room, Crawford espied a very fine view of Burlington Quay, and said, 'here's houses, however – we'll take this with us.' [Plate 18]. Crawford would hear no denial, and calling a coach, got into it with the artist, picture and all. They luckily found Mr. Horner where they had left him. 'Good morning, gentlemen,' said Mr. Horner, 'well, have you brought those sketches?' 'Sir', said Crawford, 'this is not a sketch – this is a finished picture.' 'Did you do it?' enquired Horner. 'No,' Crawford replied, 'My head's too thick. I have no pretension whatever to be an artist – it's my young friend's doing.' 'So – this is a view of Burlington Quay; what countrymen are you?' 'Honest Yorkshire,' said Crawford, 'and so are you, if I may judge.' 'Just so,' said Horner, 'I am of Hull – were you ever at Hull?' 'Yes, several times; I know Hull well.' Horner looked first at the picture, then at Chambers; as if dubious that he had done it. At length he asked, 'Where is the line of light?' Chambers knew nothing of the line of light, and was silent. Crawford stepped in to his relief – 'You will please to excuse him, sir; he is particularly shy – he wants confidence – I wish I could give him some of mine.' Horner smiled, and asked if the picture was really his work. 'Certainly it is,' replied Crawford. 'I hope and trust you do not take us for counterfeits. You may rely upon it we are sterling, and I hope we shall always be found so.' 'Well,' said Horner, 'this is certainly a beautiful picture.' 'There!' exclaimed Crawford, 'you hear, George, what the gentleman says. You thought it not worth looking at, but the gentleman thinks otherwise.' 'Yes,' said Horner, 'it is a very good view – very well executed.' 'Sir,' said Crawford, 'if you would admit him into this building, he would not leave without laurels – there is no deception in him, he is real genuine.' Horner laughed; and, exacting a promise that they would not tell tale, he led the way into the building, saying, 'You will see what there is to do.'

They were struck mute with astonishment at the magnitude of the operations going forward. The building appeared much larger inside than out. Several artists were at work in swinging boxes, suspended from lofty scaffolding. Horner pointed out one in particular, and said, 'What do you think I pay that man there?' 'What! that little fellow working with a pound-brush?' said Crawford, 'I'm sure I can't say'. 'I pay

Plate 19. Thomas Horner's panoramic drawing of London from above the cupola of St. Paul's Cathedral. Ink 7 x 24in. (18 x 61cm). The full width of all the sections of this original drawing is 92in. (234cm) to complete the full 360 degree view. The problems of projecting this inside a circular building on to 24,000 square feet of wall space divided into sixteen flat canvasses can be imagined.

The Trustees of the British Museum

him nearly a thousand a year,' said Horner, 'and I do not think him half paid.' 'Good God!' exclaimed Crawford, 'a thousand a year, and not half paid! If thou and I had that between us, George, we might ride in a coach.' The artists laughed, on hearing this; but deemed our rustic friend and his bashful protege favourites of the projector, for no persons, not even the Royal family, had been allowed admission to see the wonderful works there. Horner, calling out to the man with the pound-brush – 'Parris! you're wanted,' led the way to a kind of workshop, and shewed Chambers' picture to Parris, asking him what he thought of it. The man of art said it was very good; and when told who had done it, he could scarcely believe his eyes, so much are we apt to judge by appearances, and so little appearance of a great man was there in Chambers. Mr. Horner now unfolded some large sketches, taken from the cupola of St. Paul's, and comprising views of every part of London, as seen from the cupola – in short, forming a picture of the whole of London [Plate 19].

Our visitors expressed their surprise and gratification, and were about to take their leave, when Mr. Horner said, 'Stop! – do not be in such haste. I will tell you what you must do. You must take a sketch from some eminence.' 'Some eminence? – What's that?' Crawford asked. Horner smiled again, and said he meant some high place, such as the top of a house. 'My house,' said Crawford, 'is four stories high, counting the garret-window in – will that do?' 'Yes, very well', said Mr. Horner; and after giving them some further instructions, respecting the nature of the sketch he requested, he bade them good-day.

Crawford got Chambers to come to his house early the next morning, and after breakfast set him to work to sketch from his back-garret window. Chambers made an elaborate sketch during the day of the house-tops in that densely-crowded district, with Shadwell church in the distance, and having transferred it to canvas, he took it to Horner, who could scarcely credit the excellence of the work done in so short a period. 'It's all real,' said Crawford; 'you may see the colour is not yet dry: we are not counterfeits, sir. I'm sure, if you give him a trial, he will give you satisfaction.' 'Well,' said Horner, 'I think I must; Chambers, you may come tomorrow – but you must take lodgings in this neighbourhood – I will give you my card, and you may make use of my name for anything that you may want – I will be answerable.' 'God bless you, sir', exclaimed Crawford; 'but I will take care that he is supplied with the needful.' 'I am not afraid but he will do, if his head will allow him to swing in those

boxes,' said Horner. 'Sir', Crawford replied, 'he is just the chap for that; why he served some time at sea – he is a sailor.' Accordingly, Chambers was introduced to his brother painters as the sailor-artist, by which name he was distinguished as long as he stayed.

Mr. Parris, the foreman, provided him with materials and apparatus, and Chambers hoisted himself up – a feat which none had done before him.

To be near the Colosseum, as required by Horner, George and Mary Ann moved, in late 1827 or early 1828, from 19 Sydney Place, Commercial Road to 44 Cleveland Street, Fitzroy Square, a street mainly inhabited by artists and engravers. Later in the year they moved again, to the next street, Upper Charlton Street, now Hanson Street, to live at number 21. Neither house exists today, the area having been redeveloped with, notably, the Telecom Tower across the road.

The Ackermann aquatint engraving, published in June 1829 (Plate 20), shows the arrangement inside the Colosseum at the time the work was in progress. The central tower with 'Ascending Room', the first passenger lift in London, and the old Cross and Ball from St. Paul's Cathedral above can be clearly seen. Viewers on the gallery were thus placed as if above the dome of St. Paul's with the relevant parts of the Cathedral visible below them (Plate 19).

Mr. Parris called out, 'Now! you are high enough – begin with the chimney-pots. I dare say your first strokes will be your finishing ones!' Chambers did not forget this cutting stroke, which the conceit or the jealousy of Mr. Parris had prompted him to give; but he took a noble revenge. He began to paint upon a part which a previous artist had spoiled; and in the evening, when Mr. Horner came in, he asked Parris what he thought of the sailor-artist. 'His tints resemble your own, I think,' said Horner; and calling on Chambers to come down, he said, 'I want a word with you, sailor. I have only to tell you this – that you have done, in a most masterly manner, more work in a day than a fine German artist that came here with a livery servant spoiled in a week.' But the great satisfaction which Chambers gave to Horner was anything but satisfactory to the other artists engaged. They remonstrated with him for getting through so fast, and complained that he would cover the canvas in a few days, if he went on thus; when they must all be thrown out of work. They spoke more prophetically than they thought. Seeing that Chambers' style harmonised so well with that of Parris, Horner concerted that they twain should finish the work themselves. Parris being the head man, reserved all the best things – such as the churches and public buildings – to himself, and grieved the gentle spirit of Chambers by painting after him, and putting the finishing strokes to his work.

Parris had a politic design in this – it gave him a colour to declare that Chambers was merely engaged to do the subordinate or mechanical portions of the work, and

Plate 20 (Opposite). The geometrical ascent to the galleries in the Colosseum. Aquatint Rudolph Ackermann 1829 12 x 9½in. (31 x 24cm). The arrangement inside the Colosseum in April 1829. The 'Ascending Room', the first passenger lift, and the old cross and ball from St. Paul's Cathedral can be seen at the centre. Chambers could well have been the painter working at the lower left, near the river.
Westminster City Archives

COMPRISING

A DESCRIPTION

OF

THE BUILDING;

THE PANORAMIC VIEW

FROM THE

TOP OF ST. PAUL'S CATHEDRAL

THE CONSERVATORY, &c.

PRINTED FOR THE PROPRIETORS, AND SOLD AT THE EXHIBITION;
AND BY ALL BOOKSELLERS.
1829.

Plate 21. A description of the Colosseum and the panoramic view. Engraving 1829 4 x 8¼in. (10 x 21cm). Even while the painters were still working, the Colosseum was opened to the public at an entrance fee of five shillings, in order to raise funds to complete the project.

Trustees of the British Museum

that the credit of this magnificent view belonged chiefly, if not wholly, to himself. Nay, so far did Parris envy the touches of others in this great public work, that he hid what they had done by painting smoke over it, although by so doing he spoiled the picture. But he could not disfigure or obscure the River Thames, which was Chamber's work, although his name is not personally associated with the praises bestowed upon it.

Unfortunately for Chambers, Mr. Horner's affairs became embarrassed by the breaking of some bank, and he was compelled to leave the Colosseum without the wages due to his work, and robbed of the fame which he had no less hardly earned.'

After Stephenson absconded in December 1828 Horner's financial situation became untenable and in January 1829 a committee of his friends was set up to take over the project. £60,000 was still needed to finish the Colosseum. It was opened, unfinished, later in January with an entrance fee of five shillings to help meet the costs (Plate 21). 'For several months it was London's most fashionable entertainment, enhanced by the sight of Parris and his depleted staff swinging in cradles'.[1] There were hundreds of visitors. In June the future Queen Adelaide paid her third visit. It had been announced in March that Horner had gone abroad.

It seems likely, therefore, that, having started at the end of 1827 or beginning of 1828, Chambers was retained as Parris' only assistant when Horner found it necessary to cut back on expenses. The Ackermann print (Plate 20) was probably based on the scene as it was in April 1829.[2] Chambers would then have been one of the two lower painters shown working on the panorama itself at that time. But he left soon afterwards and returned to the east to live at 11 Wapping Wall, back in the area he knew so well from his earliest days in London.

Watkins evidently enjoyed recounting the anecdotal aspects of this episode in Chambers' life and was probably partisan in his support for his friend and criticism of Parris. There may have been some truth in Parris overpainting, for

1 Hyde pp.54 et seqq.
2 Hyde p.38

50

progress on the work had been dogged from the outset by the difficulty of achieving a uniform treatment with a number of individual artists, each wishing to introduce his own effects.

Nor was the praise of the representation of the Thames, recorded by Watkins, universal. Some later press reviews were critical and found it unworthy of the rest of the work. Any painting which Chambers had done in that section may therefore have been overpainted or altered later by another hand.

The Colosseum was finally finished in 1832. Special displays and attractions were added from time to time, such as an artificial ice rink in 1841, but it was never a great commercial success and ultimately closed in 1864. The building was demolished in 1875 and the present Cambridge Gate built on the site.

Chapter 4

A PAINTER OF PICTURES 1828-30

Chambers' foray into panorama painting at the Colosseum may have broadened his experience of painting but, if it left him out of pocket, he probably felt that he had not gained much from it. The style and subject-matter added little to the skills he wished to develop. However, painting on a larger scale for a distant viewer may have been of some benefit as a bridge from the constraints of ship portraits to the freer expression of sea painting to which he aspired.

His ship portraits had already shown a concern with broad composition and the portrayal of sea and background landscape as well as the subject vessel itself. It was therefore a relatively small step for him to create a more generalised image such as

Plate 22 (Left). The North Foreland. Engraving R. Brandard after G. Chambers 4¼ x 6in. (11 x 15.5cm). Another from the series of coastal views. The importance of the Foreland as the navigational turning point between the Thames estuary and Dover Strait is emphasised by its subordination in the composition to the sea and passing shipping.

Courtauld Institute of Art, University of London

Plate 23 (Above). North Foreland. Watercolour, pen and ink, and surface scraping on paper 6½ x 8¾in. (16.5 x 22.6cm). Signed with initials and dated 1833 or 35. It was a favourite subject to which Chambers returned several times. The Toledo Museum of Art

the North Foreland, later published as a print (Plate 22 and Appendix 4). Although this is a topographical subject produced for a series of coastal views, the sea and passing shipping are accorded a major part in the composition, reflecting the headland's significance as a turning point for shipping in and out of the Thames. The sea itself assumes a crucial importance in the balance of the picture and offsets the towering cliff. One imagines the *Recovery* in the Downs done for Mr. Chapman being perhaps a forerunner of this study and also of a later watercolour, 'North Foreland', at The Toledo Museum of Art, Ohio (Plate 23).

In 1828 the Royal Academy accepted Chambers' 'Sketch on the River Medway' (No. 81) for its annual exhibition. The image has not been traced but Medway subjects remained favourites with Chambers throughout his life. A good example is reproduced as Plate 70 and others are discussed on page 149. The sketch is likely to have been in oils but two drawings in the British Museum, a view near Gillingham and a waterside scene, both undated, may give an idea of

the tenor of Chambers' work at this time (Plates 24 and 25). They are working sketches probably taken in the open air. The waterside scene shows an artist, presumably himself, at work – a personal touch many artists, including van de Velde the Elder, have practised over the centuries. A watercolour sketch of a hay-barge in the Tate Gallery (Plate 26) is a further example of Chambers' handling of a similar subject. Dating these drawings to this period makes the assumption that Chambers used watercolours in his sketches even before he is said to have turned formally to this medium (see page 98) and exhibited works in it.

Few other and more formal works from this period have been traced which is probably an indication of the time Chambers was required to dedicate to the Colosseum.

The Royal Academy again accepted a picture from him in 1829. It was entitled 'Off Ryde, Isle of Wight' (No. 336). Its present whereabouts are unknown, but a

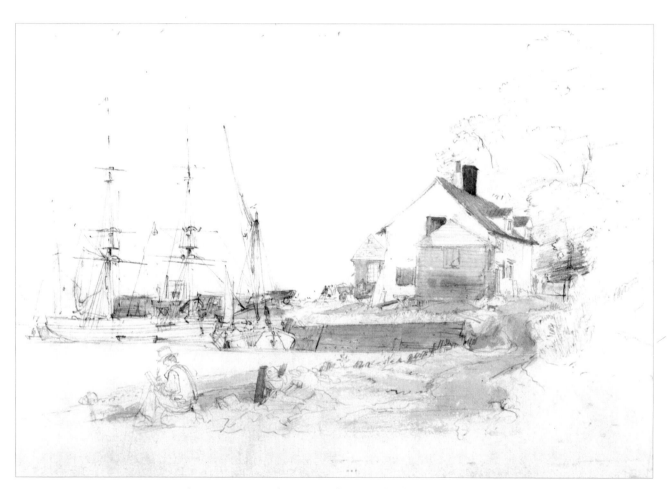

Plate 24. Waterside scene with artist sketching. Pencil with grey wash 10 x 13in. (25 x 33cm). Chambers pictured himself sketching beside this quiet backwater with its trader and barge at the quay.
Trustees of the British Museum

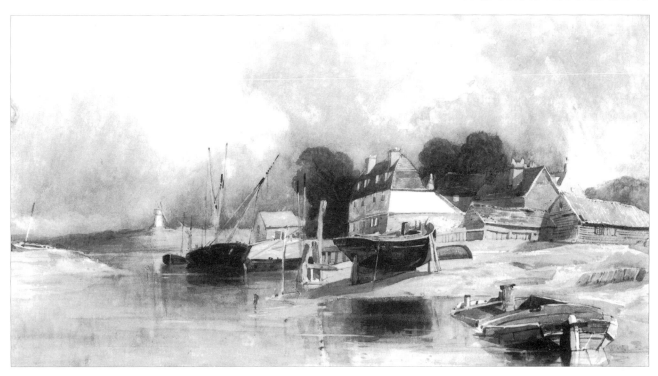

Plate 25. View near Gillingham. Watercolour 10 x 16½in. (26 x 42cm). Chambers liked the Medway, a tributary at the mouth of the Thames, for its peace and quiet. Trustees of the British Museum

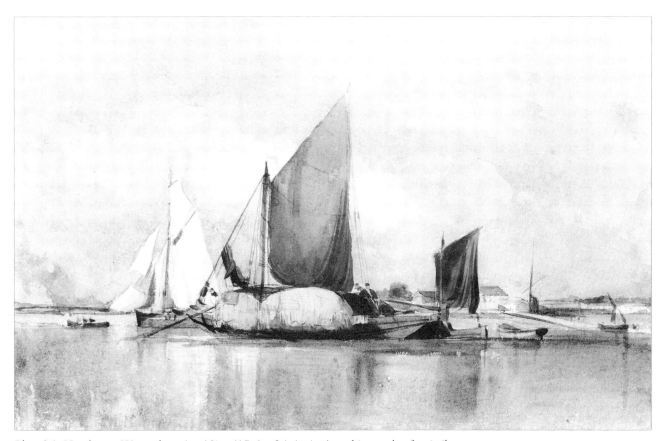

Plate 26. Hay-barge. Watercolour 6 x 10in. (15.6 x 24.4cm). A working study of a similar scene.
The Tate Gallery

Plate 27. Off Ryde, Isle of Wight. Pencil on card 10½ x 14½in. (26.5 x 37cm). Even in a simple on-the-spot sketch, Chambers always allowed space to speak for itself.

National Maritime Museum, London

pencil sketch now at Greenwich may refer to it (Plate 27). A later oil from a location slightly further west, showing only part of Norris Castle, may give an indication of the character and quality of the Academy picture. The painting 'Fresh Breeze, Off Cowes' (Colour Plate 5), also in the National Maritime Museum, Greenwich, is signed and dated 1833. Here the sea and the distant shoreline provide the main content while the vessels play a minor part. None the less the open boat and the people in it are a vital part of the composition, adding interest and a lively foil to the expanse of water and long coastline. It is one of his most successful sea-pieces, capturing the scene with spirit and authority, and it is tempting to think that the earlier picture could have been similar.

Chambers had a picture at the British Institution in 1829, not having exhibited there in 1828. His exhibit at the Society of British Artists, Suffolk Street, in that year, which was his first, was 'Shipping on the Strand' (No. 97). He continued thereafter to exhibit at the Society every year up to and including 1838 (Appendix 2).

Although the spring of this year brought the disappointment of losing his job at the Colosseum and the return to the east, 14 June 1829 gave George and Mary Ann the joy of the birth of their first child, a son. He was baptised George William Crawford on 8 July at St. Paul's Church, Shadwell, near 11 Wapping Wall, where they were living at the time. The father's occupation is given in the register as 'Artist'. Christopher Crawford, after whom the third Christian name was given, stood sponsor to the child, any difference of opinion with Chambers over the wisdom of marriage being magnanimously forgotten.

Chambers was an affectionate husband and father.

When from home he never forgot home – he always thought of those he had left there, and ever returned with presents to them. He used to write to his wife in such terms as the following:

My dear, I hope you are well, and take care of yourself – if anything should happen that you are ill, write, and I will return immediately. Go by my advice – you will find it is genuine, and for your welfare and happiness, though you don't think so. Do not be imposed upon, as you have been at all times, by your friends. My dear, you are now getting a

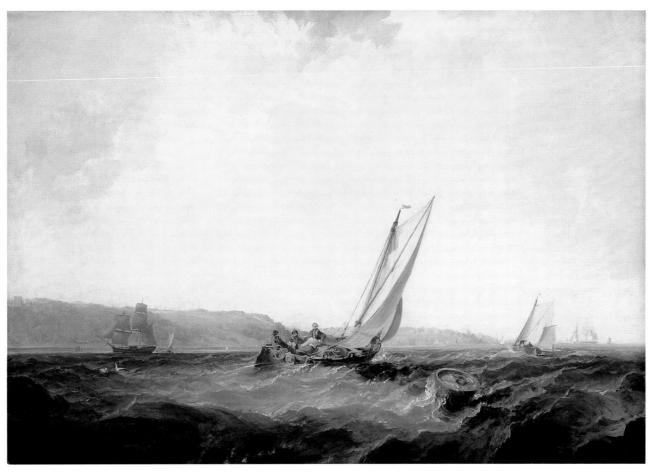

Colour Plate 5. A sailing boat in a fresh breeze off Cowes. Oil on canvas 20 x 28in. (51 x 71cm). Signed and dated 1833. When developed into a final oil painting, the spatial value of the sea, sky and distant shoreline is powerful, while the open boat and its occupants associate the viewer with the human activity of the scene. National Maritime Museum, London

family, which will be a blessing to you, if you prove constant and faithful, and you will be a lady if it lies in my exertions to make you so, and God spares my health – there is no fear but we may see many days of pleasure, which the study of my profession has so far prevented. Believe me it is a hard struggle to climb the hill to fame.

R.P. Bonington had died, at the age of twenty seven years, on 23 September 1828. The sale of the contents of his studio was held in London by Sotheby's on 29 June 1829. An annotated copy of the sale catalogue has survived.[1] Lot 83, 'Sketches of Antient Monuments, some tinted...19 [items]' by Bonington, was knocked down for £1.14.0 to Chambers. There is no confirmation that this was George but the hammer price was low, one of the lowest in the sale. It is tempting to believe therefore that he might have wished to spend some of his meagre means on buying a group of sketches not only for their intrinsic value but also as a reminder of a leading contemporary artist he greatly admired and sought to emulate.

1 Reproduced in Pointon, *Bonington, Francia & Wyld*, Appendix 3

Chapter 5

SCENERY PAINTER AT
THE PAVILION THEATRE 1830-31

Among Chambers' friends was a young artist, named Dodd, who had come up from Whitby, where he had served an apprenticeship as a common painter; but being dismissed by his master, at the instance of an employer, one Mr. Barry, whom Dodd had offended, he had gone upon the stage, and afterwards practised portrait-painting in London. Dodd had painted a portrait of Mr. Farrell, the manager of the Pavilion Theatre

which was exhibited at the Society of British Artists in 1830 (No. 461 from W. Dodd, 1 Philpot Street, Commercial Road).

The Royal Pavilion theatre in Baker's Row, Whitechapel Road, opposite Cannon Street Road, was close to the present site of the London Hospital. It was very much a variety theatre with a rapidly changing programme of melodramas and comedy pieces interspersed with performances by horses, ponies, jugglers, conjurors and acrobats. However, among the 'Daring Equestrian Feats' was a strong maritime flavour as, for example, 'A New Nautical Recreation' called the *Sailor's Return* among whose characters were Bob Backstay, Harry Hawser and Jack Junk. A Quadruple Hornpipe was one of the dance routines.

The life of the theatre must have been hectic in the extreme, particularly for John Farrell who was not only the lessee but also the author of many of the plays, the stage director and an actor. William Wyatt, his partner until 1830, also acted in lead roles. It was still the age of the actor-manager. A fresh production was introduced each week, invariably billed as 'An entirely new production...' with other sensational accolades. It then went 'into repertory' but as the programme changed every evening and there were usually six or seven parts, each piece was repeated frequently and often 'revived'. A critic's notice of November 1828 praises the performances in 'The melodrama of *The Abducea* (from the prolific pen of Mr. Farrell)... particularly that of Farrell, whose Jack Cutaway we pronounce one of the best performances of a British sailor the stage can boast'. Wyatt played Barebones. One playbill claims that the evening's performance totals '133 other characters played by the numerous company'.

Panoramas were the fashion of the time in theatres as well as in special buildings such as the Colosseum. Clarkson Stanfield, another ex-seaman and Chambers' senior by ten years, had been employed as a scene-painter since 1816, initially in London and then with a touring company. On returning to London in 1821 he worked with David Roberts at the Coburg (the 'Old Vic') until December 1822 when they both moved to the Theatre Royal, Drury Lane. 'Here over the next twelve years, Stanfield established his dominance as the most brilliant theatrical painter of the age, with work which both raised scenic standards and had considerable effect on the development of popular taste in landscape art. He was

particularly famous for his great 'moving dioramas' in Christmas pantomimes. He painted similar exhibitions for showing outside the theatre; panoramas of 'The Destruction of Algiers', 1816, and 'The Battle of Navarino', 1827, which he painted with Roberts and others, were toured in England and Europe (1824-29)'.[1]

The Pavilion regularly featured panoramas in its programmes. A press notice in late 1828 for *The Queen of the Butterfly Bower or Harlequin and Old Bogie* states: 'In the course of the Pantomime will be introduced a splendid Moving Panorama portraying the banks of the Thames in an excursion to the Nore. Painted by Mr.P. Phillips.' Philip Phillips (1802-1864) was both a successful scene-painter and later, unusually, also theatre manager of the Bower Saloon.[2]

During 1829 the performances tended to move 'up-market' with *The Beggar's Opera* and *As You Like It*. But the maritime appeal was not overlooked with *The Spectre Pilot*, a nautical melodrama, and *John Overy, The Miser of Southwark Ferry*.

The big billing, however, was for '*Fifteen Years' Life of a British Seaman or the Perils of the Ocean* by J. Farrell, a nautical drama, months in preparation'. This incorporated 'the most splendid scenery ... a grand moving Panoramic View of the Battle of Navarino, painted by Mr.P. Phillips, with new music, properties' etc. A playbill claimed that the panorama occupied 'upwards of 5000 yards of canvas'. The production was, according to an advertisement, 'nightly hailed by the approbation of an overflowing and brilliant audience' owing, no doubt, as a critic said, to 'the taste of the public at the present period for nautical spectacles and the decided merits of the piece'. A later press notice on 6 September 1829 considers that 'Navarino is wonderfully improved and certainly deserves the attention of every lover of the arts'.

These were years of peace when there were no spectacular naval battles to provide material for dramatists and the stage, or indeed for marine artists. The Battle of Navarino, 1827, in the War of Greek Independence, was the most recent major naval engagement and still fresh in the public's mind. The Bombardment of Algiers, over a decade earlier, was the last major action before Navarino. The peace continued for a further twenty years until the Crimean War once again brought naval and military conflict into prominence.

Stanfield's work in the theatre and as a more formal painter was influential on other artists. W.L. Leitch's recollection of Stanfield telling him 'that the stage is an excellent school for learning art, provided we studied nature at the same time',[3] would have been equally well received by Chambers. Stanfield was a considerable influence upon Chambers and in many respects a role model for him.

Dodd had

> heard Chambers express a wish to paint a scene for a theatre, he mentioned this to Farrell. Farrell went to Chambers', and saw a picture of Portsmouth on the easel, which our artist was painting for Colonel Long, one of Chambers' earliest west-end patrons. Farrell was much pleased with it, and praised it to two young artists, who have since acquired much distinction, viz. Jones and Forrester, the Alfred Crowquill.

The identity of Jones has not been established, but it might have been Calvert Jones, who later became a friend and pupil of Chambers, and whom Watkins met

1 Archibald p.182
2 in litt. Dr.P van der Merwe – author, October 1995
3 MacGeorge p.46

Colour Plate 6. Village and distant country of Hohenwald. Skelt's scenes in Der Freischutz, *Scene 1st. & 4th. No. 1. 6 x 7½in. (15 x 19cm). Toy theatre scenes can give an idea of the scenery Chambers would have been painting at the Pavilion Theatre.* Photograph by Theatre Museum, V&A

in 1835. Alfred Henry Forrester (1804-1872) was a caricaturist who had published his *Absurdities* in 1827 under the pseudonym Alfred Crowquill.

> Chambers was invited to the theatre, and leave given him to paint a scene. He began very awkwardly, because he was ignorant of the art of painting in distemper, which is a style suited to artificial light, and in which a kind of composition is used, that dries to a different colour. Nor did Chambers know how to measure perspective. But Farrell taught him, and he soon learned. While he was quietly working away, the other artists, who witnessed his exertions half in contempt – half in jealousy, shook their hands over his head, to express their sense of his insignificance. They also gave advice to mislead him; but he took his own way, and made them change their tone, when, after finishing the scene, a view on the Liffey, at Dublin, they could not but perceive its merit, and found it greatly admired by the audiences.

The scene formed part of *Mother Carey's Chickens or Harlequin and the Enchanted Cape,* and a review published on 27 December 1829 echoed the enthusiasm: 'The Scenery is of the first order and does credit to the talent of Mr. Phillips, particularly a view near Clogheen and the submarine palace of Mother Carey. A view of Dublin, painted by Mr.Chambers, was highly applauded.'

Colour Plate 7. The Awful Incantation. Skelt's Incantation in Der Freischutz, *No. 4. 6 x 7½in. (15 x 19cm). Toy theatre scenery was usually published soon after the live stage production and often copied it. Here the scene-painter gives his imagination full rein to reflect the gruesome plot.*

Photograph by Theatre Museum, V&A

The nautical flavour of shows at the Pavilion is not surprising since its Whitechapel location attracted a clientele from the nearby shipping community along the north bank of the Thames to the east of London Bridge. Indeed, there was repeated press praise at the time for Farrell's enterprise and success in raising the Pavilion to new heights in an 'unlikely neighbourhood' so far east of London's traditional theatre quarter. Colonel Long,

hearing that Chambers resided in Wapping, thought it was out of town; and that the Pavilion Theatre was at Brighton.

A few months after the trial described above

Farrell quarrelled with Phillips, his scene-painter, and remembering Chambers, engaged him at a salary of two guineas a-week, which he soon doubled.

Der Freischutz which opened on Monday 27 September 1830 was Chambers' 'premiere'. For the first time the playbill announces: 'The Scenery by Mr.

Plate 28. Royal Pavilion Theatre playbill for Monday 27 September 1830 (detail). Chambers as scenery painter for Der Freischutz – *his 'premiere'.* Photograph by Theatre Museum, V&A

Chambers' (Plate 28). The scenes listed are those called for in Weber's opera: 'Gothic Hall; Village and Distant Country of Hohenwald; The Wolf's Glen, where the "Awful Incantation!" takes place; Room in Ranger's House'. A press review said 'The Scenery was grand and appropriate'. The opera, first performed in London in 1824, was itself an indication of how the Pavilion was becoming more ambitious under Farrell's management, but the drama's marksmanship, magic and banditry would have well matched the tastes of the audience. The next play, opening on 20 October was *The Pilot or a Tale of the Sea:* 'The New Scenery by Mr. Chambers'. This was followed by *Knights of the Cross,* then *The Bier Kroeg or The Yager's Rest* and afterwards *The Marriage of Figaro* with Chambers established as principal scene painter.

A press report of 14 November reads: 'A new Burletta, called the "Royal Visit", has also been produced; it is a very indifferent piece, and as it did not meet with the applause that was expected, no one has claimed the credit of its authorship. It has, however, one redeeming quality. The view of the interior of the Guildhall, with a representation of the banqueting table, and the throne of the king, were astonishingly grand, and far exceeded the expectations we had formed of the capabilities of the Pavilion for such exhibitions. Mr. Chambers, thy abilities as a scene-painter compel us to honour thee'.

1830 closed with *Hamlet* and the *Barber of Seville.* The playbill for 19-20 January

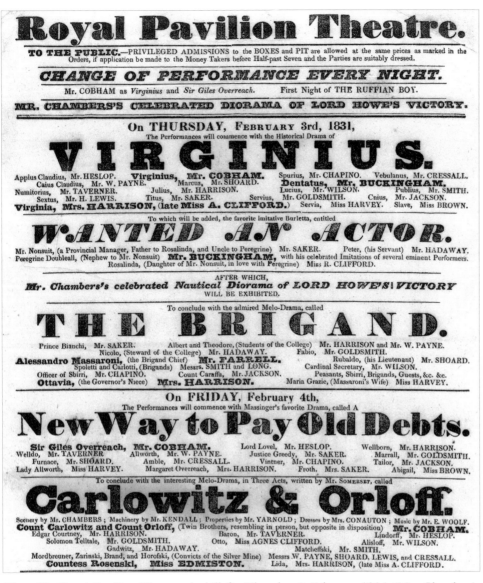

Plate 29. Royal Pavilion Theatre playbill for Thursday 3 February 1831 'Mr. Chambers's Celebrated Diorama of Lord Howe's Victory' (detail). Some of Chambers' inspiration for these scenes may have come from a large painting of the battle by Robert Dodd, which hung in the dining room of a tavern near the theatre.

Photograph by Theatre Museum, V&A

1831 announces 'A Splendid Nautical Moving Diorama Accurately Describing Lord Howe's Victory on the Glorious 1st.of June' (1794) and an advertisement for 31 January repeats 'Mr. Chambers' celebrated Nautical Diorama of Lord Howe's Victory will be exhibited'. It appeared again as a headline on the playbill for 3 February (Plate 29). Some of the inspiration for these scenes may have come from a panoramic painting (76 x 134in., 193 x 340.5cm) of the battle by Robert Dodd (1748-1815) which hung in the dining room of the Half-Way House, a tavern close by the theatre. Signed and dated 1795, it is now in the National Maritime Museum. *The Pilot* and *Carlowitz and Orloff* were two more new pieces for which Chambers provided the scenery before the season ended on 15 February.

Chambers' scenes were more like pictures, and possessed equal attraction with new plays. But his duty was very close and continuous – he was frequently obliged to work night and day, and had sometimes to paint flats between the acts of a piece in

actual representation. Nor was his time wholly taken up at the theatre – he kept painting cabinet pictures at home, for private commissions, and pictures to exhibit.

One picture was exhibited at each of the British Institution and Society of British Artists in the spring of 1831 (Appendix 2).

It was probably because of this pressure of the work at the Pavilion that Chambers and his family at about this time left 2 Northumberland Place, Commercial Road, to which they had moved at the end of 1829 from Wapping Wall, to live at 12 Somerset Place, New Road, to be even closer to the theatre.

The theatre re-opened on Easter Monday, 4 April, with *Martha Willis, The Servant Maid or Service in London,* based in part on Hogarth's *Harlot's Progress.* For the following show, *Man of the Black Forest,* Mr. Tomkins, principal artist of the Adelphi Theatre, was brought in and a review reports: 'Tomkins has painted part of the new scenery, and Chambers has executed the Act-drop, which represents a view of Greenwich'. Charles Tomkins (1798-1844) was a gifted young painter who had worked with Stanfield at the Coburg Theatre. The Pavilion is described as 'now the most elegant theatre in London, greatly enlarged' and was said to rival the Royal Opera House in size.

Chambers was back as principal artist for *Virginius* and *The White Nun or the Heart of a True Blue* although sharing the credits with J.,T. and E. Morris, presumably members of the same family. This billing with one or more of the Morrises continued through most of the immediately ensuing pieces: *OBI – three fingered Jack, Alfred the Great or the Patriot King, Timour the Tartar or The Mingrelian Princess, The Field of the Cloth of Gold or the Knight of Burgundy,* and a *New Comic Pantomime: The Sylph of the Sunflower.* A reversion to the equestrian when 'Mr.R.Adam's Stud of Horses' performed in *The Orphan of Hindostan or the Mine of Rubies.* This was followed by *Alp, The Tartar Khan or The Mountain Pass* and *The Youthful Days of William IVth or British Tars in 1782, Prince William Henry in New York in 1782.* Royalty held the same fascination then as now! *The Wreck of the Leander Frigate or The Fatal Sand Bank* and *Kenilworth or The Days of Queen Elizabeth* were new pieces in July (Plate 30).

It is tantalising to read of all this artistic effort devoted to staging these plays without being able to find a reproduction for illustration, but the work was transitory in the extreme. Images of some scenes from the leading West End theatres have survived, but not from the Pavilion. Scenes from contemporary toy theatres can, however, give an idea, especially as they were often published immediately after the arrival of a successful new production on the live stage and were probably copied from it. Colour Plates 6 and 7 reproduce scenes from *Der Freischutz* which may suggest some of those upon which Chambers worked in his 'premiere'. 'The Incantation' was evidently one in which the artist lavished much imaginative skill in order to convey the gruesome horror of the proceedings.

Chambers remained as the leading scenery painter in the subsequent productions but the Morrises were replaced by Wilton. *The Banks of Allan Water or the Death of Fair Eleanor* was followed by *Cornish Miners, The Beggar of Brussels or the Mendicant Murderer, Caesar Borgia, The Scourge of Venice,* and *Oath of Freedom or the Patriots of Poland.* On 27 September a newspaper reports: 'Last evening, the great moral lesson, "A London Tradesman's Life or Fifteen Years of Prosperity and Adversity" was repeated for the twenty-fourth time and was, as usual, hailed

ROYAL
Pavilion Theatre.

Stage Manager, - Mr. FREER.

First Night of the Grand Nautical Melo-Drama, of THE WRECK OF THE LEANDER.

Revival of MASANIELLO; or, THE DUMB GIRL OF PORTICI. *Masaniello,* Mr. FREER.
Fenella, (the Dumb Girl) Mrs. W. H. PAYNE.

The Melo-Drama of KENILWORTH having been honored with a Splendid reception, will be repeated on WEDNESDAY.

On MONDAY, July 18, TUESDAY 19, & WEDNESDAY 20, 1831,

Will be presented, for the first time at this Theatre, an entire New Nautical Melo-Drama, founded on a terrific Anecdote, entitled, The

Wreck of the Leander Frigate;
Or, THE FATAL SAND BANK.

The Scenery by Messrs. CHAMBERS and WILTON ; Properties by Mr. YARNOLD ; Machinery by Mr. JOHNSON ;
Dresses by Mrs. CONAUTON ; Music by Mr. E. WOOLF.

Captain Catteret, (Commander of the Discovery Ships) Mr. HEILD. Vermont, (his First Lieutenant) Mr. CHESTER.
Darband, (a Midshipman) Mr. CHAPINO. Pierrevert, (First Lieutenant of the Hero) Mr. BROADFOOT.
Ben Block, - - - (an English Sailor) - Mr. FARRELL.
Falkland, (Husband to Valentine) Mr. BENSON. Boatswain of the Leander, Mr. SMITH.
Spalatro, Rapino, and Juan, (Pirates) Messrs. CARROLL, HESLOP, and W. H. PAYNE. Henry, (a Child) Miss NORMAN.
Cariboo, and Pawhowtan, (Indian Chiefs) Messrs. SHOARD and WILSON.
Valentine, - - (Wife to Falkland) - - Miss MAC CARTHY.
Ulah, (an Indian Girl) Mrs. EVANS. Chittibaw, Miss MELSOM. Benowee, Miss YATES. Pirates, Sailors, Indians, &c.

STATE CABIN OF THE LEANDER FRIGATE. | CONFLICT of the PIRATES with the CREW of the LEANDER.
Conspiracy of the rescued Pirates to obtain Command of the Vessel. Deceived by the appearance of part of the Wreck, the Pirates plunge into the Ocean.
AWFUL STORM, and Striking of the Vessel upon the Breakers. *Rising of the Waters,*
Efforts of the Crew to save the Vessel ; she becomes Imminent Peril of all on the Sand Bank. Escape on the Raft, and the Sand
A TOTAL WRECK. Bank overflowed by the Waves.
Escape of the Crew in Boats to the Fatal Sand Bank. VALLEY IN THE ISLAND OF OTAHEITE.
Rescue of the Child by the Heroism of a British Tar, and The Crew of the Leander protected by the Indians.
FINAL SINKING OF THE VESSEL. *Ceremony of an Indian Marriage,*
THE FATAL SAND BANK! WITH CHARACTERISTIC BALLET.
In the South Pacific Ocean, with Fragments of the Wreck and Rude Tent. The Pirates obtain the Arms and fire on the Indians, in the hopes of exasperating them
Attempts of the Pirates to obtain possession of the Ship's Boats, defeated by the to the destruction of the Crew. The Savages, excited to revenge by the treachery of the
intrepidity of the English Seaman. Pirates, attack the Crew, about to assassinate Falkland, the Hostage, when he is saved by
CONSTRUCTION OF THE RAFT. the ingenuity of the Sailor.
Renewed efforts of the Pirates to become Masters of it. THE ARRIVAL OF A CONVOY SHIP,
And Final Rescue of the Crew.

To which will be added, on *MONDAY and TUESDAY,* the Laughable Burletta called

THE SPOILED CHILD.

Little Pickle, Miss GROVE. Old Pickle, Mr. SAKER. Tag, Mr. BUCKINGHAM. Miss Pickle, Mrs. GASKELL.

On *WEDNESDAY,* The Laughable Burletta, called

A PILL FOR PORTUGAL.

Principal Characters by Messrs. HEILD, HESLOP, HADAWAY, CARROL, PAYNE, SAKER, & CHESTER ; Miss GROVE & Miss YATES.

To conclude with, on *MONDAY and TUESDAY,* The Historical Romantic Drama, called

MASANIELLO;
Or, The Dumb Girl of Portici.

Alfonso, (Son of the Duke of Arcos, Spanish Viceroy of the Kingdom of Naples) Mr. CHESTER. Lorenzo, (his Friend) Mr. SHOARD.
Duke of Mataloni, (Grandee of Spain) Mr. GOLDSMITH. Magistrate, Mr. WILSON. Gonzalo, (Captain of the Guard) Mr. BROADFOOT.
Sergeant, Mr. W. H. PAYNE. First Soldier, Mr. JACKSON. Second Soldier, Mr. CHAPINO. Pietro, Mr. HEILD.
Giuseppe Aniello, Mr. HADAWAY. Borella, Mr. BENSON, in which he will Sing the admired National Air of the " Barcarole."
Thomaso Aniello, - - (a Fisherman) - - Mr. FREER.
First Citizen, Mr. SAKER. Second Ditto, Mr. SMITH. Third Ditto, Mr. WOOLF.
Fenella, (the Dumb Girl of Portici, Sister of Masaniello) - - Mrs. W. H. PAYNE.
Elvira, (a Spanish Princess) Miss YATES. Briella, (Wife to the Sergeant) Mrs. SAKER.
Hymeneal Ballet, and Grand Castanet Dance, by Mrs. W. H. PAYNE.

To conclude with on *WEDNESDAY,* The Splendid Historical Melo-Drama, entitled

KENILWORTH.

Dudley, - (Earl of Leicester) - Mr. FREER.
Earl of Sussex, Mr. WILSON. Lord Burleigh, Mr. GOLDSMITH. Oxford, Mr. SHOARD.
Sir Henry Leigh, Mr. JACKSON. Salisbury, Mr. CHAPINO. Sir Thomas Bowyer, Mr. SMITH.
Sir Walter Raleigh, Mr. W. H. PAYNE. Nicholas Blount, Mr. SAKER. Sir Richard Varney, Mr. HEILD.
Edmund Tressilian, Mr. CHESTER. Antony Foster, *alias* Fire the Faggot, Mr. HESLOP. Michael Lambourne, Mr. CARROLL.
Wayland Smith, Mr. HADAWAY. Giles Gosling, Mr. GOLDSMITH. Laurence Goldthread, Mr. BENSON.
Secretary, Mr. BROADFOOT. Officers, Pages, Soldiers, &c.
Amy, (Countess of Leicester) Miss MAC CARTHY. Elizabeth, (Queen of England) Mrs. WINGROVE.
Countess of Rutland, Miss ROGERS. Janet Foster, Miss YATES. Cicely, Mrs. EVANS.

On THURSDAY, a new Melo-Drama, of peculiar interest, called THE BANKS OF ALLAN WATER, will be produced.

An entire New Piece, of strong, local, and domestic interest, from the Pen of Mr. FARRELL, is in preparation, and will speedily be produced.

BOXES 2s. **PIT 1s.** **GALLERY 1s.**
Second Price to the Boxes, (to commence at Half-past Eight,) 1s. No Half-Price to the Pit. Half-price to the Gallery, (to commence at Eight,) 6d.
Entrance to the Gallery in Baker's Row. Acting Manager and Treasurer, **Mr. E. YARNOLD.**

Places for the Boxes may be taken of Mr. NODDER, on application at the Box Office from 11 to 3. Family, or Select Boxes to be had nightly
MAURICE & Co., Printers, Fenchurch Street.] Doors Opened at Six o'Clock, and Performances to commence at Half-past Six precisely.

Plate 30. Royal Pavilion Theatre playbill for Monday 18 July 1831 Wreck of the Leander Frigate. *Nautical subjects were always popular with the river and sea-going folk who made up a large part of the audience.* Photograph by Theatre Museum, V&A

throughout with unqualified applause... The scenery by Chambers adds another wreath to the chaplet he had obtained before'. The following production, however, *Victorine or the Maid of Paris,* was to be the last for which Chambers painted the scenery.

By this time George, Mary Ann and the infant George had already moved to 37 Alfred Street, Bedford Square, back in the artists' quarter where they had lived while working at the Colosseum, but on the east side of the Tottenham Court Road. Today called Alfred Place, it has been entirely rebuilt with modern blocks. Here he was more conveniently located for the upper class residents of the West End from whom he was receiving a growing number of commissions. This increase in work for private patrons probably also explains why he had had assistants working with him at the Pavilion and why he finally felt able to give up the regular but onerous paid employment there. This would have been confirmed after his visit to the King and Queen at Windsor in mid-October and the commissions he then received.

One is left with the impression that Chambers' quiet and careful disposition probably felt more at home in the studio or sketching in the open air than in the bustling life of the theatre. None the less, he will have learnt something from his hectic and demanding twelve months at the Pavilion. Although operating in very different media from those employed in conventional cabinet and exhibition painting, the very variety of subject matter, broad scope and speed of execution were undoubtedly a challenging learning experience. He was evidently not practised at stage perspective when he started and had to be instructed by Farrell. It is interesting to speculate in this context upon the extent to which Chambers' use of 'viewer's perspective', which became one of the characteristic and most effective elements of his style, may have had its beginnings in the varied demands of painting scenery for the stage. From this period also seems to date a greater freedom in his handling of people, ships and buildings which contributed to the naturalistic fluency of his work. 'The Opening of London Bridge', 1831, is an example (Colour Plate 14).

> His successor at the Pavilion, Mr. Leitch, so much reverenced his work, that he avoided painting it out as long as possible, and several relics of his master-hand long remained behind him.

William Leighton Leitch (1804-1883) was born in Glasgow, where he worked in a lawyer's office until he was engaged as a scene painter at the Theatre Royal, Glasgow, in 1824. Already married with three children, he went to London and, with introductions from David Roberts, pursued the same occupation. It was thus that he became one of Chambers' successors at the Pavilion, starting there in May 1832. He had a painting accepted by the Royal Academy in 1833 but then went to Italy, partly for study and partly for the good of his health, with the financial help of Mr. Anderdon, a London stockbroker. He stayed for four years, in Venice and later in Rome, becoming well known as a teacher.[4] His friendship with Chambers was renewed on his return and he will appear again later as a supporter of Chambers and a help to his widow (see pages 176 and 185).

4 MacGeorge pp.60-72

Chapter 6

'THE HAND OF A MASTER and THE EYE OF A SEAMAN' 1830-31

During 1829

Admiral Capell, passing through Greek Street, saw in the window of Mr. Smart, picture-frame maker [Thomas Smart at no. 53], two small marine paintings, by Chambers, placed there for sale. The Admiral, struck with their nautical exactness, purchased them, and making enquiry who the painter was, and where he lived, he called upon Chambers, and gave him a commission. He likewise introduced his friend, Colonel Long, to him.

Admiral the Hon. Sir Thomas Bladen Capel G.C.B. was born on 25 August 1776, the fifth and youngest son of William, 4th Earl of Essex. He went to sea in 1792, commanded men-of-war throughout the Napoleonic Wars and was in command of the *Royal George,* yacht, from 1821 until his promotion to Rear Admiral in 1825. He was subsequently, from 1834 until 1837, Flag Officer in command of the East Indies Station. In the interim, however, he was without appointment and moving in naval and aristocratic circles in London.

The picture of Portsmouth which Chambers painted for Colonel Long (see page 59) was exhibited at the British Institution in 1830, the title of the picture being 'A fresh breeze, Portsmouth in the distance' (No. 493). For topographical detail Chambers may still at this stage have been relying on sketches he took on his voyage on the *Runswick* in 1826, unless, having more time after leaving the Colosseum, he made a special journey to Portsmouth for Col. Long's picture. It has not been traced but several outstanding versions of the scene will be examined later.

Admiral Capel and Colonel Long recommended Chambers

to other friends, particularly to Admiral Mundy, and Lord Mark Kerr. Mark Kerr, accompanied by his nephew, the Marquis of Lothian, called at the theatre to see him − a mark of condescension which did not pass unobserved by Farrell.

It was equally an indication of the esteem in which Kerr held Chambers, that he should go so far out of his way to see him.

Lord Mark Kerr (Colour Plate 8) was born in 1776, a grandson of the 5th Marquis of Lothian. He was a Midshipman in the *Lion* (64 guns) on Lord Macartney's embassy to China in 1792 and came to the command of the *Cormorant* (20 guns), which had been captured from the French in 1796, on 13 January 1798. In her he took part in the recapture of Minorca and other successful actions. As his first and victorious command this ship would have had a special place in his affections. After bringing *Cormorant* home to Spithead, he relinquished command on 3 July 1799. She was in the Mediterranean again the following year and was wrecked on the Egyptian coast. Back in this country, Lord Mark Kerr married Charlotte, later Countess of Antrim in her own right. He was promoted to Rear Admiral in 1821 and Vice Admiral in 1837. He died in

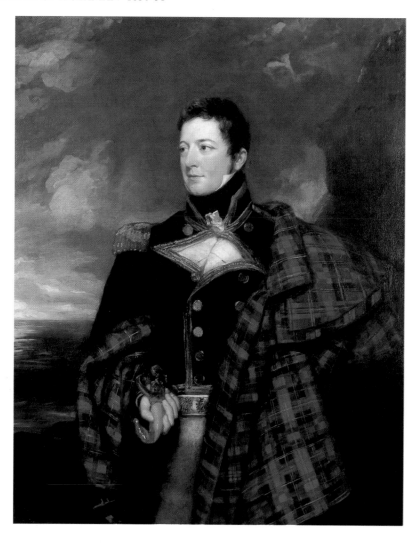

Colour Plate 8. Admiral Lord Mark Kerr by Margaret Carpenter. Oil on canvas 47 x 38in. (119 x 96cm). Chambers' principal aristocratic patron, who introduced him to the King and to others who gave him commissions. Private collection

September 1840, a month before Chambers. His collection of paintings by Chambers has remained in the possession of his descendants.

Lord Mark Kerr was delighted to meet with a painter that could pourtray the scenes of his most important services on canvas, to illustrate his own descriptions on paper. Not satisfied with employing Chambers, 'to keep his hand in, which he thought so highly of,' as he delicately and complimentarily expressed himself, he got others to employ him, and even offered to sell pictures for him. He took a pride in him as well an interest, and never ceased advancing his prospects. Knowing his deficiencies, both in fortune and education, he supplied both for him in the heartiest and humblest manner. When he dissented from him, he still deferred to him. The following extract from one of his letters will show the gentlemanly style of his correspondence:-

'There are few things that give me greater pleasure than bringing the talent which I think you possess into view. I therefore request you will never think of thanking me for any services which you may fancy I do you. The only thing I hope is, that you will never, for one moment, lose sight of endeavouring to improve yourself, and never ceasing to do so until ALL who shall see your pictures may acknowledge their excellence. With talent such as yours, you should never rest satisfied with mediocrity, but endeavour unceasingly not to be surpassed.'

Chambers would not trouble his patron, even in matters for his own promotion. The greatest difficulty in bringing him forward, lay in his own backwardness to come. Crawford experienced this, when introducing him to shipowners and captains – much more so did Mark Kerr, when bringing him before admirals and noblemen. He

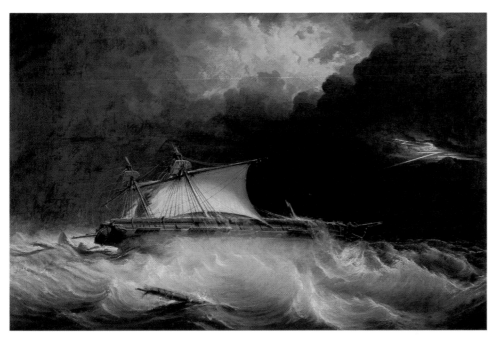

Colour Plate 9. The Cormorant *in a gale. Oil on canvas 19 x 28in. (48 x 71cm). Lord Mark Kerr gave the artist a detailed written commission for this painting and praised him for it when completed. Chambers did not usually paint storm and shipwreck scenes unless commissioned to do so.* Private collection

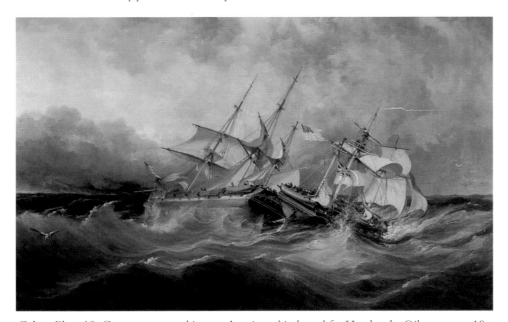

Colour Plate 10. Cormorant *speaking an American ship bound for Hamburgh. Oil on canvas 19 x 28in. (48 x 71cm). A companion piece to the previous, which also shows in detail how some of the damage caused by the storm has been temporarily made good. Although the situation of the two vessels as they speak to each other looks perilous, a collision was avoided, doubtless by good seamanship, as they both drifted to leeward.* Private collection

saw there was no danger of praise making him vain – that, on the contrary, he needed it. He writes as follows:-

'I cannot tell you how much I admire each of the drawings and sketches you have sent me – nor how much I am obliged to you for them. I fear from the excellence of the little one of Epping, you may be induced to exert yourself yourself in landscape as well as in marine. But I do trust you will study and stick to the latter.

In the former you will find many competitors; but in the latter, by constant study and practice, I think you will find none.' Again:- 'I have not said half enough of the sketches – Gravesend is nature itself. The Rotherhithe is, I should say, as fine a drawing as I ever saw; and its companion is as good in its way, and full of vigour – it is hardly possible to say which is the finest. The departing storm, with the deep tone, and the still unsettled state of the sea, is done with the hand of a master, and the eye of a seaman; whilst the repose of the vessel and mariners makes a contrast, rendering the past and present time both apparent and descriptive.'

With approbation, support and faith in his abilities from such an elevated source, it is not surprising that Chambers dedicated himself with determination to the pursuit of perfection in the highest reaches of marine painting, in spite of the necessity to provide for the daily wants of his family.

Lord Mark Kerr's commission for a picture of the *Cormorant* is an interesting example of the precision with which naval patrons set out their requirements in terms of the ship, weather and sea state for the artist to follow – a strictness which could sometimes also, as Chambers was to find later, constrain the fullest artistic expression of the painter.

The Cormorant was a long low French corvette, built at Havre de Grace, by an American. She was painted black, with two red narrow bands, or ribbons, and a red fiddle-scull head. The wind at N.W. by N. was blowing a hurricane, with thunder and lightning, and a heavy sea – she in a race. The effect of which, added altogether, carried away, at one lurch, her bowsprit, foremast, main and mizen topmasts. The foremast head fell through the back of the mainsail, and tore away three or four cloths of it, without injuring the bolt-rope. We clapped a tackle on the foot-rope, immediately under the first sound cloth of canvas left, which fortunately bore the pressure of the sail without splitting. The land on the French coast, I think it must have been Isle de Bas, was two miles to leeward; but owing to the extreme darkness of the storm, (excepting in the weather-bows, and nearly a-head, whence now and then, and indeed, almost constantly the lightning flashed) only a gloomy looming was perceptible. The race in which the ship was, seemed at times almost like molten silver. We were obliged to keep the mainsail full, as if it had once touched, it must inevitably have blown to ribbons; but after the first hour and half, the wind backed in our favour, so that, with a flowing sail, we cleared Ushant, and at length settled in a heavy and steady gale at N.E..

N.B. – The gale commenced so suddenly as scarce to give us time to shorten sail; but this was done, and we were under close reefed main topsail and courses, with our gaff down at the time she entered the race. Her bowsprit lay remarkably flat. But for the darkness occasioned by the gale, it would have been a winter twilight. No quarter boats.

After taking command, *Cormorant* was part of a squadron blockading the French coast from St. Malo eastwards to Le Havre. The mishap described took place off the Ile de Batz on 18 February 1798. That it happened so soon after Kerr took over was undoubtedly another reason why the incident remained clearly imprinted on his memory.

Chambers brought originality and artistic feeling to the portrayal (Colour Plate 9) and Lord Mark Kerr's praise of the painting was generous:-

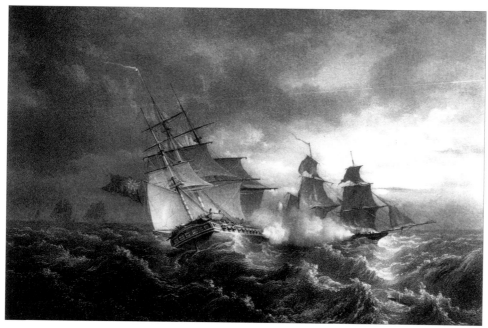

Plate 31. The Capture of Le Furet *of 16 guns, from a French squadron by the* Hydra *off Cadiz Febry. 26th. 1806. Lithograph by Paul Gauci after G. Chambers 9 x 12in. (22.5 x 31cm). The original was painted for Admiral George Mundy who had been in command of* Hydra *at the time of this engagement. It was lithographed in 1833 by Paul Gauci, a close friend of the artist.*

Sir, − I am very much gratified by the painting you have done for me − it is full of genius, and represents the Cormorant's situation in the most perfect manner. I consider the idea of shewing the land through the medium of the lightning as admirable, and the illuminated race done to greater perfection than anything I ever saw of the kind. The rain, the clouds, the light and shade, are all executed in the most skilful manner. I think, in short, the whole betokens a talent of the very highest description.

The crew of *Cormorant* inevitably spent the days after the gale making good the damage. The captain's log for Tuesday 20 February records: ''Fresh Breeze and Squally. Spoke an American Ship bound to Hamburgh'.[1] This must have been the incident Chambers was commissioned to depict as a companion piece to the previous painting (Colour Plate 10). A jury foremast has been rigged on the stump of the original and crewmen are busy on the main topmast, while the mizzen mast is still in disarray. The situation of the vessels appears hazardous in the extreme but the log makes no reference to a collision, so it must be assumed that good seamanship, both drifting to leeward, kept them apart. Chambers was probably either following Kerr's detailed description or else fore-shortened the distance in order to make the scene more dramatic.

Another pair of smaller paintings shows the *Cormorant* in action on the coast of France (Colour Plates 11 and 12). The location cannot be identified with certainty but such inshore search and attack missions were part of the everyday blockading role of a small warship such as *Cormorant*. Chambers has imbued them with typical clarity from the light effects of the sky and clouds.

It must be remembered that Chambers was now painting for the first seamen of the day − naval commanders, whose taste was not less refined than their knowledge was practical. His pictures had to undergo the strictest scrutiny from the most able judges. Two subjects which he painted for Admiral Mundy, one the capture of a frigate, and the other the storming of a fort, were lithographed by his friend Gauci. [Plate 31, Colour Plate 13 and Appendix 4.]

1 Crown Copyright PRO
Captain's Log ADM 51.1300

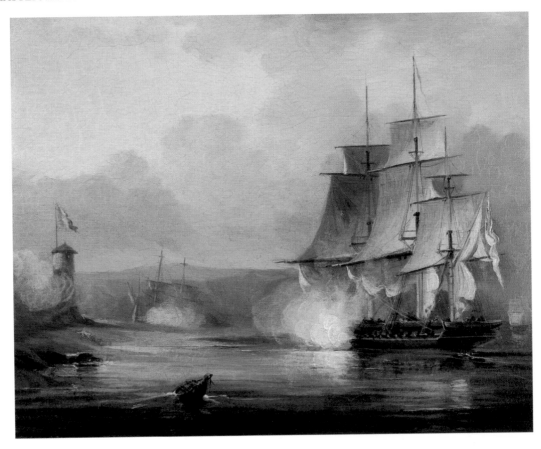

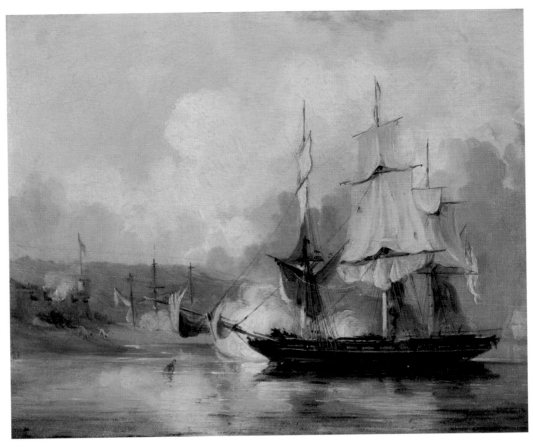

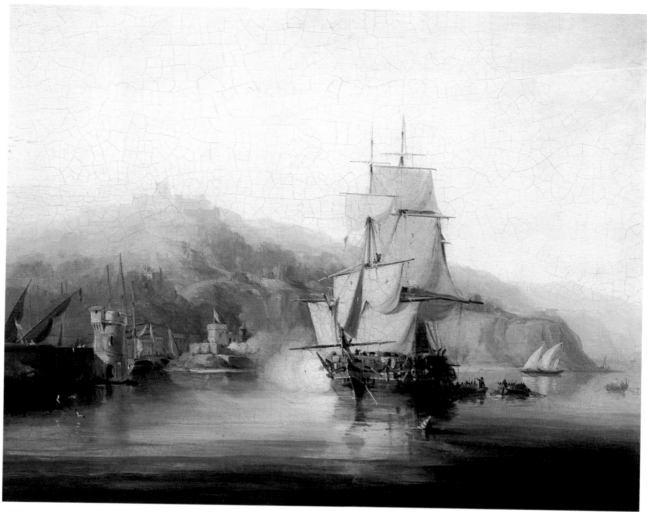

Colour Plate 11 (Opposite, above). H.M. Corvette Cormorant *20 guns off the coast of France under my command M.R.Kerr 1797. Oil on canvas 9 x 12in. (23 x 30cm). Engaged on a Channel blockade of the French coast, this scene depicts a typical everyday search and attack mission for a small warship such as* Cormorant.

Private collection

Colour Plate 12 (Opposite, below). H.M. Corvette Cormorant *20 guns off the coast of France under my command M.R.Kerr 1797. Oil on canvas 9 x 12in. (23 x 30cm). A pair to the previous, showing a similar scene. Lord Mark Kerr had evidently forgotten that he actually took over command only on 13 January 1798.*

Private collection

Colour Plate 13 (Above). HMS Hydra *at Bagur. Oil on panel 16 x 18in. (41 x 46cm). Signed and dated 1832. Another commemorative painting for Admiral Mundy of an action on the coast of Catalonia in August 1807. King William IV liked the original so much that he ordered a copy of it, which is still in the Royal Collection.*

Private collection

George Mundy, was appointed to the *Hydra* in October 1802 and continued in command for eight years, serving mainly in the Mediterranean. In 1804-05 he was under the orders of Hon. Thomas Bladen Capel. The actions for which he commissioned these paintings from Chambers were evidently the most memorable events of this command. He later served under Lord Exmouth at Algiers in 1816. Like many senior naval officers he became a Member of Parliament, for Boroughbridge in Yorkshire in 1818. At the end of 1829 he also was appointed to the *Royal George* but relinquished command on promotion to Rear-Admiral seven months later. He became Vice-Admiral of the Red in 1841.

The first picture painted for Admiral Mundy was of the capture of the French frigate *Furet* (20 guns) by the *Hydra* (38 guns) on 26 February 1806 (Plate 31). After chasing a French squadron which broke out of Cadiz, Mundy's report to Admiral Collingwood continues:

> observing one of them to be much astern of the rest, I thought it very possible to cut her off, and, after a chase of two hours, succeeded: in coming up with her she fired a broadside at our rigging, and surrendered.

> I find her to be the Le Furet French man-of-war brig, commanded by Monsieur Demay (Lieutenant de Vaisseau), mounting eighteen long nine-pounders, but pierced for twenty guns, only four years old, and of the largest dimensions, and stored and victualled for five months, of all species.[2]

The picture was hung at the 1832 exhibition of the Society of British Artists (No. 416). Plate 31 is from Paul Gauci's 1833 lithograph.

The second picture was of the taking of three prizes at Begu, or Bagur, on the coast of Catalonia by the *Hydra* on 7 August 1807 (Colour Plate 13). Bagur, on the Costa Brava, is located behind the cape of the same name and some way inland from the shore and fort shown in the painting. The despatch to the Admiral reads, in part:

> I chased three armed polaccas into the harbour of Begu last night. After reconnaissance this morning, the ship was anchored at the entrance to the port and began the attack.

> A party was landed which dislodged the defenders from the fort and town, boarded the vessels and brought them out of the narrow harbour.

> When I review the circumstances… [and the problems the party had in towing the ships out] deliberately laying out hawsers to the very rocks that were occupied by the enemy and warping them out against a fresh breeze, exposed to a galling fire of musketry, I feel perfectly incapable of writing a panegyric equal to their merits.

Casualties were light: one killed and six wounded.[3]

In his assessment of this painting, Mundy, more critical than Kerr, wrote:

> There is one thing must be altered, which is the lighthouse, as it is remarked by officers conversant with that coast (the Spanish) that such buildings are not to be seen — it must be destroyed. A very good judge, who has been in the Mediterranean, also has remarked as the sole error, in his opinion, in the picture, that the sky is not sufficiently blue cast for a Mediterranean sky, and I rather lean to that opinion.

It is interesting to note that although the lighthouse is still in place in the painting in the Royal Collection (see page 78), it does not appear in the version painted for Lord Mark Kerr (Colour Plate 13) or in Gauci's lithograph.

Later Mundy wrote again:

> The picture arrived quite safe, and it has been seen and admired by several

persons who are pretty good judges. The only fault I think they find is with the smoke, and I am of the same opinion. The fact is you have not been in the way of witnessing that sort of thing, but on seeing it once you would directly observe what I mean. I should, therefore, advise your going to Portsmouth the first saluting day, and view it both close and distant, and I am quite confident you will see and correct the error immediately, and it will serve you ever after.

It is not only the patron's own judgement which is brought to bear. The picture must also pass muster with his friends!

The matter of the portrayal of gunsmoke, and the changes it underwent as it issued from the mouth of the gun, was a subject of constant debate between patrons and artists. In part this was no doubt due to the rival claims of accurate pictorial depiction on the one hand and artistic composition and impression on the other. Chambers was to suffer criticism on this score again in respect of another later commission from a retired naval personage (see page 132).

Chambers took Admiral Mundy's advice to go to Portsmouth to see for himself as his sketches and paintings give ample evidence of visits to the naval port. It is diverting to compare this with the treatment accorded Benjamin West (1738-1820), Court favourite and Royal Academician, later to be its second President, who had had a similar difficulty sixty years earlier in painting 'The Battle of La Hogue'. On that occasion 'an admiral took the artist to Spithead and to give him a lesson on the effect of smoke in a naval battle, ordered several ships to manoeuvre as in action and fire broadsides, while the painter made notes'.[4] Chambers was later to copy that painting for Greenwich Hospital (Colour Plate 32).

Chambers' friend Paul Gauci, who lithographed these two paintings, published by Ackermann in 1833, was one of two sons of M. Gauci, a lithographer. Paul was also a painter of landscapes and exhibited several times at London shows between 1834 and 1863, the subjects being English topographical views. His principal activity, however, was as a lithographer, collaborating with his father and with Louis Haghe and Thomas Shotter Boys on landscapes and producing a succession of lithographs after notable portraits. He later published a *Practice Drawing Book*. Gauci remained a friend of Chambers for the rest of his life and will appear again later in the narrative.

4 Erffa and Staley p.209

Chapter 7

ROYAL PATRONAGE 1831–32

On 30 September 1831 Lord Mark Kerr wrote to Chambers:

If ever you exerted yourself do so now. I have this day begged his Majesty (who says he wants a picture or two), to try your skill. I dine with him on Monday, and then will request him to mention any subject he would like you to undertake. Of course his Majesty will want a specimen ere he gives you any order on the subject.

Colour Plate 14. The Opening of London Bridge by King William IV on 1st. August 1831. Oil on canvas 29 x 44in. (74 x 112cm). Chambers had started this painting, from a sketch taken on the spot at the time of the ceremony, but did not finish it until Lord Mark Kerr suggested that it might appeal to the King. When it was sent for inspection, the King suggested that the artist should go to Windsor to study the Canalettos in order to improve his handling of the subject-matter. None the less, the King liked the picture enough to buy it for fifty guineas. The Worshipful Company of Fishmongers

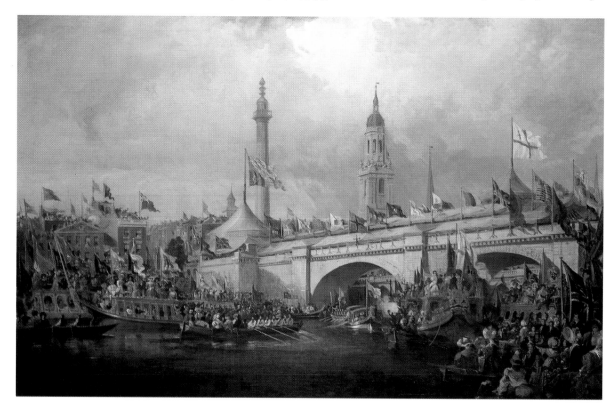

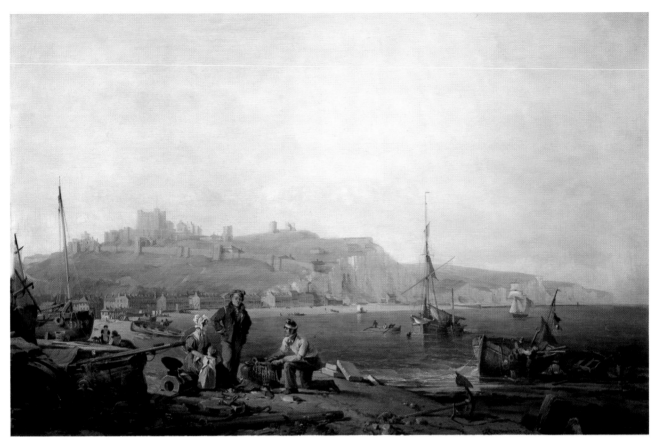

Colour Plate 15. A View of Dover. Oil on panel 19½ x 28in. (49.5 x 69cm). Chambers was bidden to Windsor with his portfolio of drawings and Queen Adelaide selected a sketch of this view of Dover to be painted as an oil for her collection. The Royal Collection © Her Majesty The Queen

What is become of your opening of the bridge? – is it sold? or is it one you would like to offer to the King for his approbation. Let me have an answer to this by return of post, directed to me at Sir Edward Paget's, Sandhurst, Bagshot. I most earnestly hope you may give satisfaction.

Accordingly Chambers ransacked his sketch-books and portfolios, to see what subjects he had that were likely to suit. The picture of the opening of London Bridge, alluded to by Mark Kerr, was one he had commenced from a sketch taken by himself, from the house of a friend in Tower Street, who thought that the subject would be likely to sell to some of the civic authorities that figured on that occasion. Chambers had not yet become an adept in drawing figures, and the many figures in this animated piece, put him out of conceit with it, and he left it unfinished. But he now resumed it at the suggestion of Mark Kerr, who thought it likely to please the royal fancy, because King William had opened the bridge in person.

The King had commissioned Clarkson Stanfield to paint the official record of the opening of the new London Bridge on 1 August 1831. The picture is still in the Royal Collection. In order to make the sketches for his painting Stanfield took a boat, which he shared with his friend Edward William Cooke (1811-1880), and moored it on the Thames to the south-west of the bridge. The viewpoint of Chambers' painting is very similar, being probably on the river bank, but there is no record of a Tower Street in this area from which the view might have been obtained (Colour Plate 14).

Besides this view of the opening of London Bridge, Chambers sent to the palace a picture which he had painted for Admiral Mundy. [Colour Plate 13.]

In a few days the painter received the following communication from his friendly patron:

Hollinwood, Wednesday.

Chambers, I have received a letter from Sir Herbert Taylor, the contents of which will, I trust, be pleasing to you.

Windsor, Oct.11, 1831

His Majesty is very much pleased with Mr.Chambers' pictures: he will keep the one of London Bridge, at 50 guineas, but he wishes it to be a little more finished, and some enlivening touches to be given, particularly to the bridge, which is flat and wants relief. His Majesty also wishes to have a copy of the Hydra on the coast of Spain, as the one sent is sold, and her Majesty has desired me to order for her two of the smallest size.

If Mr.Chambers will come here (to Windsor) next week he will have an opportunity of looking at the collection of Canaletis which the King wishes him to look at, as he thinks therein he will find some useful hints for his bridge.

P.S. Mr.C. had better bring any sketches he may have, from which the Queen may choose her subjects.

You see, Chambers, that Sir H. proposes your going to Windsor early next week, with your sketches, and, of course, in compliance with this you should take the earliest opportunity of doing so.

Lord Mark Kerr then goes on to set out a draft reply in suitably courteous language for Chambers to copy and send to Sir Herbert.

Chambers, 'as a child', went by his patron's directions. He had been nearly misled by some cockney friends, who persuaded him that it would be necessary for him to appear in a court dress, and a suit was actually made for him. In this he would have appeared like Pope, as described by Johnson. No such etiquette, however, was needed. Accompanied by a friend he took a coach to Windsor. He stayed all night in the town, and proceeded next morning to the Castle, which he said was like a 'little town' in itself. After he had got access to Sir Herbert Taylor, the King's private secretary, his difficulties vanished, for Sir Herbert received him with much hearty kindness and polite attention.

The King came, ushered by a train of red-legged livery men, to Sir Herbert's apartments – Chambers made his obeisance as well as he could, but the Royal William soon put him at his ease by the familiarity of his address. 'Well, Mr.Chambers,' said he – 'how dy'e do? – I've been expecting you. Let me see what you have brought.' Chambers opened his portfolio of sketches, and turned them over to the King's view. 'Ah, very good, very good,' said William. 'I'll go and bring Adelaide – there is a good light here – she can see them here very well.' With that he walked away, and presently returned, leading the Queen, arm in arm. 'This is Mr.Chambers,' he said – 'he has brought his sketches for you to look at – and I would like to see your choice.' Taking up a sketch of a storm scene, he said – 'I would choose that!' The Queen replied – 'I don't like that – it is too terrible.' 'Oh, ma'am,' he said, with a smile – 'we sailors like such subjects best – eh, Mr.Chambers?' However, the Queen chose a view of Dover [Colour Plate 15], and another of Greenwich [Colour Plate 18], marking the sketches with a pencil. Sir Herbert, courtier like, chose the same subjects, and made his mark beside the Queen's. The King said that the picture of the opening of London Bridge, which he

had received, and the copy of Admiral Mundy's picture, were better than he expected, and remarked that he remembered the Admiral when he himself was in service. He gave Chambers permission to copy the Canalettis in the Castle, but unfortunately our artist could not avail himself of this tempting opportunity of further ingratiating himself with his royal master.

In spite of the King's averred enthusiasm for storm scenes, the copy of Admiral Mundy's painting was, of course, quite calm (Colour Plate 13), as were those chosen by the Queen.

At the commencement of this interview, Chambers had felt somewhat disconcerted, for he was little versed in the set phrases of a court, but he recovered his self-possession when engaged in the proper business that had taken him there, and, with all a painter's zeal for his art, he adjusted a picture that the Queen was looking at, telling her, that she had it in a wrong light.

Chambers said he would do his best to please them, and the King desired Sir Herbert to give him to the care of Page Thomas, who was directed to shew him the apartments in the Castle, and to get him refreshments. Chambers found the page more pompous than the King.

Our friend came away much pleased with his reception. Many eager enquirers crowded around him, to whom he told his adventures minutely, even to losing his hat in the Castle, for he had put it down in some passage and could not find it again. He said the King was a jolly good fellow, and the Queen a nice little woman. His account was caught up, and appeared with many exaggerations in the daily papers.

Among the more amusing of these pieces of 'creative' reporting, one states that Captain Mundy's capture of Bagur was by night and Chambers had relieved

the sombre veil of night, and introduced some sea-gulls skimming the wave. 'Hallo! Hallo! Chambers' said his Majesty, 'this will never do, to have birds flying about at night – they were all gone to roost.' 'So they were, your Majesty,' replied Chambers, with the greatest naivete, 'but you gave such a broadside with your guns, that they all woke up and flew about.' 'Ah, so I did – so I did, Chambers; I forgot that – very good – very good.'

The King subsequently gave the painting of the "Opening of London Bridge" (Colour Plate 14) to Admiral Sir Thomas Byam Martin, GCB, KSS, who had been master of ceremonies on that occasion. The Admiral had a long and distinguished naval career, becoming Comptroller of the Navy in 1816. He was MP for Plymouth from 1818 to 1831 and filled many important posts, including Commissioner of Longitude and Director of Greenwich Hospital. Among other ceremonial appointments he had been assistant supporter of the canopy over the royal body at the funeral of George IV and was to perform a similar role on the death of William IV.

The painting is now owned by the Worshipful Company of Fishmongers and hangs in the Court Room of the Hall which overlooks the present London Bridge, successor to that pictured at its inauguration. It is in excellent condition and the freshness of the colours creates a vivid image of the gaiety and excitement of this royal ceremony. Any difficulty Chambers may have been experiencing with drawing figures is not readily apparent in the crowded scene where figures in boats and on the shore are inevitably one of the main features of the composition. A splendid sense of grandeur and animation is conveyed by a rather free handling of the paint. The account in Watkins, quoted above, leaves the impression that the

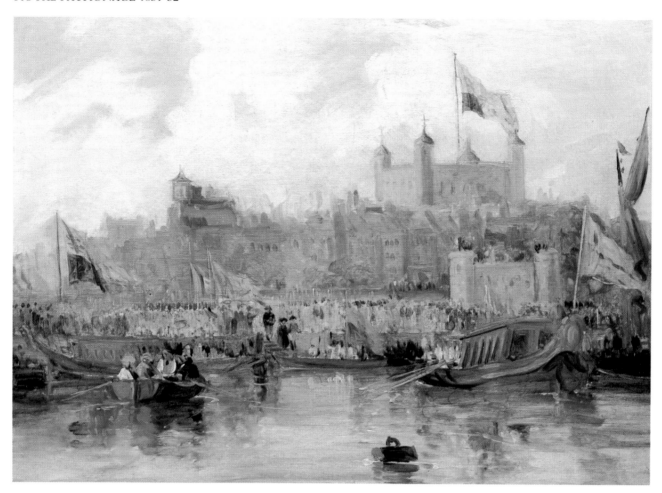

Colour Plate 16 . The
embarkation of William IV
from the Tower of London
for Greenwich. Oil on panel
9 x 12in. (23 x 30cm).
Chambers was accustomed to
sketch in oil paints on
millboard or panel and this
pair of sketches of a state visit
to Greenwich may well have
been done on the spot in the
fresh air.
Private collection

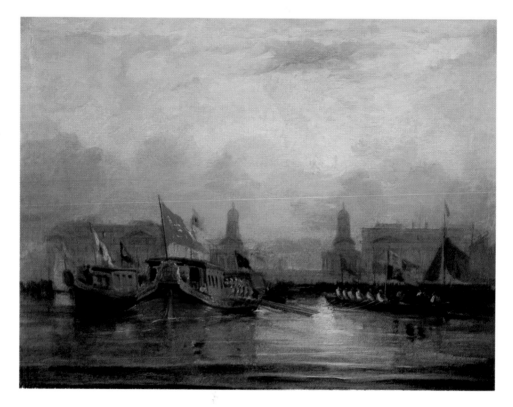

Colour Plate 17. The arrival
of William IV at Greenwich.
Oil on panel 9 x 12in.
23 x 30cm. Painted with
great freedom, the colour
qualities are vividly noted for
future development into a
finished work.
Private collection

King was satisfied with the final product, and in particular the bridge, even though the invitation to copy the Canalettos was repeated. While the bridge remains the dominant feature, the picture is well balanced, with the large City barges on either side leading the eye to the barges of the royal party in the centre middle distance and the glimpse of the old bridge beyond. The foreground boats filled with people and the crowds lining the roofs of the buildings reflect the animation of the occasion. Although Chambers rarely portrayed this type of busy scene again, there is a sense that he could have built upon the success of this painting to develop further in this direction, had he been inclined. But his inclination always remained towards the interpretation of water and shipping.

A pair of small oil sketches of King William IV leaving the Tower in the royal barge and arriving at Greenwich may have been associated with this painting (Colour Plates 16 and 17). Their date is uncertain but, as they were acquired by Lord Mark Kerr and remain in his family collection, they may have been painted at about this time as a record of another royal occasion.

The 'View of Dover' (Colour Plate 15), chosen by Queen Adelaide, is similarly in a genre of coastal and landscape scenes which was very popular at the time. This was particularly so among painters in watercolour, a discipline to which Chambers was shortly to turn. The interest of a recognisable view with foreground 'staffage' invariably proved appealing. Chambers has handled the composition and subject-matter in a competent and attractive manner, balancing a fine distant view of Dover Castle and the coastline with figures on the beach and in adjacent boats. The brushwork is on this occasion tighter in order to achieve accurate topographical and figurative representation.

The graceful proportions of Wren's designs for the buildings of Greenwich Hospital beside the Thames and their spacious layout, with the open vista to the old Royal Observatory on the hill behind, have always furnished a favourite subject for marine and topographical painters and continue to do so. The famous Canaletto painting of the view, now at the National Maritime Museum, is perhaps the best example. Chambers, however, chose a more oblique and intimate view which gave equal value to the dignified proportions of the Hospital and to the modest neighbouring houses with the busy life of the river and foreshore. His customary low viewpoint emphasises the vertical coherence of the composition while laterally balancing human foreground interest with the more distant river scene (Colour Plate 18). Chambers has succeeded in irradiating the entire composition with a vibrant texture of light which imparts a rich glow while at the same time defining light and shade. This is reminiscent of the permeating light Claude Lorrain achieved in his landscapes. Since there were nine Claudes in the National Gallery soon after its opening in 1824, it is quite possible that Chambers had studied them and absorbed some of the technique.

Sir Oliver Millar in his catalogue *The Later Georgian Pictures in the Collection of H.M. the Queen* suggests that a watercolour of this scene, now in the Laing Art Gallery, Newcastle-upon-Tyne, may be the original sketch upon which the Queen and Sir Henry placed their marks. It is a large drawing but has unfortunately been fixed to its mount and the reverse cannot be examined. There are significant differences in the detailed composition but this would not be unusual as the artist

Plate 32. Haybarge on the Thames above Greenwich. Pencil and watercolour 14 x 21½ (35 x 54.5cm). Chambers was often about on the river, sketching the craft and their people, and assembling a body of material for inclusion in his larger and more formal works. Greenwich Hospital always provided a grand background. National Maritime Museum, London

Plate 33 On the Thames. Pencil and watercolour on wove paper 8 x 11in. (20 x 28cm). Signed and dated 1833. A peaceful scene which illustrates how adept Chambers was at interpreting the life of the river with deeply-felt sensibility. He seemed to prefer the softness of watercolour as a medium in which to express these sentiments.

Courtesy of the Board of Trustees of the V&A

worked up the final oil. Plate 32, of a drawing of a haybarge upstream of Greenwich Hospital, shows Chambers' delight in depicting the scenes and figures on the river as well as his experimentation and preparation for final works.

A watercolour in the Victoria and Albert Museum, known as 'On the Thames' (Plate 33), is another brilliantly executed study with Greenwich Hospital in the background. The initials G.C. adorn the stern of the barge where a crewman sprawls atop the load, talking casually to friends on the bark. Two birds afloat in the foreground add a further point of animation.

The Queen's pictures were later engraved, 'Dover' by T.A. Prior and 'Greenwich' by J.B. Allen, for the *Royal Gallery of Art* published by James S. Virtue (Appendix 4).

Queen Adelaide bequeathed both her pictures to Queen Victoria and they have remained in the Royal Collection.

Another version of the Greenwich picture was painted in oils by Chambers in 1835 and is now in the National Maritime Museum (Colour Plate 18). This, again, has changes of detail but is essentially a recreation of a successful and popular image.

In 1838 Chambers returned to the Hospital as a subject with another original and satisfying work (Plate 34). Although the viewpoint is this time the more usual

Colour Plate 18. View of Greenwich Hospital. Oil on canvas 27½ x 40in. (70 x 101.5cm). Signed and dated 1836. The second picture chosen by Queen Adelaide was of the dignified buildings of Greenwich Hospital. Chambers prefers an oblique view from the river bank where his typically low viewpoint enables him to balance the tall grandeur of the architecture with the foreground interest of people engaged in their everyday pursuits.
National Maritime Museum London

Plate 34. Greenwich Hospital from the North. Oil on canvas 18½ x 28in. (47 x 71cm). Signed and dated 1838. A more usual view of the Hospital from the river, but the bustle of craft in the foreground brings absorbing human interest and animation to the scene. The transom of the haybarge bears the initials 'G C' and ''38'.
Courtauld Institute of Art, University of London

one across the river, it is closer and the jostle of boats in front of the Hospital immediately brings interest and vivacity to the scene. The quality of composition rivals that of his earlier paintings. It is not only signed and dated but also carries his initials and '38' on the transom of the haybarge. This device was quite common among marine painters and occasionally used by Chambers. The picture was with a London dealer in 1930 but its present whereabouts are unknown.

This review of the paintings for the King and Queen, with their related studies and later versions, focuses on the second main grouping found in Chambers' works. It may be described as waterside scenes and events. They are closer to the popular landscape views of the time but retain notable distinguishing features. Architectural detail is more prominent, occupying its place of importance in the subject-matter, and is expertly handled. Although there is less water, it always features in the foreground, usually calm as the locations are sheltered. Its role is subordinate, providing the intermediate surface upon which boats and people figure conspicuously and in which reflections are featured. People themselves become an integral and sometimes, in the scenes of celebrations, a dominant part of the composition. They are much more than 'staffage', adding a lively human dimension to the scene. While the use of space remains an important element, it is more tightly controlled in order to emphasise the action or architecture. Works in this thematic group were usually painted in response to commissions, but Chambers none the less succeeded in bringing his own individuality to them and imposing his stamp of authority.

The narrative returns to the account of the visit to Windsor in October 1831 and concludes:

Chambers paid dearly for the high honour which his merit had won for him. It had rained all the way to Windsor, and as he could not procure an inside seat, he got wet through, and in consequence contracted a severe cold, which, with his mental excitement, brought on his old rheumatic complaints, and disabled him for the present from executing the royal commissions. He was confined to his room six months, and the tide of carriages that had begun to roll to his door, turned into another street. His illness, however, was productive of one compensating benefit – Dr. Roupell, who had been recommended to him, proved ever after one of his kindest friends.

Our artist's malady was increased by the fiery impatience which he felt to resume his labour. The doctor desired that the unfinished performances which hung about his room should be removed out his sight, but he would not permit this. He studied when he could not paint. At length his capricious and unaccountable pains left him as suddenly as they had come, and he immediately set to work to follow up his fortune.

He executed the King's commission first. On sending the pictures home, the following note was received:-

St. James's Palace, March 12, 1832.
Sir Henry Wheatley is commanded by the King to acknowledge the receipt of Mr. Chambers' pictures, representing the opening of London Bridge, and the Hydra frigate on the coast of Spain, and his Majesty begs to know what part of the coast of Spain is represented in the latter picture. Sir Henry will be happy to see Mr. Chambers at St. James's Palace either to-morrow or Wednesday morning, about eleven o'clock, when he will pay Mr. Chambers for the pictures.
G.Chambers, Esq., 37, Alfred St., Bedford Sq.

The Queen's pictures were afterwards acknowledged thus:-

Windsor Castle, July 8, 1832

Dear Sir, – Your two pictures arrived safely on Tuesday last; but the precarious state of the Queen's niece prevented my submitting them immediately to her Majesty, and since I have done so pressure of business has prevented my writing earlier to you. I am now happy to acquaint you, that the Queen is extremely pleased with both pictures, and that they are highly approved of by others who have seen them, as indeed they deserve to be, particularly that of Dover. I have received her Majesty's command to pay you thirty guineas for each, and as her Majesty retains the frames, I enclose Mr. Burton (the Queen's treasurer's) cheque for eighty pounds thirteen shillings, for which I request you to send me a receipt. When you have finished the pictures for me, I shall be obliged to you to send them to my house in the Regent's Park, with a frame similar to those of her Majesty's, and if you will inform me when you do so, I will send you a cheque for the amount. I remain, dear Sir, your very obedient servant, H.TAYLOR.

G.Chambers, Esq., 37, Alfred St., Bedford Sq.

The frames for the Queen's paintings appear to have been made by Morland, a maker who also, for a time, supplied frames to J.M.W. Turner. One or two other contemporary frames on paintings by Chambers are identifiably by the same maker.

Chambers may already have been feeling the early effects of the chill when he declined the royal invitation to stay and copy the Canalettos. It seems, none the less, to have been a golden opportunity missed. The sickness which followed and the long delay in delivering the paintings may also have been a reason why there was no follow-up to the royal commissions.

Lord Mark Kerr presumably felt that he had done what he could for the young artist, although Chambers painted some pictures for him in 1832. There were many other artists to whom the royal couple could turn for pictures. John Christian Schetky (1778-1874) had been Painter in Watercolour to the King when Duke of Clarence, became Marine Painter in Ordinary to George IV and the Duke, an appointment which continued in William IV's reign and into Queen Victoria's. William John Huggins (1781-1845), perhaps the most prolific and popular marine painter of his time, was appointed Marine Painter to King William IV in 1836, the King admiring his work 'rather for its correctness than its art'.[1] Many of Huggins' works were lithographed by his son-in-law, Edward Duncan (see page 117).

After the privileged start he had enjoyed, Chambers had no further association with the royal family and received no other marks of royal favour. One can only speculate on the reasons for this. His shyness would almost certainly have deterred him from, for example, trying to take up again the missed opportunity to copy the Canalettos at Windsor. Competition from other artists, and their patrons who had the royal ear, would have been keen. It is none the less disappointing that after such an apparently successful beginning nothing further ensued, particularly as Chambers always showed his awareness of the need to attract important patrons and to make the 'big hit'.

The only exception was the purchase by the then Dowager Queen Adelaide of a watercolour by Chambers at the 1840 exhibition of the Old Water-colour Society, 'Dover Pilot-Lugger returning to the Harbour' (No. 258). It appears that she bought it at the exhibition rather than as the result of a commission. Perhaps she was then reminded of the artist and her earlier purchases (see page 177 and Plate 81).

1 Redgrave p.219

Chapter 8

A DEALER'S SPONSORSHIP
and ARTIST FRIENDS 1832-33

In spite of the setback occasioned by the breakdown of his health after the visit to Windsor, 1832 brought Chambers some compensations. The satisfaction of finishing off the paintings for the Queen was accompanied, on 16 June, by Mary Ann's safe delivery of their second child, another son. He was baptised, William Henry Martin, at St. Pancras, the parish church of their home in Alfred Street, on 11 July 1832.

Colour Plate 19. Figures on a beach. Oil on millboard 11 x 15in. (28 x 38cm). The handling of this beach scene is characterised by its colour and variety. Private collection

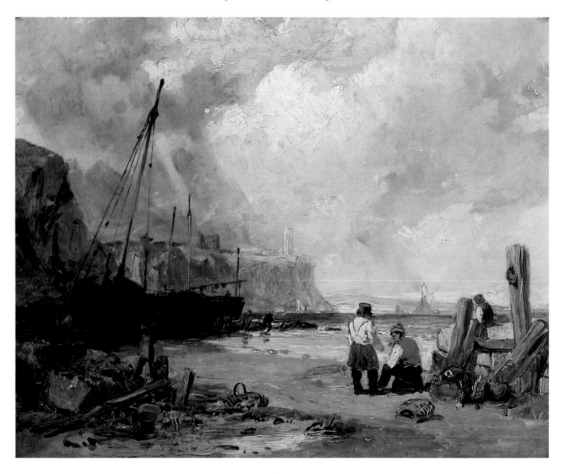

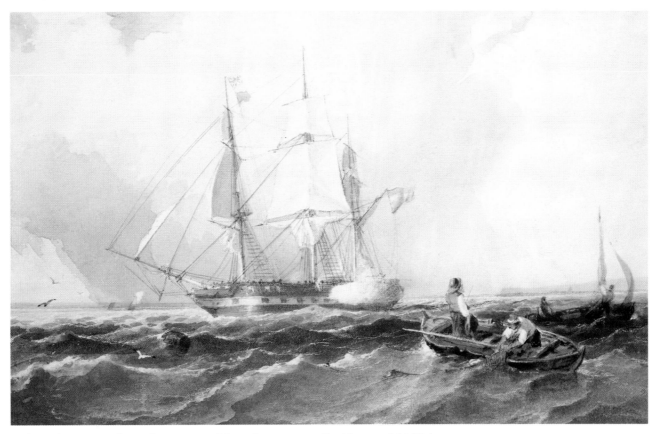

Colour Plate 20. A frigate firing a gun. Watercolour over pencil with scraped highlights on wove paper 7 x 11½in. (18.5 x 29cm). Chambers here rivals Bonington in his sensitive response and delicate use of colour.
National Maritime Museum, London

The first two names were after the King, out of pride and gratitude for the Royal patronage the artist had received. There is no apparent explanation for the third name unless it was after John Martin (1789-1854), who was a noted illustrator, pamphleteer and painter of spectacular Biblical episodes. Martin also came from the north, having been born near Hexham, Northumberland. He started life modestly in Newcastle-upon-Tyne as a painter of carriages and decorator of porcelain before moving to London in 1806. Being older and longer established than Chambers, he may have befriended the new arrival in his early years in London. They were, however, very different in temperament, Martin being known as 'Mad Martin' both for the cataclysmic scenes he painted and for his debauched life-style. Watkins held him in very high regard, referring to him as 'the great Martin, certainly the most wonderful painter of the day' and recounting anecdotes about him, so it seems likely that Chambers also admired him and perhaps counted him among his circle of friends.

Lord Mark Kerr gave Chambers a letter of introduction to Mr. Carpenter, the picture-dealer of Bond Street, desiring him to introduce Chambers to all his friends. Carpenter possessed several pictures by Bonnington, which he showed to Chambers, telling him that when he could paint one as good, he would hang it up beside them. It was not long before a picture of his reached this high honour.

That may have been the picture painted for Carpenter and hung at the SBA in 1833, discussed below.

The early influence of Bonington's work on Chambers is illustrated by a small

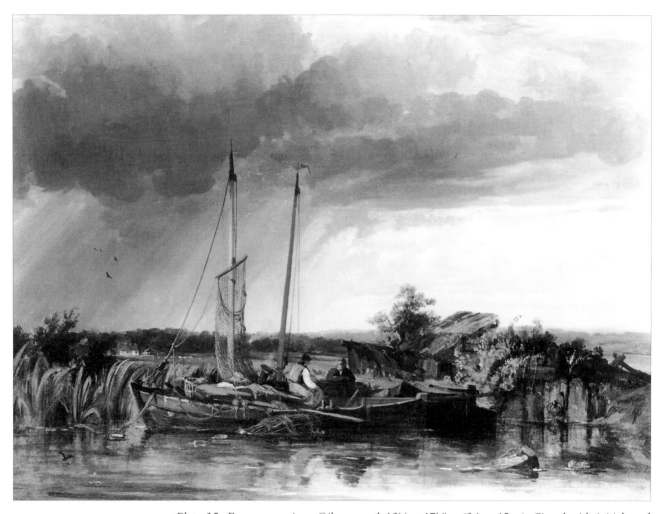

Plate 35. Barges on a river. Oil on panel 13½ x 17½in. (34 x 45cm). Signed with initials and dated 1831. Experimenting with a more pastoral setting, Chambers emulates Bonington in this intimate riverside scene. Yale Center for British Art, Paul Mellon Collection

oil known as 'Barges on a river', dated 1831 (Plate 35). This pastoral scene is a departure from what had already become typical Chambers subject matter, but bears certain resemblances to a similar scene painted in about 1824 by Bonington, 'On a French River'. The keen interest in the foreground figures in the boats, the uncrowded composition and pervading sense of quiet purposefulness can be observed. The palette and brushwork are restrained, in keeping with the handling of the rustic setting.

A beach scene with figures, owned by Lord Mark Kerr and still with his descendants, is undated but would also have been produced at this period (Colour Plate 19) – again an unusual subject for Chambers but one which is reminiscent of beach scenes by Bonington such as 'Sunset in the Pays de Caux', 1828, in The Wallace Collection. The open space, mellow tones enlivened by bright foreground touches, and the radiant luminosity which permeates the entire work, are characteristics derived from Bonington. Eugène Delacroix (1798-1863), Bonington's friend, wrote of him: 'particularly in water-colour, he makes his pictures like diamonds that flatter and seduce the eye'. It was this quality which Chambers also aimed to achieve. The warm brilliance, conveyed through soft tones, continued to identify Chambers' painting and remains today a distinguishing

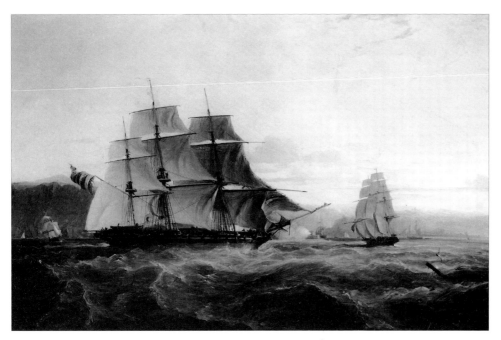

Plate 36. An East Indiaman and other shipping off the coast. Oil on canvas 17½ x 25½in. (44.5 x 65cm). Signed and dated 1832. A traditional subject handled with the artist's new-found technique and feeling. The striped sleeve apparently over the ensign is a curiosity. Sotheby's

feature. His technique was already well developed with confident brushwork and discriminating palette.

These early works, capturing some of Bonington's romantic sensibility, were closer to the conventional landscape mode and part of Chambers' search for self-expression. Constable was also a continuing influence at this time with his dedication to the truthful depiction of country scenes and landscape, particularly in oils. Although Chambers did not pursue countryside themes, he learnt much from Constable about the handling of both clouds and foreground figures. His inclination was towards marine subjects, where he felt more at home by reason of his experience and knowledge, and he soon devoted himself to the search for purity in sea painting. In following this direction he was encouraged by Lord Mark Kerr himself (see page 69). An example of the level of accomplishment he attained with his mature watercolours of the sea, and the enduring influence of Bonington on him, is 'A frigate firing a gun', dated about 1835 (Colour Plate 20). This bears favourable comparison with Bonington's 'Vessels in a choppy sea', c.1824-5, at the Yale Center for British Art.

Plate 36, 'An East Indiaman and other shipping off the coast', an oil painting from this period, shows Chambers blending some of his new-found technique and feeling into the handling of a more traditional subject. The coastline bears some resemblance to that in 'HMS *Hydra* at Bagur' (Colour Plate 13).

The Carpenter family was important and influential in the London art world at this time. James Carpenter and his son William were, with Dominic Colnaghi and John Barnett, the principal dealers who sponsored Richard Parkes Bonington. William and his wife Margaret became good friends of Bonington. William was also a notable scholar and in 1845 became Keeper of Prints and Drawings at the British Museum. After Bonington's death Carpenter was one of the leading publishers of lithographs after the artist's work (see page 184). Margaret Carpenter (née Geddes, 1793-1872) was a prolific portrait painter noted for her Eton College leaving portraits.[1] She painted Lord Mark Kerr (Colour Plate 8) and her

1 Pointon. Bonington, Francia & Wyld, p.54

portrait of Lady Mark Kerr was hung at the Royal Academy in 1824. This may have been how Lord Mark Kerr first came to know the Carpenters.

Thus, thanks to his aristocratic patron, Chambers once again had an introduction to people who could provide real assistance.

The introduction to Carpenter seems to have been instrumental, during 1832, in bringing Chambers together with two of his contemporaries who were also struggling for wider recognition and who were to become close friends, Thomas Sidney Cooper (1803-1902) and James Baker Pyne (1800-1870).

Cooper was born in Canterbury and started work at the age of twelve as an assistant to a coach painter and later as a scene painter, but spent his leisure time painting and drawing from nature. In 1823 he went to London, worked at the British Museum and then became a student at the Royal Academy. After four years he moved to Brussels, married and stayed until 1831. On his return he settled in London. Cooper developed a specialisation painting cattle in landscape and first exhibited at the Royal Academy in 1833, continuing to do so every year thereafter until his death. He was elected an Academician in 1867 and lived to the age of ninety-nine, being appointed CVO in 1901.

J.B. Pyne came from a similarly unprivileged background in Bristol. Having been articled to an attorney, he taught himself to paint and then worked as an artist in Bristol. There he taught William James Muller (1812-1845), who was apprenticed to him in 1827 for two years, and went on to become a distinguished painter. Pyne exhibited at the British Institution in 1828 and had moved to London by 1832, the time here described by Cooper. The Royal Academy accepted one of his pictures in 1836 and he later travelled extensively on the Continent and in England. He enjoyed a high reputation, owing a considerable debt to Turner and Bonington, in 1841 became a member of the Society of British Artists and later its Vice-President. He was, however, not a strong character and had various personal problems. Watkins wrote to admonish him and criticised his rashness, while Chambers' letters refer to his being in the Queen's Bench for four or five weeks in 1840 (see page 175).

Cooper's autobiography, *My Life,* was published in 1890. In it he writes (p.221):

Mr. Carpenter afterwards commissioned me to paint a half-length picture of a Kentish farm, similar to commissions that he had already given to George Chambers and J.B. Pyne. These were new men, like myself, and we three soon became intimately acquainted.

We saw a good deal of each other during the time that we were painting these pictures, and I soon became sincerely attached to poor George Chambers, our friendship lasting till his death, which occurred about seven years later, while he was still quite young. His early death was a very great loss to art, for, had he lived, I feel convinced that he would have become one of the greatest marine painters of his time, or, indeed, of any time... His painting of rough water was truly excellent, and to all water he gave a liquid transparency that I have never seen equalled. He understood the rigging and form of every variety of vessel, too, perfectly, and his ships were all in motion....

Poor George was full of fun, and had a fund of anecdotes, rendering him a most pleasant companion. Some of his stories were painful, others gay. Of the latter, I well recollect one that he used to tell us. He was living at a public-

house near the Thames, which was much frequented by the captains and sailors of small vessels, and the landlord, having a fellow-feeling for anyone so badly off as was George Chambers, charged him nothing for his board and lodging, but took some of his sketches in payment, and got him, moreover, custom among the seafaring men who frequented the place.

One day, when he was hard at work in a back room on a little picture, which he had been commissioned to paint, he heard a commotion and cries of fire in the house. He ran into the bar, and found that the chimney was alight, and men were trying to sweep the soot down with a broom, but the flames had taken hold of it too high up the chimney for this means of extinguishing the fire to be successful. George Chambers, seeing this at a glance, caught up a thick mat, and ran with it to the roof, and, climbing up the stack of chimneys, he put it on the top of the one that was on fire, thus stopping the smoke. As there was a stiff breeze, he sat on the chimney-pot, to prevent the mat from blowing away. Suddenly, a moment after he had taken his seat, he found himself, mat, and everything dislodged, with a loud report, so he went down again to see what had happened. Then he found that one of the Captains had fired a carbine up the chimney, with a large charge of gunpowder! No one knew that Chambers had gone aloft, and when he stopped the smoke from coming out at top, thinking that by excluding the air he would put out the fire, the smoke had come down into the room in such volumes that the other people present were frightened, and had resorted to this measure, which effectually removed all the soot. When he told them what he had done, they gave him a cheer, and all laughed heartily – as did we, also, when he related the story to us.

The three pictures which we had painted were sent in due time to the Suffolk Street Exhibition, and were all accepted, being the talk and admiration of all at the private view.

The title of Cooper's painting at the 1833 Society of British Artists' exhibition in Suffolk Street was: "Landscape and Cattle" (No. 13). Pyne's was entitled: "Clifton, Near Bristol" (No. 118). Later these two occasionally collaborated, as, for example, in "Clifton from Ashton Meadows; the cattle by T.S.Cooper", which Pyne showed at the British Institution in 1836 (No. 128).

Chambers' name was now before the public, and the press kept it so. Though not always correct in matters of minor importance, it is often so in the main, as the following extracts may shew. Speaking of the picture which Chambers had painted for Carpenter, exhibited at the Society of British Artists in 1833, the daily papers said:-

We mentioned the name of Chambers amongst the candidates for pictorial fame. A Portsmouth ferry boat crossing to the Isle of Wight, is a very clever – nay, masterly thing. When we saw it, we said this man has seen the sea. We have since heard that the painter is a naval officer, and, moreover, that he is patronised by the King, who has himself been a traveller upon the 'yeasty waves', and knows agitated water from a field of new-mown hay. There is great truth and freedom in the delineation – the sea is nature itself. We heard an artist of some skill compare the handling to that of Calcott; but we perceived little or no resemblance.

A critic in the *Townsman* also referred to Callcott in writing about the picture:

> Were we to afford a column, justice could not be done to the transcendent merits of the picture before us, which we do not hesitate to say has not been surpassed even by the ablest masters. With the scientific and judicious arrangements of the great Calcott, and the decision and atmospheric expanse of the no less admirable Stanfield, Mr. Chambers possesses that *sine qua non* of all claims to the attention of posterity – namely, a style unprejudiced by too much reference to 'rules of art', and untramelled by following too closely in the steps of another, however great.

The Literary Gazette also appreciated the naturalism of his style: 'Mr. Chambers has shown how much may be effected without those meretricious aids which are frequently resorted to as substitutes for truth and nature.'

Augustus Wall Callcott (1779-1844) studied under John Hoppner and at the Royal Academy. His early works were pastoral and genre paintings but in 1806, when elected ARA, he exhibited two marines. Thereafter he produced marine paintings until about 1830. These were limited in number and mainly commissioned works which therefore tended to disappear from public view after their initial exhibition. This may be the reason why Callcott is less well known today than in his own time, when he was highly regarded as a marine painter. He was much influenced by Turner and they were friends, rivals and collaborators. For some years Callcott also influenced Turner. But as Turner's style evolved, Callcott remained firmly in the conventional Dutch tradition typified by Albert Cuyp (1620-1691). He was elected an Academician in 1810 in place of Paul Sandby and knighted in 1837. By that time he had become a leading figure in the art world and was appointed Surveyor of the Queen's Pictures in 1843.[2] As a painter Callcott was admired for his technical skill, as well as his 'scientific arrangements', and in these respects Chambers may have borne him some resemblance. It is possible to trace influences of Callcott in Chambers' work both in the choice and handling of subject matter. But, as people, they could not have been more different, Callcott moving easily in aristocratic circles and cultivating wealthy patrons. For whatever reasons, Chambers had a great admiration for Callcott and named his third son, born in 1837, after the distinguished Academician (see page 150).

The reviewer of the SBA exhibition in *The Times* of 25 March 1833, too, found a resemblance to Callcott in Chambers' picture:

> This is a production of a new artist, who, as we hear, has changed the naval profession for that in which he now appears before the public for the first time. From such a beginning as this we may reasonably augur much future excellence, 'unless', as Fuseli said of Wilkie at the commencement of his career, 'it is chance!' Such efforts as this have, however, never yet been the result of chance. The shipping appears to be minute and correct, which if the common report concerning the artist be true is not surprising, but the power which is displayed in representing with freedom and truth, the natural effects of the scene, the sea and the distance, display talents of a very high order. The general effect of the picture reminds the beholder of a sea-piece of Callcot, which everyone will recollect to have been at Somerset-house two years ago (an Ostend boat), but the resemblance does not approach imitation.

2 Blayney Brown pp.13-20

Plate 37. A Seascape. Oil on canvas 20½ x 25½in. (52 x 65cm.) Signed and dated 1833.
Although the title has changed, this is probably the painting exhibited at the Society of British Artists
in 1833 to much acclaim in the press. Courtesy of the Board of Trustees of the V&A

The report in *Lo Studio* was less effusive but none the less complimentary:

> The Portsmouth Ferry-boat crossing to the Isle of Wight is also from the
> pencil of another aspirant to fame and public favour. The painter, Mr.G.
> Chambers, needs no better advocate than own work; it is, therefore, that we
> do not enlarge upon his merits further than to say that he has faithfully
> depicted nature, both in sky and water, and, happily chosen his effect, and as
> happily transferred it to canvas.

The painting which attracted such critical acclaim has not been traced with certainty
but seems likely to be the oil now in the Victoria and Albert Museum, signed and
dated 1833, known as 'A Seascape' (Plate 37). This painting is in the uncomplicated
style of Chambers' early work. The composition is well balanced but simple,
encouraging the viewer to focus attention on the sense of space and naturalistic
handling of sky and sea, appreciating the typically short waves over the shoal waters
off the Gosport shore. The low viewpoint into the open ferry-boat, surging upward
on a wave, brings the movement close to the picture plane. These were the qualities
which distinguished the painting and took the eyes of the critics.

Cooper goes on to record a conversation he had at the 1833 SBA exhibition with
Robert Vernon (1774-1849), one of the most important collectors of the day, who
was in 1847 to donate a large part of his collection to the nation. It is now divided
between the National Gallery and the Tate Gallery. Cooper recounts:

> Then, looking again with careful scrutiny over my painting, he said: 'I
> should like to have that picture very much, but I see it is in the hands of a
> dealer, who asks £100 for it; and it is worth it, though I feel sure you did not
> get anything like that for it from him; and as I have not yet bought a single
> picture in my collection from a dealer, I shall not have this.'

Plate 38. Tilbury Fort. Pencil and watercolour 6½ x 11½in. (16.5 x 29cm). Signed and dated 1838. A picture with this title was the subject of an acrimonious exchange of letters between the artist and Carpenter, the dealer who sponsored him.
Courtesy of Agnew's

Vernon was later to pay the highest price, £26.5.0, for a picture by Chambers at the posthumous auction sale of his studio contents (see page 184 and Appendix 3).

Cooper continues his narrative to describe Carpenter's pressure upon him to accept a commission for three pictures at £30 apiece, which he declined after receiving advice from James Duffield Harding.

In spite of Carpenter's role in bringing on these artists, the part played by dealers in the promotion and marketing of artists' work remained a sore topic. It had ever been thus. A century earlier, Charles Brooking (1723-1759), the most accomplished marine painter of his time, who also died young and in poverty, was the victim of an unscrupulous dealer. Chambers' relations with Carpenter never seem to have been easy.

> Mr. Carpenter sometimes took him with him to Margate, the London tradesmen's bathing place; but Chambers complained that these excursions cost him as much as though he had gone upon his own charges.

In 1837 Watkins published a *Memoir of Chambers. The Marine Artist*, the draft of which he submitted to its subject for approval. Chambers replied:

> It is very amusing. However you have recollected the different incidents quite puzzles me. The only thing I should like to have altered, if it lies in your power, is the mention of Mr. Carpenter, as 'fledging young artists'. Anything else. It will not do to speak the truth at all times. If it should happen to fall into his hands, he would take every opportunity to do me a mischief. I shall never be able to repay your kind feelings towards me, and trust you will ever find me worthy of it.

The expression alluded to by Chambers, stood in the Memoir as follows: 'Mr. Carpenter, a gentleman who deserves much credit for fledging young artists' – it was altered, at Chambers' request, to 'for encouraging young artists'. Chambers was afraid

that Mr. Carpenter would take it in an ironical sense, and probably read fleecing for fledging. It is customary for authors to complain of the tyranny of booksellers – actors, of that of managers – and painters, of picture-dealers. Picture buyers go to a dealer's shop, instead of to the artist's studio – and thus the dealer has it in his power to deal with the fame of an artist as well as with his paintings.

Carpenter sometimes sold a picture for thrice the money which he had paid to Chambers for painting it, and when the artist remonstrated, he was told that 'he ought to be content to live in a garret while his fame was sounded for him'. Competition among dealers alone enhances the price given to artists. Now, the only way to remedy this, is for the artist to have a shop of his own wherein to exhibit and to sell his pictures. This might look too much like making a trade of a liberal profession, but where is the shame? Hogarth pursued this plan, and thereby freed himself from the tyranny of dealers. He would not let a merchandizing dealer have a picture of his on any consideration.

Carpenter being a bookseller, wished Chambers to take books in exchange for pictures; and by such notes as the following used to work the painter 'to an oil'.

<div align="right">January 2nd, 1837</div>

My dear Chambers,
You use me very ill. You promised me two drawings last week. I begin to think that I am to be served last on all occasions; but I dare say you have your reasons for serving me thus. The gentleman I promised should see them has been here, and was much disappointed.

<div align="center">Your's truly,</div>

<div align="center">J.Carpenter.</div>

The first letter of an exchange in 1839 has survived in manuscript.[3] Its punctuation and spelling are evidence that, as Chambers used to say, he would rather make a sketch than write a letter. The hand is, however, well formed.

<div align="right">May 13th 1839</div>

Dear Sir,
I have finished the small picture of Tilbury fort which you said you would like to have thairfore would not dispose of it before you had your choice of it I have painted it very carefully and think it would please you. if you will be good enough to drop me a line to say wether I shall keep it for you before Thursday next as I have promised it to a gentleman should you not like it. I would have called and showed [illegible] only that I feel very [?] unwell today. an answer will oblige.

<div align="center">Your Most Obt.</div>

<div align="center">(signed) G.Chambers</div>

7 Percy Street, Rathbone Place.
to Mr. Willm. Carpenter,
 10 Notingham Place,
 New Road

A drawing of Tilbury Fort is reproduced as Plate 38 which may have been the picture in question or, more probably, a study for it.

3 National Art Library, V&A Museum London

Letters from James Carpenter reproduced in Watkins appear to be replies to this communication:

<div align="right">June 6th, 1839</div>

Friend Chambers,

I hope you perfectly understood me, that my taking your picture must depend upon my approval of the alterations you proposed to make, when done – and further, that you are at liberty to take it to a better market, if an opportunity offers, and believe me
Your very sincere friend,

<div align="center">J.Carpenter.</div>

G.Chambers, Esq.

And later:

Mr. Carpenter's compliments to Mr. Chambers – begs to say that as he can employ his time to more advantage, Mr. Carpenter will not impose upon him the task of executing the commission for the fifty-two drawings.

If the gentleman who has seen the picture of Tilbury Fort, which you tell me is finished, will give the same price I agreed with you, or more, let him have it by all means, but do not sell it for less.

There are references elsewhere to a series of drawings of the Thames which was not realised (see page 160). These may have been the drawings referred to by Carpenter. The curt dismissal in the final note is clearly a threat out of pique and sounds terminal to their relationship. No record has survived of further contact between them although Carpenter's name appears, with six others, on the subscription notice for Watkins' posthumous biography of Chambers as a sponsor of the publication (Plate 85 and page 187).

Chapter 9

MEDICAL FRIENDS and TOURS WITH A SKETCHBOOK 1833

The treatment of Chambers' blistered hands in Whitby by Mr. Allan mentioned above (see page 30) led to the doctor's appreciation of the young artist's talents and introductions to potential patrons in London.

Another doctor responded similarly when treating Chambers for the aftermath of the chill he caught going to Windsor in October 1831.

His illness, however, was productive of one compensating benefit – Dr. Roupell, who had been recommended to him, proved ever after one of his kindest friends. [Chambers] was recommended to try country air and diet. His kind doctor frequently gave him a run out of London to his country seat at Chart Ham in Essex.

George Leith Roupell (1797-1854) was a physician at St. Bartholomew's Hospital who specialised in fevers. He succeeded to his father's estates, presumably Chart

Colour Plate 21. View of Scarborough. Watercolour 9½ x 13½in. (24 x 34cm). A typically lively and truthful work depicting the harbour at Scarborough, not far from Chambers' native Whitby. In the right background work is under way on the outer harbour wall.

Ham, in 1838, but died of cholera contracted at Boulogne in 1854. His portraits and books were bequeathed to St. Bartholomew's but the paintings by Chambers were apparently not included. Dr. Roupell bought a large painting, 'Emigrants Embarking', which was exhibited in the British Institution in 1835 (No. 88) and much praised by the critics. He remained medical adviser and a staunch friend to Chambers until the end of his life and bought one of the sketches made on the artist's final voyage to Madeira.

Writing later, in March 1834, Chambers says:

> I am glad to say I have been quite well for these last six or seven weeks and hope to keep improving. I have been under one of the first-rate doctors, Dr. Roget; and hope, in time, to get quite clear of my complaint, which is a disorder of the nerves connected with the spinal marrow.

Dr. Roget does not figure as prominently as Dr. Roupell in the subsequent years of Chambers' life but remained a supporter. He was undoubtedly responsible for passing anecdotal information about the artist on to his son, John Lewis Roget, who wrote the standard history of the early years of the Old Water-colour Society, published in 1891. The latter owned a drawing by Chambers which was shown at the Royal Academy loan exhibition in 1908.

> A Mr. Miles turned Chambers' attention to a new style of art, in which he soon became remarkably proficient. His scenic-painting had laid the foundation for his excellence in water colour drawings, and he loved them for the superior effects which he could produce in them. Besides they were lighter and cheaper, and more fashionable, and peculiarly English. Above all they pleased the ladies best.

The identity of Mr. Miles has not been established. It is possible that it was Miles Edmund Cotman (1810-1858), son and pupil of John Sell Cotman (1782-1842), the leader of the Norwich School. In 1828, and again in 1831, they sailed John Sell's boat from Norfolk to the Thames and spent time on it there during the summer, exploring the estuary and the Medway. Miles became an enthusiastic painter of marine watercolours and it is entirely possible that he met Chambers, who also loved the Thames, and encouraged him to take up the medium. John Sell moved to London in 1834 on being appointed Professor of Drawing at King's College School and Miles joined him as assistant two years later. The watercolour style of Miles was lighter in tone than that of his father and Chambers may initially have been influenced by it, but he subsequently moved on to develop his own crisp and fresh technique.

The efforts of painters in watercolours to organise themselves into an association of comparable stature to that of the Royal Academy had had a chequered history. The Society of Painters in Water-Colours was founded in 1804 with many of the notable watercolour painters of the day as its leading members, including William Sawrey Gilpin, Nicholas Pocock and William Henry Pyne. Its development, however, was fraught with financial difficulties and differences of opinion regarding the admission of oil paintings to overcome the deficit. This divided the Society and it was in 1813 superseded by The Society of Painters in Oil and Watercolours. Still financially precarious, the Society reverted in 1820 to watercolours only and henceforth grew in strength. A.V. Copley Fielding, a successful painter of marine subjects among others, was elected

President in 1831, a position he held until his death in 1855. Under his leadership the Society continued to flourish and became firmly established.

Since, however, it was a close society with limited membership, other associations inevitably sprang up to provide an outlet for aspiring artists who were not invited to exhibit at the Society. One of these was The New Society of Painters in Watercolours, open to all, formed in 1832 under the patronage of Queen Adelaide. This followed in the footsteps of an earlier association, having the same name, which had been in existence from 1807 until 1813. The New Society changed its title in 1833 to Associated Artists in Water Colours for its second exhibition in Old Bond Street, which opened on 15 April, about a month after the SBA.[1]

Taking advantage of its open status, Chambers marked his conversion to the medium by exhibiting three pictures at this show. *Lo Studio,* a contemporary arts journal, records his participation thus:

> Mr.G.Chambers has several drawings, amongst which those we most admired were No. 88, 'Burlington Pier, Flamboro' Head in the distance' (Plate 18), which is true to nature; and No. 117, 'Peter Boats, Sea Reach', which is a masterly little drawing.

The *Literary Gazette* added:

> Mr. Chambers has shewn that he possesses in water-colour the same power which in his pictures in oil has so recently called forth the expression of our admiration.

George Chambers was evidently also involved in the management of the new society for his name appears on the list of the committee of the Associated Artists in 1833. This association itself became a close society in the following year and subsequently changed its title back to the New Society.[2] It was from this time that the original society came to be known as the Old Water-colour Society (OWS) in order to distinguish it from later rivals.

Chambers' health remaining poor, Dr. Roupell advised him to visit Yorkshire for the country air and in April-May 1833, having completed his submissions to the exhibitions, he returned to his native Whitby.

> There was at that time in Whitby a young artist named Carter, who had served in the same shop with Chambers, and another named Dove. Carter was attempting portraits – Dove, marine subjects – both had been prompted by the success of Chambers, and both were delighted with his visit. Chambers lent them every assistance, not merely by word, but by pencil, and he frequently went out a-sketching with them. He spent much of his time in their painting-rooms. Dove was very docile and grateful.

The friendship with Thomas Dove (1812-1886) probably dated from Chambers' time working for Widow Irvin in Whitby before moving to London, when Dove was apprenticed to George Croft, another house painter. A.S Davidson in *Marine Art and Liverpool*[3] goes on to state: 'it seems fairly definite that in his late teens he spent a month with Chambers in London'. This would have been in 1830-31. Dove moved to Liverpool where he had some success as a ship portrait and marine painter but was burdened by a large family and had to resort to house painting to earn a living. He returned in old age to Whitby and died there in the workhouse.

Chambers' willingness to help other artists, very often in spite of, or perhaps

1 Cundall p.69
2 Cundall p.74
3 Davidson pp.70-76

Colour Plate 22. Herring Fishing. Pencil, watercolour and surface scratching 9 x 15in. (24 x 38.5cm). Signed and dated 1833. Chambers portrayed the world of the sea, which he knew well from his own experience, with fidelity and feeling, but without the heavy emotional overtones which became popular later in the century. The Whitworth Art Gallery, The University of Manchester

because of, their humble origins, is one of his engaging characteristics. Instances of his generosity in this respect recur throughout his life.

George Weatherill (1810-1890) was another Whitby artist whom Chambers knew and instructed. A great admirer of Turner, Weatherill stayed in Whitby for the whole of his life and produced many watercolours, paintings and drawings of the town which, in the course of the later nineteenth century, was already becoming a favourite resort for holiday-makers. Chambers met him again in 1837 and he is often referred to in the correspondence. He later added engraving to his skills, producing prints after Turner and other works of topographical interest in Whitby. The Pannett Art Gallery in Whitby has a collection of his works. Several of his children also became artists of local repute.[4]

It was in Carter's painting-room on this visit that Watkins first met Chambers. John Watkins (1808-1850) was a member of a Whitby shipowning family who enjoyed an independent, if limited, private income. His occupation was writing, although this would have been unlikely to provide him with a livelihood. He was a playwright, poet and biographer as well as a writer of political tracts. A keen supporter of liberal causes, he lectured on the injustices suffered by the working classes in the price of bread under the Corn Laws and the poverty of their condition, being imprisoned for speaking out in support of the Chartists (see page 173). James Byers, a liberal reformer from Whitby, was the subject of Watkins' first biography, which he published himself in 1830, followed in 1839 by *The Life of the Corn Law Rhymer* on Ebenezer Elliott. In 1847 he married Elliott's daughter.[5] Watkins was obviously something of an opinionated busy-body but he was shrewd and tenacious and his writings show him to have been a sincere and generous protagonist of the people and causes he espoused. His record of

4 Harland p.13
5 Smales pp.144 and 217

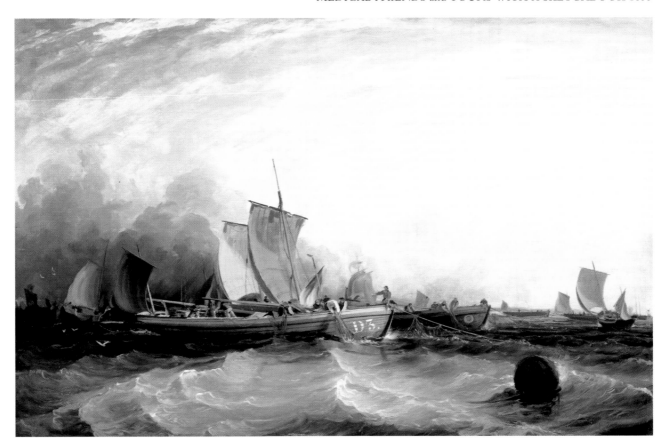

Colour Plate 23. Hauling in the nets. Oil on canvas 19 x 28in. (48 x 71cm). Signed and dated 1836. This oil may have been developed from the previous drawing (Colour Plate 22).

Christie's Images

Chambers' life is accurate and his artistic criticism perceptive, if at times over-enthusiastic and rather too candid. He proved to be a good friend to Chambers and his family and a staunch supporter of the artist's work.

After that meeting, Watkins continues:

> We frequently walked down the pier together. He always carried a small sketch-book in his pocket, which he pulled out whenever he saw something that he thought would make a sketch. I was sometimes surprised at his choice of subjects. I thought that a painter of his eminence would only take grand views; but he would stop and book an old buoy, a post, or a rock. He said these would all be of great service to him in the composition of a picture. On parting with him for the morning, he usually asked, in his quiet, indicative manner, 'Shall I see you in the afternoon? – Shall we get a sketch?'

During Chambers' visit to Whitby

> the weather was unpropitious for out-of-door sketching, so he sketched the romantic scenery through the window. But landscape views were not what he wanted – he longed to get to the sea-side. We walked across the moors down to Staithes, famed as the fishing town where Captain Cook was bound apprentice to a grocer. Chambers sketched this singular-looking place, with Kauber-nab in the background [now Cowbar Nab, the promontory to the east of Staithes]; but the young piscators gathering around us like Otaheitans, and not comprehending what was going on, began to pelt us with pebbles. We were obliged to move off. We came along by the top of the cliff to Runswick, which was sketched, and afterwards walked to Whitby. Our route in all extended above twenty miles – this was something for an invalid.

Chambers made a sketching excursion to Mulgrave woods, and to Robin Hood's

bay. He sometimes got into a boat, and sketched choice bits in Whitby harbour. He was glad when he could get away undiscovered into some warehouse quay, or raft-yard, which commanded a view of those clusters of houses and craft, which he could delineate so truly, and colour so vividly.

Scarborough, further south than Robin Hood's Bay, was a another location which Chambers painted in both watercolour and oil. The drawing now in the Victoria & Albert Museum (Colour Plate 21) is a characteristic example of life and movement as the brig beats into Scarborough harbour. The outer sea wall is seen under construction.

He was not, however, happy with Whitby, either because of an actively hostile reception in Staithes or owing to a superior attitude on the part of many townspeople. He wrote to his wife: 'The people seem to hear nothing and to know nothing. There is no society in the town.' None the less his wife joined him for the latter part of his stay, making her first visit to his birthplace.

The artist's health seems to have improved temporarily after his return to London but deteriorated again in the early summer. He was unable to work in June and July and set off again to seek improvement in the country. He wrote to Watkins in September 1833: 'My time has been spent in the delightful county of Sussex, at Tunbridge Wells, Lewes, Brighton, Shoreham &c. I have had a most delightful little residence about one mile from Brambletye House'. This was near East Grinstead and Watkins recorded that 'His family and his friend Crawford had been with him.'

The nature of Chambers' ailments is not precisely clear. His liability to chills extended to rheumatic pains which made it impossible on occasion for him to hold a pencil or brush. Writing to him in July 1833, Watkins says:

> Your disease cannot be described by the doctors, and therefore cannot be remedied by them. But I trust that, as your pain has left your inside, and settled in a less vital part, (the leg) nature, assisted by Providence, (for your complaint appears to be above human reach,) will grant you a speedy relief, and restore you once more to the arts.

This view that doctors could not diagnose his illness is confirmed by later references in the months before his death. A modern medical opinion is set out on page 181.

Although there were evidently periods during the year when Chambers was incapacitated, some of his best work is signed and dated 1833, in addition to that exhibited at the shows discussed in the last chapter. Two examples illustrate the range of his skill and sentiment and probably result from his tours in the country.

'Portsmouth Harbour from Spithead' (Plate 39) has an established provenance until its last appearance in a London saleroom in 1976. It was shown at the International Exhibition in 1862 (No. 430) under the title 'Sea Piece', when owned by Mr. Richard Ellison. It has many of the qualities which distinguish Chambers' paintings: low viewpoint, a large buoy in the foreground, a vessel in commanding centre position superimposed or, in this case almost, upon another craft, a larger ship behind and a background full of nautical and topographical interest, detailed but respecting perspective; a readiness to treat large areas of sky with freshness, using sunlight to enliven the water, ships and shore. The change of title illustrates one of the difficulties in tracing Chambers' works. Sea paintings, even with an initially identified location, as was usually the case in exhibition

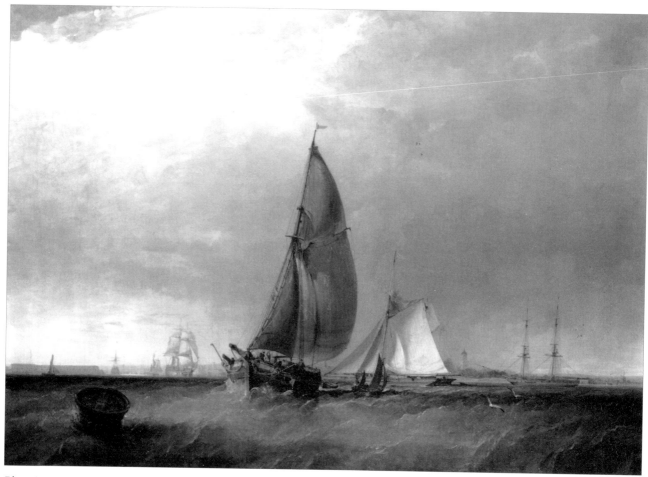

Plate 39. Portsmouth Harbour from Spithead. Oil on canvas 23½ x 33in. (60 x 84cm). Signed and dated 1833. One of Chambers' first commissions, from Colonel Long, was for a view of Portsmouth and it was a subject to which he returned, with success, in subsequent years. Christie's

catalogues, can, with the passage of time, easily take on another more generalised title or be attributed to a different location.

'Herring Fishing' (Colour Plate 22), a watercolour signed and dated 1833, takes the viewer into the unpretentious action of the fishery but handles its representation with a sense of elegance and human dignity. In 1836 Chambers produced another more complex version of the subject, in oil, 'Hauling in the Nets' (Colour Plate 23).

When Chambers returned from Sussex, he took a cottage [No. 6 Park Village West (Colour Plate 24)] near Regent's Park, which combined the advantage of a town residence with country air.

As the construction of the elegant terraces around Regent's Park advanced, John Nash, the architect, took something of a gamble and developed, at his own expense, the canal and basin around the northern perimeter of the park. A further difficult area remained undeveloped on the north-eastern edge between Gloucester Gate and the canal. In 1824 Nash leased this land and laid out a development of elegant rustic villas, Park Village West, all different and many standing in their own gardens.[6]

James Pennethorne, Nash's step-son, was responsible for the design of Nos. 1-7 Park Village West, a terrace of cottage-style houses which, although not detached as the others, are dignified and attractive. No. 6 is on the corner with large windows looking over the garden of No. 8. These cottages were immediately

6 Saunders p.109 and p.118

Colour Plate 24. No. 6 Park Village West. The artist and his family moved into this new area of attractive villas on the edge of Regent's Park, partly in the hope that the better air would improve his health.
Photograph Author

popular and came to be occupied by a variety of distinguished people, among them Edmund Kean, the actor.[7] Apart from the anticipated benefit to his health and working environment, Chambers and his family thus became residents of an exclusive and desirable part of London's latest fashionable development. He had also returned, perhaps not entirely by chance, to the vicinity of the Colosseum where he had worked five years earlier. Chambers obviously enjoyed Park Village. Two sketches of it were included the sale of his studio contents (Lots 61 and 94, Appendix 3).

7 Hibbert p.584

Chapter 10

'NATURE WAS HIS ACADEMY': ELECTION TO THE OLD WATER-COLOUR SOCIETY 1834-5

In February 1834 Chambers wrote to Watkins:

> I must tell you some better tidings, which I know you will be glad to hear. I keep on improving prices for my pictures every day. I am just painting a view of Staithes from the sketch I made when with you; it is a beautiful subject. I could have sold it to a dozen different gentlemen. There is always something good in these barbarous places, where they have not manners to allow you to sketch.

A picture with this title was exhibited at the OWS in 1834 (No. 245), marked 'Sold'. One of similar title was exhibited the same year at the SBA (No. 357).

> I have also to tell you more good news. I was last week [10 February] elected a Member of the Old Water-colour Society, which is almost as good as being a royal academician. I was unanimously elected, although I do not know one single member. There were a great number of candidates, who have been trying for years past to become members.

Chambers' pleasure at his election to the Old Water-colour Society (OWS) was justifiable. As a close society, only members were permitted to exhibit, being initially classed as 'in-elect' or associate members. In spite of its chequered history

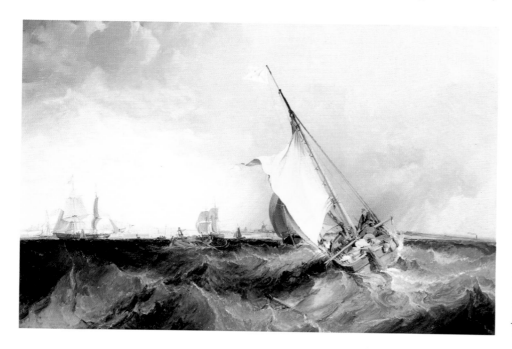

Colour Plate 25. Shipping off the coast at Margate. Oil on canvas 19½ x 27½in. (49 x 70cm). Signed and dated 1834. A distant view of the town with the foreground action concentrated on the crew grappling with the broken sprit while the sail flaps wildly in the wind.
Sotheby's

it remained the most distinguished association of painters in watercolour. Chambers was entitled to take pride in his election since he had taken up watercolour painting so recently and found it so much to his taste and talent. He was able to express his feeling for natural effects most happily in the medium. On his election to the OWS Chambers retired from his membership of the Associated Artists in Water Colours.

In spite of the evident satisfaction in being preferred for the OWS, there is a hint of disappointment at not being considered for the Royal Academy. His work had been accepted there on two occasions, in 1828 and 1829 (see pages 53 and 54). A painting submitted in 1831 was not accepted

> ... and he was so vexed, not at the academicians for rejecting it, but at the picture for being rejected, that he would not send to take it away till the exhibition was over, and did not send another till some time later.

That seems to have been in 1838 when 'Dutch vessels going out of harbour – Rotterdam in the distance' was hung (No. 293, Plate 75 and page 158). His 1839 submission was again rejected but achieved success elsewhere (Colour Plate 53 and page 169).

Various reasons have been advanced by commentators such as Watkins and art historians for Chambers' lack of success at the Royal Academy. Jealousy among established artists at the favour shown by the King and Queen to an 'unknown' and antipathy to an independently-minded young painter not working within the established conventions of the Royal Academy Schools are among them. As Watkins observed:

> Had Chambers been a pupil in the Academy, the Academicians would, probably, have regarded his performances more partially, but nature was his Academy.

Nor would Chambers' growing reputation as a watercolourist have strengthened his claim at the Academy, which was traditionally averse to the medium. He would clearly not have gone out of his way to court Academicians in order to obtain their support. His humble background, natural diffidence and lack of social graces placed him at a disadvantage to his more self-assertive contemporaries and their supporters. His age at this time would also have counted against him. Clarkson Stanfield, ARA in 1832, was forty-two years of age when elected a full Academician in 1835.

When Watkins visited the Royal Academy exhibition with Chambers in 1835 he recorded:

> In his quiet way, he pointed out several of his distinguished brethren to me. Mr. Stanfield, R.A., and *now* the first marine artist of the day, came up to him in the Academy, and invited him to his studio, but he never went; the artist might think it was indifference, but it was diffidence.

This bashful and discourteous response to a generous invitation is surprising since Clarkson Stanfield was clearly someone for whom Chambers had the greatest respect, perhaps based in part on their similar seafaring backgrounds. Apart from the experience of scene painting in the theatre, Chambers several times painted the same subject after Stanfield had exhibited a version, for example, St. Michael's Mount (see page 157 and Colour Plate 45) and was later to receive a commission to copy Stanfield's 'Trafalgar' (see page 138 and Plate 62). Chambers was conscious of the need to 'make a hit' and tried hard to achieve it. He obviously

Plate 40. Market boats rounding a buoy. Watercolour 8 x 13in. (20 x 33cm). Chambers' mature style at its best. His handling of water has progressed far beyond the white-tipped regularity found in some of his earlier paintings.
Courtauld Institute of Art, University of London

appreciated the importance of the social contact with patrons and was depressed at his lack of success in this regard. Yet he seems to have been unable to overcome his inherent shyness. Reticence, such as his failure to accept the invitation of the King and Queen at Windsor, would not have endeared him to important patrons and potentially helpful friends. Had Chambers lived longer and gained the self-confidence which comes with acknowledged success, he might have become a Royal Academician. His friend Sidney Cooper was not elected until the age of sixty-four, having become an Associate in 1845 at forty-one years of age. Even John Constable (1776-1837) was elected in 1829, aged fifty-two, by a majority of only one vote, fourteen, to Francis Danby's thirteen, after active lobbying.

On the happier theme of the OWS, Chambers celebrated his election by exhibiting eight paintings at the 1834 show, including 'Staithes, Yorkshire' mentioned above (Appendix 2). These manifest a wide range of subject matter and topographical location and are an expression of his delight at being elected.

Arnold's *Magazine of the Fine Arts* reported on the show:

> Bentley and Chambers, the two new associates, have distinguished themselves most – the former in No. 248, 'The Church of Santa Salute, Venice,' a scene of great magnificence – the latter in No. 381, 'Paying off the Maidstone Frigate, Portsmouth Harbour, sketched in 1832', which is also a splendid composition.

The *Literary Gazette* praised '209 "Peterboats" G. Chambers; a new aspirant, who has at once established his claim to our eulogy and the public applause.'

Charles Bentley (1806-1854) had been apprenticed to the engraver Theodore Fielding and was a friend of William Callow (1812-1908), who was in Paris at the same time as Bonington. Bentley had also been on the Continent and produced topographical views and marines in watercolour as well as engraving Bonington watercolours for Fielding. As a result of this, his work showed a more marked influence of Bonington than was the case with Chambers. The election to associate membership of the OWS of two painters sharing this influence demonstrated the impact which Bonington's innovations had had on the art and practice of painting in watercolour.

Market boats rounding a buoy (Plate 40) is a further illustration of the extent to which Chambers absorbed Bonington's technique and sentiment into his own lively but less mystical style.

Plate 41. Smugglers creeping for gin off Dungeness. Oil on canvas Outside frame size 51 x 69in. (129.5 x 175cm). A dramatic image, shown at the British Institution in 1834, where the subject-matter attracted censorious comment on the immorality of trafficking in alcohol. The patch of sunlight enhances the anxiety of the smugglers as one scans the approaching vessel while others haul up the contraband.
Courtauld Institute of Art, University of London

In July 1834, after the close of the exhibition, the Duchess of Kent and her daughter, Princess Victoria, were received at the Society, so Chambers may have had the opportunity to meet or see the future Queen.

The British Institution this year hung a major oil by Chambers: 'Smugglers Creeping for Gin off Dungeness' (No. 546. Plate 41). The painting is an excellent example of his skill and originality in choice and handling of subject matter as well as in execution. The action is concentrated in the left foreground, receding to the left, with the open sea view to the lighthouse to the right. The central open boat, tilted towards the viewer as the contraband is lifted from the water, brings urgency to the composition by its silhouette above the low horizon. The man with the telescope to his eye, anxiously scanning the distant ship in case it is a revenue vessel, matches the tall profile of the lighthouse tower. The patch of sunlight around the boat seems to heighten the anxiety of the smugglers in the awareness of their visibility. The *Literary Gazette* on 1 March reported:

> If the attractive character of the painting, invested as it is with the finest qualities of art in execution and fidelity of representation, had not excited our attention (for it is not placed in a situation equal to its merits), the title would have been sufficient to engage us.

The critic then continues with a fierce censure on the depravity of smuggling alcohol.[1] The picture was sold through a New York auction house in 1904 and its whereabouts are currently unknown.

'Merchantmen and other shipping offshore' (Plate 42) is another 1834 painting illustrating Chambers' apparently easy skill in handling the movement of ships and sea. Once again it is the use of space which determines the quality of the work. Typically the ships on the left are in part superimposed one on the other, a device

1 The *Literary Gazette* 1834 p.155

Plate 42. Merchantmen and other shipping offshore. Oil on canvas 27 x 35½in. (69 x 92cm). Signed and dated 1834. A more traditional sea painting but treated with all Chambers' deftness and skill. The vessel is, as usual, unidentified, and the composition balanced to allow one half to be dedicated to sea and sky – with the customary buoy. Christie's

previously used by Bonington in, for example, 'Shipping off the Coast of France' c.1824-5 now in the Whitworth Art Gallery, Manchester. This imparts a tension, but any sense of clutter is avoided. Meanwhile there is room in the other half to concentrate on the sea, with the usual buoy as a foil, and on the sky.

William Scoresby Jnr., who succeeded his father as a whaler captain (see page 19, went on to become a cleric, scientist and prolific writer. When Vicar of Bradford he sought confirmation from one of his crew of an example of atmospheric refraction. The reply from Thomas Page refers as a matter of course to Crawford and Chambers, the Whitby connection, and takes for granted the artist's ability to interpret natural phenomena:

London, March 15th.,1834.

Mr. Scoresby,

Dear Sir,

Having been informed by Capt. Lappage, it was your wish that I should say in what situation the Fame appeared in the Fuar, afterwards named by yourself Scoresby's Fuar, I have great pleasure in forwarding you all that I recollect of the phenomena. I was at the mast-head, and observed at first the entire appearance of a ship in the clouds, hull, masts, sails, &c.; but all in disproportioned and detached parts. I believe you asked me from the deck, if I saw anything; and I directly told you in what direction it was. On your observing it the sight was rather disappearing, or had altered in appearance. I need not remind you, that we immediately steered in that direction; when, on our coming near her, the vessel proved to be your father's, the Fame, of Whitby. I shall describe the circumstance to Mr. Crawford, and he will endeavour to get me a sketch of it done by Mr. Chambers, the artist.

Plate 43. Margate. Oil on canvas 43½ x 59in. (110.5 x 150cm). Signed and dated 1836. The most dramatic of several similar paintings Chambers made of Margate, to which he was introduced by James Carpenter. A copy is in Margate Local History Museum. Another version was engraved by J.T. Willmore and published as a print in 1838. Private collection, courtesy of Hahn

The first painting of Margate exhibited by Chambers was at a special SBA show at the end of 1834 (No. 314). This was a successful picture and a subject to which he returned several times over the coming years in both oil and watercolour (Plate 43). The arrangement and activity of the small boats in the foreground varies but the point of view of the lighthouse, pier and town is usually similar. Colour Plate 25 is a more distant view, the foreground action in this case being the crew coping with the broken sprit while the sail flaps wildly. All these works have the customary Chambers qualities and the treatment of the sky in particular is invariably very good. Another version, 'Margate Pier', was hung at the SBA's next regular exhibition in 1835 (No. 318). An engraving by J.T. Willmore of one of the versions was published by A.H. Bailey in 1838 (Appendix 4). Chambers' liking for the subject probably dated from his visits to Margate with Mr. Carpenter and the popularity of the resort would ensure the ready interest of potential purchasers.

Chambers did not have to wait long for his election to full membership of the OWS. It followed very shortly, on 8 June 1835. This was also cause for satisfaction. Charles Bentley and Joseph Nash, elected Associates at the same time, were not elevated to full membership until 1843 and 1842 respectively.

Chapter 11

'THE SOUL OF A PAINTER –
MOST NATURAL GENIUS' 1835

Watkins visited Chambers in London and stayed with him for four or five months at Park Village West, throughout the long hot summer of 1835. This close familiarity enabled him to describe the artist's working method, daily routine and something of his social life.

> He painted in his drawing-room; but, excepting the picture on the easel, there were no marks of its being a painting room. His colours and brushes were kept in a mahogany case, designed by himself, and having the appearance of a piece of drawing-room furniture.

The mahogany case was presumably Lot 167 in the sale of the studio contents after Chambers' death (Appendix 3).

> Of his domestic manners there is nothing particular to relate. He rose at about eight, breakfasted, went to his painting-room, worked and received visitors while at work, dined late – for he wished to prolong his working hours until light failed – and when profitably engaged would disregard all calls to dinner. Tea followed shortly after dinner; and if he had had a successful day, but more commonly when unsuccessful, he would indulge himself in a visit to the theatre. His habits were very domestic. He loved to chat with his friends around his own fireside, smoking a cigar to a glass of white brandy; his usual toast being, 'Here's better luck still'. His voice was mellow, and his smile sweet.
>
> His method of painting a picture was first to chalk in the subject, then pencil it, washing out the chalk marks. He first rubbed in the sky, afterwards the more prominent parts of the picture, but not piece by piece – he generally had the whole of the picture equally advanced, for he could not finish bit by bit. His method when at work was to paint a few strokes, then retire to see how they looked, return and rub them out with a cloth, or put in others, retire again and so on until he produced the effect which he saw in his 'mind's eye'. Sometimes he used his fingers and sometimes the stick end of his brush. His two boys drew in the same room while their father painted. His wife, like the dark-eyed Kate of Blake, cleaned his brushes for him and passed her opinion upon his performances.

Since his sons were at this time five and three years of age one imagines that their drawing, at least that of the younger, was not too serious!

> On coming into his painting room he would look around at several unfinished pictures, scarcely knowing which to place upon the easel; and very probably the one that was most waited-for would be the last touched – probably too the unfinished ones would be left alone while one that had been dismissed as finished, but which he fancied he could mend, would be resumed, as he always saw more to do than he had done. He used to regret that he could not bestow more time upon a picture, and sometimes declared that he would be satisfied with painting a good one though it did not sell. He keenly felt his fate in being obliged to 'paint for the pot', and yet he was

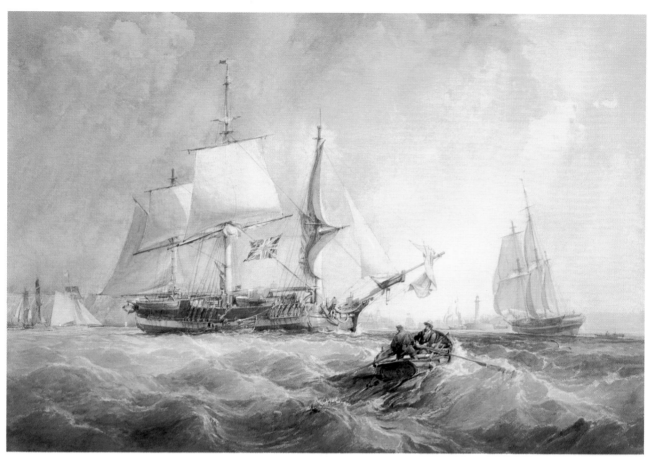

Colour Plate 26. Taking a Pilot on Board off the Port of Whitby. Pencil and watercolour 23 x 32in. (59 x 82cm). Signed and dated 1835. Exhibited at the Old Water-colour Society in 1835, this is one of Chambers' most accomplished drawings and demonstrates the full range of his skill in the medium.
The Whitworth Art Gallery, The University of Manchester

a great advocate for submitting the feelings to the situation, boasting with honest pride, that rather than want or procure his wants dishonourably, he would make and sell blacking.

Another contemporary, giving an example of the artist's homely manner of speech, recorded his remark to his wife at tea-time: 'Come Missus, its getting late let's have 'tay'.[1]

Chambers clearly never worked in a purpose-built studio. In all the homes he occupied he always had to adapt a living room to the needs of a studio. It is remarkable that he was able to achieve the striking colour effects of his 'studio' oils with the meagre natural light which probably entered his modest accommodation. This may also have been a reason why he preferred to work from nature in the open air in watercolour. There are repeated references by contemporaries to his indefatigable enthusiasm for sketching out-of-doors. Even there, he was always anxious for the bright sunlight which illuminated the natural tones he was intent on interpreting and enabled him to achieve the freshness which characterised his work.

Chambers had six paintings at the OWS exhibition in 1835 (Appendix 2), again a variety of subject matter set in familiar locations on the Thames, at Whitby and Portsmouth. 'Taking a Pilot on Board off the Port of Whitby' (No. 194, Colour Plate 26) fully demonstrates his mastery of the medium. The fluent handling of the sea and sky, the detailed activity in the small boat and on board the ship as she

1 Anderdon Collection 1838, British Museum

is held hove-to, and the Whitby shoreline beyond with the new West Pier lighthouse, completed in 1831, combine to create a totally satisfying image. The critic in the *Literary Gazette* on 2 May noted: 'The sailor's eye and the artist's hand have combined to render this one of Mr. Chambers' finest performances'.

The picture subsequently fetched the highest price to that date for a Chambers watercolour at auction, £215.5.0 at the Birch sale in 1878.[2] It was presumably then bought by W. Walton Esq., who loaned it to the Manchester Golden Jubilee Exhibition in 1887 (No. 1502).

This outstanding example provides an opportunity to examine more closely Chambers' watercolour technique. His effects are achieved by the deft use of the colours themselves in wash and in fine detailed brushwork. Some under-drawing in pencil establishes the lines of spars and rigging on vessels but thereafter the desired effect is created through the medium of the colours alone. The sea, sky and distant shoreline are conveyed by the skilful laying down of washes while a finer point is used for detail both near and far. Lighter tones pick out the background lighthouse and harbour, darker tints set the ship firmly as the centre-piece of the composition and the darkest take the eye to the two oarsmen in the open boat. Chambers was a purist in his use of colour. There is occasional scratching out to whiten wave-caps and sometimes the use of body-colour, but in general he achieved his impact by fluent and accurate brushwork. In this there is a similarity with his painting in oils. Both attain a freshness and clarity through the assured handling of colour.

2 Roget II p.237

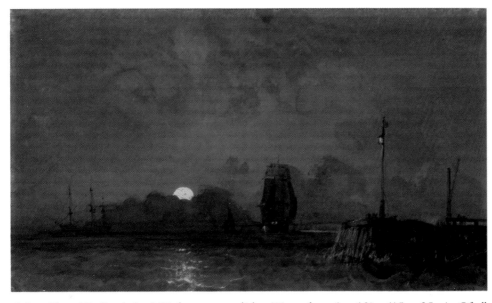

Colour Plate 27. Sunderland Harbour – moonlight. Watercolour 6 x 10in. (15 x 25cm). Of all Chambers' pictures John Watkins 'most coveted a moonlight scene of ships sailing out of harbour at night. It was a thing to dream of.' This, or another version, may have been the picture.

Courtesy of the Board of Trustees of the V&A

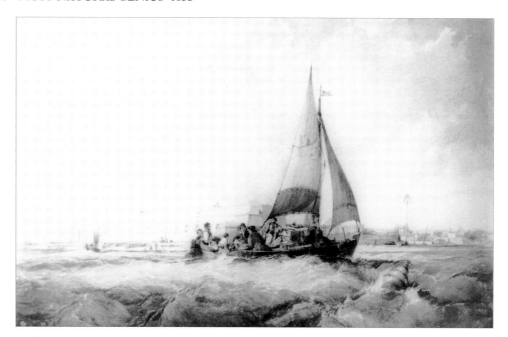

Plate 44. A Ferry-boat going into Portsmouth, passing Blockhouse Fort. Watercolour. Another work hung at the same exhibition, which again shows the artist's keen interest in people and everyday life.
Courtauld Institute of Art, University of London

'A Ferry-boat going into Portsmouth, passing Blockhouse Fort' (No. 291, Plate 44) is a closer study but has many of the same qualities as the previous work. Here the passengers in the cockpit, glad to be reaching the end of their crossing, again provide a central human interest in the composition.

Watkins visited the galleries with Chambers and commented:

> His drawings looked cold amid the glowing colours of others, but this was owing to the coldness of subject; for in truth and vigour they surpassed them all, and looked more like paintings in oil than water. Of all his pictures I most coveted a moonlight scene of ships sailing out of harbour by night. It was a thing to dream of. The difficulty of such a subject did but enhance its excellence.

The moonlight painting was one of three exhibited that year at the Society of British Artists (No.238, Appendix 2). It has not been traced but a watercolour at the Victoria and Albert Museum may refer to it, giving some idea of the finished work (Colour Plate 27). The coldness of the paintings, remarked by Watkins, was due to the water which invariably figured largely in Chambers' works. It was of prime concern to him to interpret the mood of the sea whereas many other painters, depicting coastal scenes, brought the shoreline much closer to the picture plane and used the warmer tones of the land. The term 'marine painting' had been broadened in the course of the nineteenth century to include a wide range of subject matter, coastal, river, harbour and waterside, in which the sea and shipping were not the principal elements as they had been in the previous century. Many painters who had no particular pretension to marine art produced 'marine paintings' of this type to meet the public demand, especially in the form of published prints.

For relaxation Chambers

> did not read much, but was fond of music. He could himself play well upon the flute, with which he accompanied his wife upon the piano. The different instruments seemed to figure forth their different characters – the mellow breathings of the one formed a fine contrast with the quick jingling of the other.

The skill on the flute may well have been acquired during Chambers' long early years at sea.

His old friends continued to form the core of his social circle.

> Among the friends who frequently visited Chambers, the most distinguished were Cooper and Pyne. On certain evenings they met at each other's houses to converse

and be convivial; and it was the order of the evening that each should do a drawing, to be left with the entertainer for the time being, who thus became possessed of a friendly scrapbook. Vickers, lost to the arts in early life, had been a member of these parties; and Mr. Davis, professor on the harp, sometimes delighted them by his exquisite skill on that instrument.

Between 1827 and 1836 Alfred Gomersal Vickers (1810-1837) lived and painted with his artist father, Alfred Vickers Snr. (1786-1868), at 8 Barton Street, Westminster. He achieved early distinction as a marine and landscape painter, exhibiting more than one hundred pictures at the London shows from the age of seventeen until his premature death. At the time here described, Vickers had already carried out a drawing assignment in Russia, and Russian subjects subsequently appeared among his exhibited works. Chambers possessed several of his drawings of views in Russia, which were included in the studio sale (Lots 108, 111, 112 and 115, Appendix 3).

> These private conversationés were conducted somewhat after the plan of the London Artists' and Amateurs' Conversationé, of which Chambers was a member, and where drawings were exhibited and refreshments taken, to cultivate that friendship in art, which painters, more than other persons, should be zealous to promote.

Connoisseurs and collectors were also members and the works of modern art displayed were not exclusively by the artists attending. However, the purpose was also to provide an opportunity for artists and art-lovers to meet socially from which, it was hoped, purchases and commissions would result. Up to a hundred people often attended of whom usually almost half were professional artists, including both Royal Academicians and rising talents.[3]

> Pyne, Cooper, and Chambers, each received the advice of each on what they were doing. Pyne sees nature through the glass of art, but not darkly; he beholds her face to face, and makes her smile. Cooper is mechanical; he is truly what he is designated – an animal painter. His pictures are faithful to a fault. Of the three, Chambers possessed most the soul of a painter – there was in him most natural genius. We can conceive a lover of nature to paint as well as Pyne; a plodding man of talent to acquire Cooper's skill; but none, save a painter born, could paint like Chambers. The art was natural to him; or rather it was taught him by nature – a feeling perfected by practice. Art and themselves taught the others, but Chambers worked out his own excellence. Perhaps it was their separate lines of art that contributed, or rather did not prevent the friendship which these several artists felt for each other.

Paul Gauci was also one of this group. He was a long-standing friend of Chambers whose interests were similar to those of the others in the group. He had early demonstrated his support for Chambers by lithographing the *Hydra* paintings in 1833.

Watkins continues:

> Chambers visited Swansea during my visit to him, and returned with a pupil named Harris, who copied a noble sea-view of Margate, done by his master. Harris painted in a piecemeal manner, and Chambers' instructions to him were that he should 'knock the colours more about', frequently taking the pencil and exemplifying his precepts. Harris did not care how much of the work was his master's; for he thus not only learned to paint after him, but became possessed of one of his pictures.

3 *Literary Gazette* 1831
pp.90, 106,154

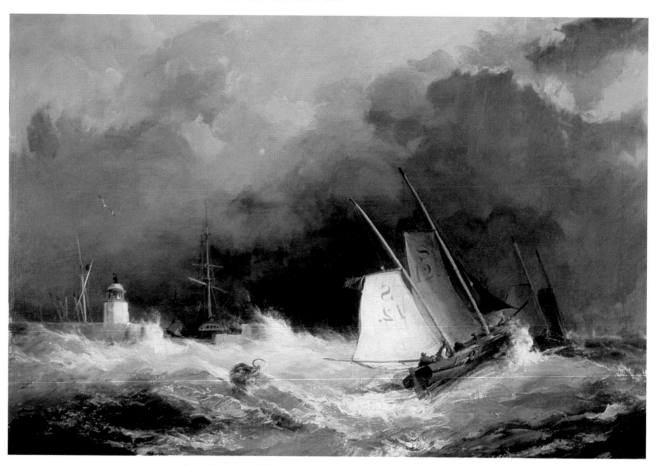

Colour Plate 28. Pilot boats heading out of Swansea harbour. Oil on canvas 25 x 35½in. (64 x 90cm). Signed and dated 1836. The pilot boats were vital to shipping using Swansea and the steep seas at the harbour entrance gave scope for dramatic representation. The National Library of Wales

James Staden Harris (1810-1887) came from a family of carvers and gilders of picture frames in Swansea. John is said to have been a capable artist and James, the elder son, inherited the talent. In 1835, when Chambers met Harris in Swansea, he was still working in the family business and carried it on after his father's death in 1836. Harris' earliest dated work is a substantial oil of Swansea Bay done in 1834 which demonstrates considerable competence and shows that Harris had serious aspirations to become a professional painter. His meeting with Chambers probably gave him the opportunity and stimulus to pursue his ambition. It was not until about 1846 that Harris established himself independently as an artist but from then on he produced a succession of very attractive and well-executed paintings of Swansea Bay and its shipping. In that year his first work was accepted for a London show and later, particularly in the 1870s, he exhibited there regularly.[4]

James Harris could presumably be spared from the business to return to London with Chambers as his father was still alive. There may also have been sufficient funds to meet the expenses of travel as well as the fees he would have had to pay Chambers for lessons. Dr.R.G. Howell has suggested that it was probably Calvert Jones who financed Harris' studies with Chambers. Watkins obviously took to Harris, for his letters to Chambers after they met in London in 1835 constantly seek news of him and request Chambers to transmit his good wishes. Harris was again with Chambers in 1836 while he was painting the Bombardment of Algiers and went to Holland with him in 1839.

The Reverend Calvert Richard Jones (1804-1877) lived in Swansea and was a

Colour Plate 29. The ruins of the Castle and Plas House, Swansea. Watercolour 9 x 13in. (22 x 33cm). Signed and dated 1836. Almost unique as a work by Chambers, being on shore, entirely without the sea or a river in the composition. Glynn Vivian Art Gallery, Swansea

close friend of C.R.M. Talbot of Margam, who was once described as 'the wealthiest commoner in Britain'. Calvert Jones often accompanied Talbot on his steam yacht cruises in the Mediterranean. He was a skilful artist, principally of maritime subjects, and was interested in calotype photography, a field in which he later made a notable contribution. Calvert Jones, as a wealthy and well-connected artist traveller, may have met Chambers in London and been responsible for inviting him to South Wales. It is conceivable that he had been one of the artists with John Farrell when he called on Chambers in 1829 (see page 59). In Swansea it was certainly he who introduced Chambers to Harris.[5] Calvert Jones remained in touch with Chambers and may well have joined him on one or both of his visits to Holland. A painting, signed Calvert R. Jones and dated 1851, has recently come to light which is a direct copy of an 1837 Dutch scene by Chambers.

Edward Duncan (1803-1882), the same age as Chambers, and a fluent marine painter, became a frequent visitor to Swansea and a close friend of James Harris. His first visit, however, was apparently not until 1839 and he may not therefore have met Chambers there. They could, none the less, have become acquainted elsewhere and it is possible that Duncan went to Holland with Chambers in 1837. Duncan, who was later elected to the Royal Watercolour Society, in any event admired Chambers sufficiently to acquire examples of his work, perhaps at the studio sale, for they were in his possession at the time of his death and sold at his own studio sale in 1885.[6]

There is some evidence that Chambers may already have visited Swansea in the previous year, 1834. The harbour and wide bay, with their large tidal range, provided Chambers with material for several important paintings. The most dramatic are those showing shipping and pilot boats in high winds and breaking

5 Howell p.29
6 Emanuel

117

seas at the harbour entrance, such as Colour Plate 28 and Plate 45, but low tide inside the harbour gives scope for an equally inspiring scene of sweeping calm and peace (Plate 46). The latter catches the spacious mood of relaxation once in port, with running figure and jumping dog. One of the former may have been exhibited at the SBA in 1836 under the title 'Running into Port' (No. 209) and Plate 46 could have been No. 506, 'Swansea Harbour'. Two others with similar titles were hung at the OWS in the same year (Nos. 3 and 204 respectively). There are echoes of Turner's work in these paintings. Turner was the dominant marine painter of the first half of the nineteenth century, his work ranging over all types of marine painting and his style evolving throughout his life. Chambers was evidently influenced by the masterpieces which he saw at exhibition and may have come to know Turner personally.

To Watkins, Calvert Jones was

> a more clever pupil [than Harris] but the one that promises to do most honour to his master is Mr. Gooding. Three guineas for two lessons was Chambers' usual fee.'

Gooding, the name always used by Watkins and Chambers, seems to have been a mis-spelling or earlier form of Gooden, who later became known as James Chisholm Gooden-Chisholm (fl.1835-65). As Watkins predicted, he became a painter of some distinction and compiled *Thames and Medway Admiralty Surveys, 1864.*

Gooden-Chisholm also joined in the sketching evenings, for he recalls that afterwards

Plate 45. Running into Port, Swansea. Oil on canvas 13 x 18in. (33 x 46cm). Signed and dated 1835. Chambers visited Swansea in 1835 and the wide bay with its large tidal range provided him with a variety of subject-matter. Yale Center for British Art, Paul Mellon Collection

Plate 46. Low tide in harbour, Swansea. Oil on canvas 23 x 32½in. (58.5 x 82.5cm). Signed and dated 1835. Inside, at low tide, the scene was very different, calm and relaxed. Sotheby's

Chambers would adjourn to his kitchen and sit over hunks of bread and cheese and glasses of beer till eleven o'clock. When no sketching night was on, I suspect, that a glass of gin and water, and a pipe, perhaps in a public house in the neighbourhood, sufficed him. He was a perfectly sober man, but this was the sort of life pursued by most of the artists, aye, and the rising ones, of the time.

He goes on to remark that Chambers had to 'paint for the pot' and spent the mornings making small drawings and paintings for this purpose. 'The disposal of these at shops would afford their producer his quantum of out-of-door exercise'.[7]

Harris introduced a friend of his of the name of White to us, and Chambers, with the goodwill that he ever manifested towards beginners, bought a drawing of him; likewise to mark his sense of White's promising talents, and to encourage them, he exchanged one of his own paintings for one of his. Chambers was remarkable, I may almost say peculiarly so, for this open-hearted and open-handed encouragement of others. He not only kept no secrets of art, but he recommended all his friends to his own patrons; for he used to say, 'If a gentleman commissions me to paint him a sea piece he may next want a landscape, and no man in England can paint a better one than Pyne – or a cattle piece, and who can excel or even equal Cooper'. This generosity was not always repaid by gratitude; in some instances it was abused.

It was Watkins' opinion that:

Of our sculptors, the habits and character of Chambers most resembled those of Flaxman [1755-1826]. He loved peace, and once presented a snarling critic with a beautiful little picture, to silence the cur's bark; who was scarcely satisfied because the donor had not given a frame with it. He was not unlike Opie [1761-1807] in natural disposition, a rough diamond needing polish.

7 Roget II pp.235-7

Colour Plate 30. St. Paul's Cathedral. Oil on panel 12½ x 18in. (31 x 46cm). Signed and dated 1838. Watkins advised that 'the river be well filled with variety of craft'. Chambers responded by embellishing his magnificent view of the Cathedral with a sumptuous display of City livery company barges on the river, but also including a stolid Thames barge. Christie's Images

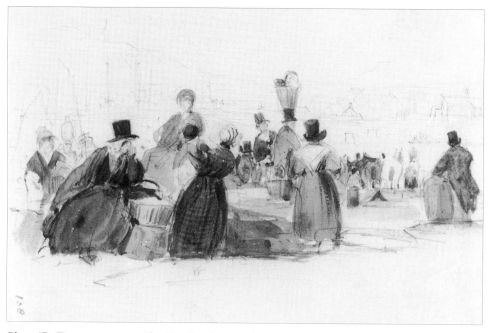

Plate 47. Figures on a quayside. Pencil and watercolour 4½ x 6½in. (11.5 x 16cm). From his early exercises copying Pyne's Rustic Figures, *Chambers was always fascinated by people and invariably included them in his marine paintings and drawings.* Royal Academy of Arts, London

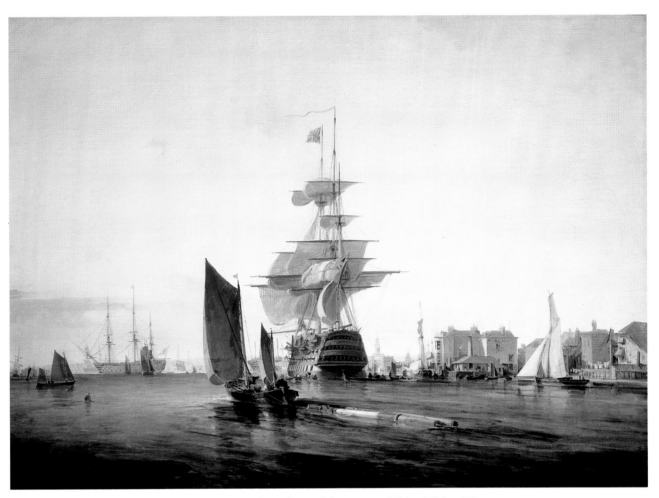

Colour Plate 31. The Britannia *entering Portsmouth Harbour. Oil on canvas 22½ x 30½in. (57 x 77.5cm). Signed and dated 1835. The most serene painting produced by the artist, embodying all the qualities which distinguish his best work.* National Maritime Museum, London

One of the results of the Welsh visit was a rare topographical painting set entirely on land. It was of the ruins of the Castle and Plas House, Swansea, signed and dated 1836, now in the Glynn Vivian Art Gallery in that city (Colour Plate 29). 'Swansea Castle – Sketch from Nature', exhibited at the OWS in 1839 (No. 195) probably relates to this watercolour. Two sketches are also likely to date from the same tour. The figures on a quayside, possibly Swansea, from the Royal Academy collection (Plate 47) show Chambers' interest and skill in drawing people as well as boats, a feature which enlivens many of his paintings. The colouring of the original sketch is also vibrant. 'All grey slate and stone' (Plate 48) is a fascinating waterside 'genre' scene drawn in pencil, which almost makes one wish that he had devoted more of his time to this type of production.

Chambers had evidently been working on preliminary sketches for a painting of St. Paul's Cathedral while Watkins was in London, for the latter wrote in September 1835, after his return to the north:

> You will by this time have transferred St. Paul's into your canvas. It cannot fail of making a noble picture, provided that great thoroughfare, the river, be well filled with variety of craft.

A small painting of this subject was sold in a London saleroom some years ago (Colour Plate 30). It was on panel, signed and dated 1838, so was probably not the

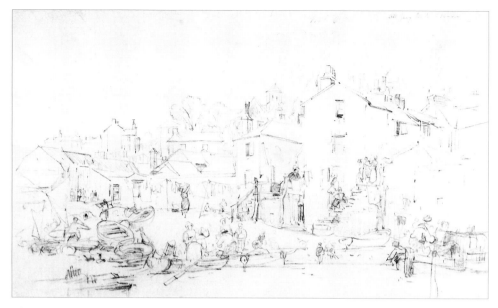

Plate 48. Waterside scene. Pencil 8 x 12½in. (20 x 32cm). Inscribed 'All grey slate and stone'. A bustling waterside scene drawn with exemplary clarity and accuracy. Trustees of The British Museum

picture here referred to. It seems reasonable, none the less, to assume that it is a similar image. The scene had not previously been attempted by Chambers and was among his group of topographical London paintings, which included the 'Opening of London Bridge' and 'Greenwich Hospital'. The work achieves its purpose successfully and, if not the result of a commission, would have had a ready sale.

William Falconer's 'The Shipwreck', an epic poem describing the agonising struggles of the merchant ship *Britannia* in a gale and her ultimate foundering, was first published in 1762. It was immediately popular and soon became a classic. The story of the valiant battle of the crew against the elements struck a chord in the awareness of nature and the strivings of the individual which characterised the growing spirit of Romanticism. The vital importance of the sea to Britain and the hardships of her mariners were also increasingly acknowledged through a period which saw the War of American Independence and the wars with revolutionary France. It has been estimated that by 1830 there were at least twenty-four British versions of 'The Shipwreck' in print.[8] Many had been illustrated, probably the most notable being editions in 1804 and 1809 by Nicholas Pocock.

John Watkins was a great enthusiast for Falconer and exhorted Chambers to emulate distinguished predecessors by illustrating a further edition. Watkins wrote an introductory essay on the life and writings of Falconer and sent it to the artist, adding

> I need not tell you that publication has done many artists good, and why not you? Let not your diffidence always get the better of you. A portrait of the Britannia as she is described at the latter end of the first canto, with a reference to the names of the ropes, &c., would make the most useful frontispiece, and the author's description of himself, seated in a cavern on the shore, writing his poem, the best subject for a vignette.

But Chambers did not take up the idea. Samuel Taylor Coleridge's romantic poem 'The Rime of the Ancient Mariner', published in 1798, was another literary work Watkins proposed for illustration without meeting with a favourable response.

Chambers' choice of a warship of the same name as Falconer's vessel for his most serene oil painting was probably entirely fortuitous. 'The *Britannia* entering Portsmouth Harbour' (Colour Plate 31) portrayed one of the largest wooden sailing

8 Miller, Charlotte. Captain Manby and the Joy brothers. Unpublished thesis 1975 p.35

122

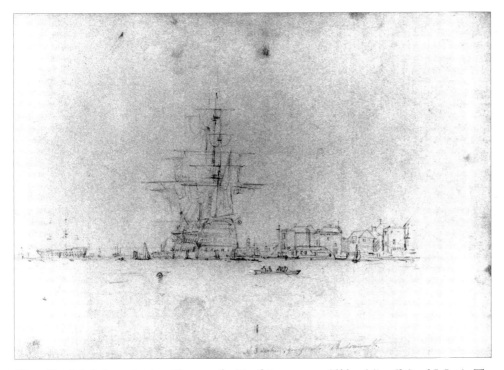

Plate 49. A 3-decker going into Portsmouth. Graphite on paper 10½ x 14in. (26 x 35.5cm). The meticulous drawing, made on the spot, which formed the starting point for the oil painting.

National Maritime Museum, London

warships, of 120 guns, ever in service in the Royal Navy. A sister ship to the *Royal George,* whose launch Chambers had sketched in 1827, *Britannia* was built at Plymouth and commissioned in 1823. Her early service alternated between Lisbon, the Mediterranean and Portsmouth. Chambers' pencil sketch made on the spot (Plate 49) and the 1835 painting, both now at Greenwich, depict her entering Portsmouth on her return from an overseas commission.

The picture is not large but illustrates the romantic naturalism which makes Chambers' works so outstanding. The low viewpoint and foreground interest of the work-boat towing the spars establish the perspective, which is enhanced by the bulk of the *Britannia's* hull and the height of her rigging in relation to the houses on Portsmouth Point. It also illustrates how Chambers developed his composition from the drawing. The diagonal recession to the distant *Victory* and small boats on the left-hand side is characteristic. Detailed handling of ship and shore fills out the activity of the harbour but avoids disturbing the peaceful mood. The sense of power imparted by the enormous man-of-war, silently under way, the sails on its lowered yards still drawing lightly, establishes an implicit tension in the serenity of the calm evening scene. It is of interest to compare the detail of foreground spars with those in the painting of St. Paul's (Colour Plate 30). The use of paint in the execution is economical and fluid.

Chapter 12

THE SUMMIT: MAJOR COMMISSIONS FOR
GREENWICH 1835-39

Captain William Locker (1731-1800) was Lieutenant-Governor of Greenwich Hospital, the home for old and disabled seamen from the Royal Navy, from 1793 until his death in 1800. He had served under Admiral Sir Edward Hawke (1705-81), victor of the Battle of Quiberon Bay in 1759, and was himself the early mentor of Nelson. Locker cherished a great admiration for Hawke and named his youngest son after him.

Edward Hawke Locker (1777-1849) entered the Navy pay office in 1795 and became Civil Secretary to Sir Edward Pellew, later Viscount Exmouth, in 1804,

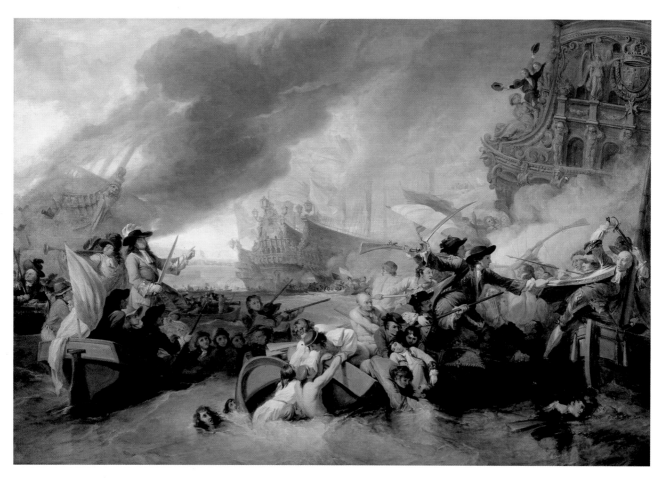

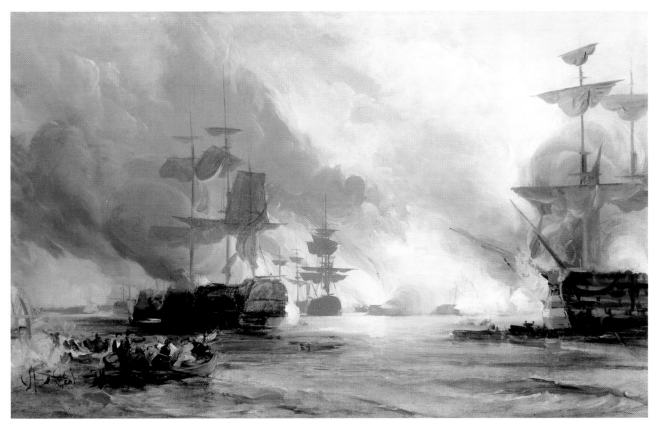

Colour Plate 33. Oil sketch for the Bombardment of Algiers. 18½ x 28⅓in. (47 x 72.5cm). This more developed sketch in oil may have been for consideration by the gentlemen subscribing towards the cost of the painting. It approaches the final version but further amendments were introduced.

National Maritime Museum, London

serving with him in the East Indies, 1804-09, the North Sea, 1810 and the Mediterranean, 1811-14. 'His emoluments, especially as prize agent in the East Indies, placed him in easy circumstances'.[1] In 1819 he was appointed Secretary to Greenwich Hospital and became a Civil Commissioner of the Hospital in 1824, which he remained until 1844. He was himself an excellent artist in watercolour.

Greenwich Hospital, founded in 1694 as the Naval equivalent of the Royal Hospital at Chelsea, had been completed in 1751, the first pensioners being admitted in 1705. Its Painted Hall, originally intended as the refectory, was in fact only briefly used for that purpose before James Thornhill's nineteen years decorating it (1708-29) made this impractical. As soon as the ceiling was finished in 1712 it became and remained a substantial visitor attraction, the income going to support what became the Royal Hospital Schools. The Hall was thereafter only used by the Hospital inmates on special occasions.

1 Dictionary of National Biography

Colour Plate 32 (Left). The Destruction of the French Fleet in the Port of La Hogue 1692. After Benjamin West. Oil on canvas 60 x 84½in. (152.5 x 214.5cm). Signed and dated 1836. Chambers' first commission from E.H. Locker for the gallery he had established in the Painted Hall at Greenwich Hospital, it was an exact, full-size copy of the original, painted for Lord Grosvenor. It established Chambers' ability to work on such a large scale and led to the commission for the Bombardment of Algiers.

National Maritime Museum, London

E.H. Locker wrote in the preface to the earlier editions of the catalogue of paintings at Greenwich Hospital:

> This noble apartment had been thus left unoccupied nearly a century, when in the year 1795, Lieut. Governor Locker suggested that it should be appropriated to the service of a National Gallery of Marine Paintings, to commemorate the eminent services of the Royal Navy of England.

The idea was not taken up, but 'in 1823 it was revived, with happier success, by his son.'

The Hospital had by that time already accumulated a number of naval portraits and other paintings, largely by gift or bequest from its officers and their families. The earliest, a portrait of its first Lieutenant-Governor, Captain John Clements, was presented by his widow when he died, shortly after taking up office in 1705. Under Locker's active guidance and support this existing collection was rapidly built up to achieve its new objective. He succeeded in enlisting the early support of King George IV, who gave twenty-nine paintings from the Royal collection. Locker made a point of obtaining major battle pieces to illustrate the actions in which the leaders had gained distinction and also to give visual balance to the display. The King completed his magnificent donation in 1829 with two monumental battle scenes, P-J.de Loutherbourg's 'Battle of the Glorious First of June', painted in 1795, and J.M.W. Turner's matching 'Battle of Trafalgar' of 1823. These remain centrepieces in the National Maritime Museum, which, on its establishment in 1934, became the custodian of the Hospital collection.

Watkins records Locker's leadership thus:

> Mr. Locker may be said to be the founder of the Greenwich Gallery; by indefatigable exertions, and by a great outlay of private expenditure, he has brought together a noble collection of naval portraits and pictures. The charge for seeing them is threepence – a small sum to purchase such a great gratification. This admission money annually contributes a large addition to the funds of the Hospital.

Benjamin West painted 'The Destruction of the French Fleet in the Port of La Hogue by Vice-Admiral Sir George Rooke Kt., 23rd.May 1692' for Richard, Lord Grosvenor, probably between 1775 and 1780, as a companion piece for 'The Battle of the Boyne, 1 July 1690' which he painted in 1778. The pair was intended to commemorate the two battles, on sea and land, that had put an effective end to the exiled James II's hopes of regaining the English crown from William and Mary. In West's painting James is shown on the headland in the distance watching the battle. Even as he saw his hopes of crossing to England being shattered by the boats of the English navy he is reported to have exclaimed: 'None but my brave English tars could have performed so gallant an action'.[2]

In late 1835 Chambers painted an exact, full-size copy of West's original in the Grosvenor Gallery for Greenwich Hospital (Colour Plate 32). The precise nature of the commission is not clear but a letter from Locker which has survived in manuscript[3] suggests that it was a formal order for the Hospital Gallery.

> Mr. Locker has just received a note from Mr. Seguier whom he requested to look at Mr Chambers' Copy of La Hogue, stating that it is not necessary to do more to it, & that it is a very creditable performance.
> Tho' he has not heard from Mr. Carpenter junior he no doubt fulfilled his

2 Erffa and Staley p.209
3 National Art Library, V&A Museum London

promise to Mr. Locker of looking at the Pictures at Grosvenor House, & he troubles him with the present note merely to save him the pains of writing. He has requested Mr Chambers to send down the Picture next Monday and come himself to receive payment, and to make some preparatory arrangements respecting 'Algiers'.
Greenwich Hospital,
 23d. January 1836

William Seguier (1771-1843) was Conservator of the King's Pictures, Curator of the Grosvenor collection and the first Keeper of the National Gallery, which opened in 1824. He was thus one of the most distinguished art experts of the time. The younger Carpenter was, as noted above, also highly regarded for his knowledge of painting and evidently among those consulted by Locker. Seguier was also Superintendent of the British Institution and encouraged young artists, including Chambers.

> Mr. Seguier introduced our artist to General Phipps, who was an eminent picture-fancier. The General invited Chambers to his house, shewed him his collection of drawings, was delighted to find that Chambers had sketches from his native scenery about Mulgrave, bought a drawing of Runswick of him, and promised to call upon him when he returned from the continent, whither he was about to depart for the good of his health; but, alas! he returned a corpse.

General Phipps was a member of the leading landowning aristocratic family in the neighbourhood of Whitby, Mulgrave Castle being a few miles north-west of the town. Henry Phipps (1755-1831), 1st Earl Mulgrave and Viscount Normanby, had been First Lord of the Admiralty from 1807 to 1810.

Chambers' copy of West's painting was his first attempt at anything on such a large scale. The one hundred guineas he received for it was also undoubtedly his highest fee yet for a single picture. Its success led to the commission, mentioned in Locker's note, for Chambers to paint an original work depicting the Bombardment of Algiers, by the squadron led by Sir Edward Pellew, on 27 August 1816. This was a punitive expedition against the Barbary states whose corsairs ravaged shipping along the North African coast. The action was a success, obtaining the release of 1,083 Christian slaves, payment of a ransom and an undertaking from the Dey of Tunis to abolish slavery in his domains. In recognition Pellew was created Viscount Exmouth.

The painting was for presentation to the Hospital Gallery in commemoration of the event. Locker had served for many years with Pellew and it may be assumed that the initiative was his. It was clearly he who managed the placing of the commission and the supervision of the work. The cost of two hundred guineas was subscribed by a group of the Admiral's friends and associates.

This price appears to have been by far the highest Chambers was ever able to command for a picture. The painting is larger than 'La Hogue' and the price reflected not only the size but also the high regard in which Chambers was held, as an original artist, by Locker and his colleagues. Chambers' pay at the Pavilion Theatre had been at the rate of about two hundred guineas per year for the time worked and, for comparison with another industry, a reasonable annual salary for a middle-ranking railway engineer would have been about the same.

Plate 50. Sketch of 3-decker and details. Graphite on paper 10 x 14½in. (27 x 38cm). Chambers knew Portsmouth well, but he went there again specifically to obtain material for his great assignment to recreate the bombardment of Algiers, which had taken place in 1816.
National Maritime Museum, London

Plate 51. Sketch of hulk and details, inscribed Egmont 74 guns. Graphite on paper 10½ x 14½in. (26.5 x 37cm) (verso Plate 27). Even a warship retired from service and converted for shoreside use was of interest to the artist.
National Maritime Museum, London

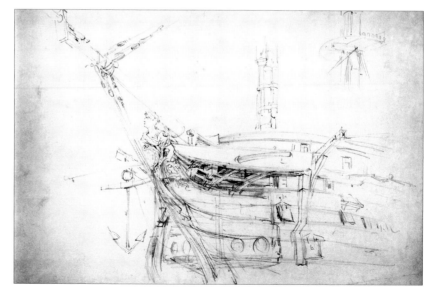

Plate 52. Ship's bow, bowsprit and figurehead. Graphite 11 x 15in. (27.5 x 39cm). (verso Plate 16). The bow of the Impregnable was to be the dominating feature at the right-hand side of the finished painting.
National Maritime Museum, London

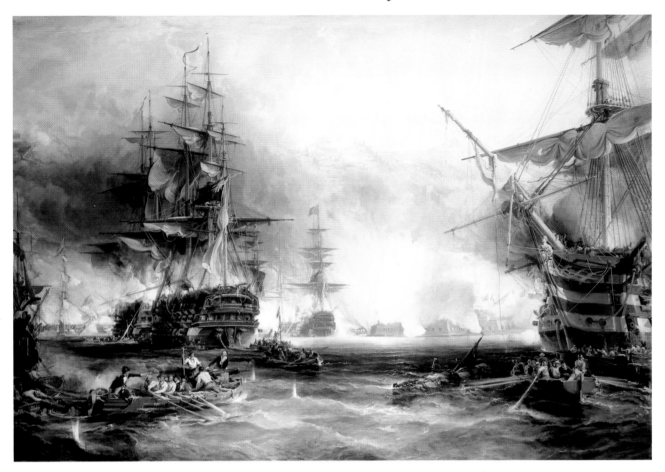

Colour Plate 34. The Bombardment of Algiers. Oil on canvas 69½ x 99in. (176.5 x 251.5cm). Signed and dated 1836. The final oil painting overcomes most of the compositional difficulties and is a distinguished work of art, with a broad painterly approach and a balance of detail and atmospheric impression. National Maritime Museum, London

Chambers responded to the accolade and the challenge by careful and exhaustive preparation for what was to become his finest set-piece painting (Colour Plate 34). James Harris (see page 116) recalled that when Chambers received the commission he made many beautiful studies, varying the arrangement for the general effect; but would not begin the picture itself for some time, 'for', he said, 'I am to have a large sum for it and I must study it well, and not slash it off merely to get the money'.[4]

Watkins says that 'Chambers went to Plymouth for the express purpose of sketching men-of-war for this picture'. This may be correct but no evidence of it has been traced and it seems much more likely that he in fact went to Portsmouth which is not as far from London and a location with which he was already very familiar. Roget, also, states that he went to Portsmouth.[5] There are at the National Maritime Museum several sheets of drawings by Chambers of parts of men-of-war (Plates 50-52). One is inscribed as being of the *Egmont* (74guns) (Plate 51). The *Egmont* was launched at Northfleet in 1810 and in commission until 1814 when she was paid off. She was at Portsmouth until sent in 1862 to Rio de Janeiro as a Depot Ship and was sold there in 1875. There is no date on the drawing but if it was one of these preparatory sketches it would support Portsmouth as the location rather than Plymouth. It is also of interest to compare the ship's bowsprit in Plate 52 with that of the *Impregnable* at the right-hand side of the finished painting (Colour Plate 34).

The structure of the 'Bombardment of Algiers' evolved in a manner illustrated

4 Roget II p.234
5 Roget II p.234

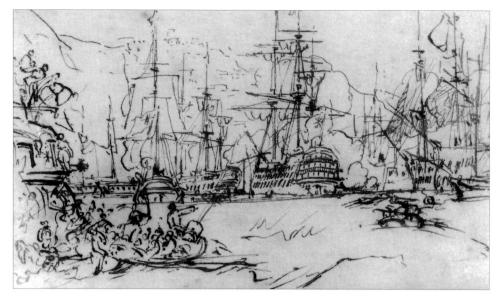

Plate 53. Sketch for the Bombardment of Algiers. Pen and ink 3½ x 5½in. (9 x 14cm). Some very early ideas for the composition. Private collection: photograph Courtauld Institute of Art

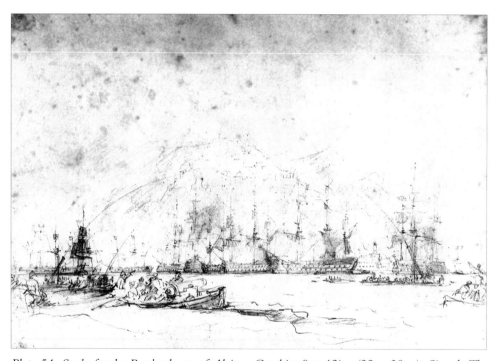

Plate 54. Study for the Bombardment of Algiers. Graphite 9 x 12in. (22 x 30cm). Signed. The distant linear arrangement was quickly abandoned, but the left foreground close-up of a boat crew and howitzer was, fortunately, retained continuously until included in the final oil.

National Maritime Museum, London

in four drawings reproduced as Plates 53-56. They show how Chambers weighed the problems of reconciling the competing visual demands of ships, fortifications, explosion, fire, smoke and steeply rising landscape in the background in a complex composition while at the same time paying due heed to the need for historical accuracy. The fourth drawing (Plate 56) is inscribed 'First Thought for the Bombardment of Algiers' but its greater finish and its proximity to the

Plate 55. Study for the Bombardment of Algiers. Grey wash over graphite 9 x 12in. (22 x 30cm).
This arrangement is much closer to that of the finished work.　　　　National Maritime Museum, London

Plate 56. First Thought for the Bombardment of Algiers. Brown wash over graphite on wove paper
8 x 13in. (20.5 x 33cm). With the introduction of colour effect, this may have been for preliminary
discussion with Locker. The composition was to be substantially altered with the removal of the vessels
in the centre middle distance.　　　　National Maritime Museum, London

finished work suggests that it was the later of the drawings. The inscription
perhaps indicates that it was a project for discussion, possibly with Locker. It is of
interest to note that the rocket-firing apparatus at the extreme left appears in some
of the drawings and is carried into the finished work.

An oil sketch was also produced (Colour Plate 33), presumably for scrutiny and
approval by the gentlemen who contributed to it, before the final painting was

Colour Plate 35. Detail of The Bombardment of Algiers. The boat's crew almost carries the viewer into the heat, noise and danger of the action. The figures are powerfully created with broad, bold brush strokes. National Maritime Museum, London

undertaken. In the event the composition was radically changed again, the vessels in the centre middle distance being entirely eliminated to reveal an open view to the exploding and burning fortifications.

The finished painting has been recently cleaned and refitted in its original frame. It is an epic and dramatic presentation which convincingly overcomes the compositional problems and incorporates areas of fascinating detail. The use of viewer's perspective not only emphasises the towering height of the ships' rigging and background landscape but also brings detailed individual action to the foreground with the ships' boats and straining oarsmen. These last show Chambers' mastery in portraying the human form with a few bold strokes (Colour Plate 35). The result is to bring the viewer into a sense, almost a physical feeling, of the heat, noise and danger of the engagement.

The bombardment commenced at 2.00 p.m. and continued until ten o'clock when all shore batteries had been silenced. Chambers has set the action early on, when the ships in harbour had already taken fire and there was a large explosion on the Mole but before the lighthouse, just visible under *Impregnable's* bowsprit, had been destroyed. It is still daylight, which enables him to introduce two light-sources, from the sun to illuminate the sails and steep hillside behind and from the fire itself.

The presence of a Dutch squadron at the action is acknowledged by the inclusion of the forward part of the Dutch flagship *Melampus* in the left background.

Watkins criticised the painting:

> He has fallen into the defect with regard to the colour and form of the smoke that was pointed out to him by Admiral Mundy. Gunpowder smoke is of a dead white colour, and bursts from the gun into a cloud at once – it is not poured from the cannon's mouth. There is an inky or purply haze about this picture which detracts from its great merits, but time may mellow this, and then it will be regarded as one of the best naval and historical pictures in that glorious gallery.

Locker's criticisms, having accepted the picture and had it at Greenwich for some time, include the grey tone but are also more wide-ranging. Writing to Chambers on 17 December 1836 he said:

> Since you left your picture with us, I have frequently and carefully examined it, to ascertain why the general effect, at a distance, diminished the satisfaction I received when looking at it in detail when close. It certainly wants that broad and striking effect so necessary to a Gallery picture, and especially as it is placed near the Death of Nelson, which, as a night-scene, very successfully executed by Devis, tries it hard.
>
> There is too much light generally in your picture, giving it a grey tone, which contrasts ill with the picture by its side. The white smoke at each end

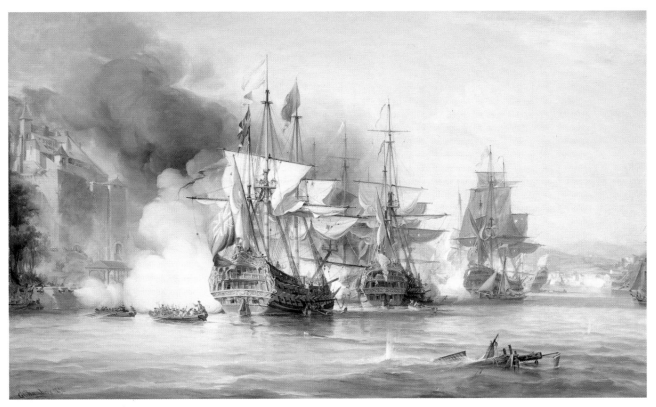

Colour Plate 36. The Capture of Porto Bello 21 November 1739. Oil on canvas 26½ x 40in. (67.5 x 101.5cm). Signed and dated 1838. By contrast, this engagement seems rather docile. Chambers has created a masterpiece by concentrating the action on the left-hand side, allowing long, light perspectives into the distance on the right. National Maritime Museum, London

of the picture disturbs the concentration of light; and the dark mass of the sea, which so well throws back the *Queen Charlotte* [centre background] and the Explosion, thus becomes a black mass in the centre of the picture, and offends the eye when seen at a distance. The sails of the *Albion* and *Minden* [left middle distance] are not sufficiently relieved from the dark cloud behind them; and the rigging of the *Impregnable* [right foreground] has too sketchy an appearance when united with the black clouds behind her.

In making these free remarks on your picture, it is but right to inform you, that, having formed this opinion after repeated inspections, (for the defects were not apparent to me at first), I have since asked the opinion of Sir Jahleel Brenton (himself a very good amateur artist); and two other gentlemen also well acquainted with painting, have since examined the picture carefully, and, without telling them my opinion, they expressed nearly the same sentiments, while they cordially concurred in the general merit of the execution.

You may probably think it worth your while to come and look at it before it is seen by other artists; as, if these objections are well founded, it is fair you should have an early opportunity of examining it for yourself, and your future success may be greatly concerned in the consideration.

Believe me very sincerely yours,

E.H. Locker

Since the picture had been accepted, and it may be assumed that Locker had had it subjected to third-party scrutiny beforehand in the same way as 'La Hogue', the letter seems to be unnecessarily petulant. It seems rather hard to criticise the painting on the grounds that it suffers by comparison with its neighbour, Devis'

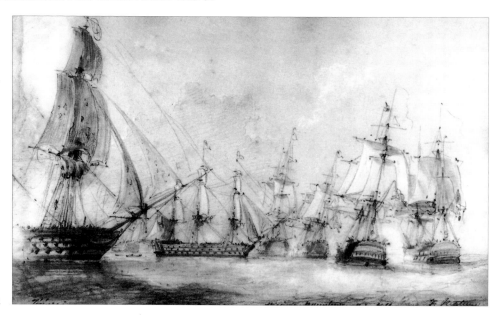

Plate 57. Study for the Battle of Trafalgar. Victory *and* Temeraire *about to break the enemy line. Graphite and white body-colour on grey paper 7 x 10in. (17.5 x 26cm). The names of the ships are written across the foot, from left to right:* Temeraire, Victory, Stissima Trinidad, Redoutable, F[rench] Neptune. *The drawing is detailed and accurate but does not detract from the fine uncluttered composition.* Private collection: photograph National Maritime Museum, London

'Death of Nelson', a very different subject and treatment. Nor does it seem today to lack a 'broad and striking effect'. The last paragraph does not exactly suggest that Chambers should rework the painting but seems to carry a sinister threat that, for his own good, Chambers should at least express himself in agreement with the criticism.

Close examination of the painting today makes it clear that Chambers did not rework it. His customary impasto was applied to the small areas of intense light colour such as the sea, the explosion and the sails. Some minor areas of later damage have been made good.

The picture was exhibited at the British Institution in 1837 (No. 261) where it attracted the following notice from the critic of the *Literary Gazette* on 4 March:

> Battles by water, as well by land, have undergone a great change in the manner of their representation since the times of Serres, Paton &c. They have now less of the geometrical, and more of the picturesque. As a work of art, this does great credit to the talents of Mr. Chambers. It reminds us of the destructive effects of the 'Leviathans afloat', described by the poet as 'like a hurricane eclipse of the sun.' Perhaps there never was a warlike enterprise, the results of which were so gratifying to humanity as the bombardment of Algiers.

Watkins says that because of Locker's criticisms Chambers was disappointed in the hope, which had been held out, that he would receive a commission to paint another large picture for the gallery. This may have been the case, although no other large work was in fact commissioned in the immediately following years. It is, furthermore, contradicted by the fact that Locker himself personally gave Chambers a commission in 1838.

This was a painting to commemorate the centenary of the taking of Portobello by Admiral Vernon on 21 November 1739, one of the most memorable events of the conflict with Spain known as the War of Jenkins's Ear (Colour Plate 36). Commodore Brown, Vernon's second-in-command, was an ancestor of Captain Locker and had received the Spanish commander's sword on his surrender. When completed Locker presented the painting to the Greenwich Hospital Gallery.

The proportions of the work are more modest than those of the 'Bombardment of Algiers'. Perhaps this is one of the reasons why the painting succeeds so well. The more limited dimensions permit a tight structural composition employing strong diagonal lines of sight. Chambers' skill in conveying perspective by

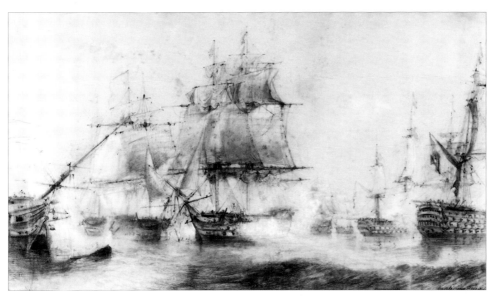

Plate 58. Study for the Battle of Trafalgar. Victory after breaking the line, raking Redoutable. *Graphite and white bodycolour on grey paper 17½ x 30in. (44.5 x 75.5cm). Larger than the previous study, its size and quality would almost entitle it to stand alone as a finished work. The inscriptions read, from left to right:* French Neptune, Temeraire, Victory's *boat adrift,* Redoutable, Victory, Neptune, Conqueror, Bucentaure, Santissima Trinidad.

Private collection: photograph National Maritime Museum, London

gradually receding detail and subtle changes in colour tones, which maintain the interest without impairing the clarity, is well exemplified. The general arrangement is similar to Samuel Scott's (1701/2-72) painting of the same scene (Version B), done in 1740, and later engraved, but its tighter execution and strong colours distinguish it as an exceptional and original creation. An interesting historical error is that Chambers has depicted the blue ensign's Union flag in its post-1801 form with the red Irish saltire. If Locker noticed this defect he evidently did not have it corrected!

The position with regard to Chambers' paintings of the Battle of Trafalgar is less clear. A group of working drawings in a private collection, which has been handed down within the family, provides another fascinating insight into Chambers' meticulous preparation for complex battle scenes (Plates 57-61). The drawings are in graphite and ink, with some touches of bodycolour, and some have evidently been subject to 'cut-and-paste'. Most are inscribed with ships'

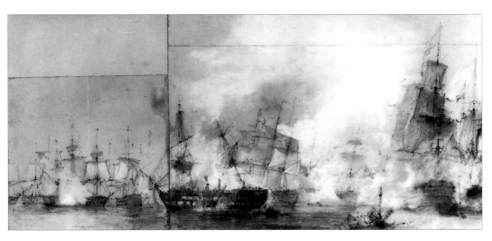

Plate 59. Study for the Battle of Trafalgar. The battle fully engaged. Graphite and white body-colour on grey paper. 10½ x 27in. (22 x 56cm). On the left, the van of the combined Franco-Spanish fleet is turning in order to join the centre of the action. The wind was very light which made all manoeuvres slow and difficult. On the right, Bucentaure, Victory *and* Redoutable *are battered but still hotly engaged.*
Private collection: photograph National Maritime Museum, London

135

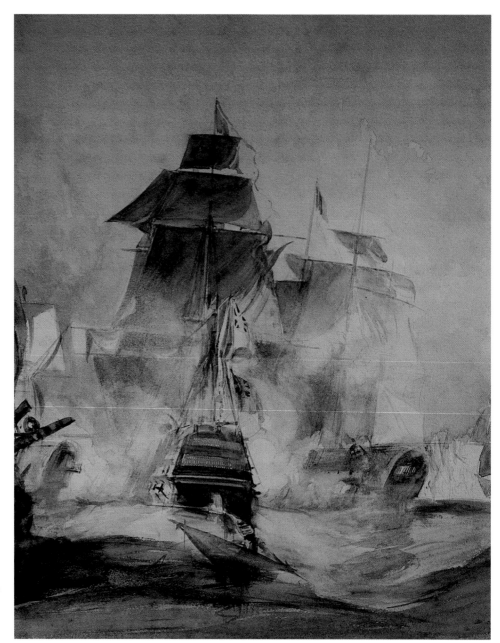

Colour Plate 37. Study for the Battle of Trafalgar. Watercolour 13 x 10in. (33 x 25cm). A more restricted sketch than Plate 59, but, as in the others, the handling of smoke sustains the spatial effect while also conveying the lack of visibility, which was a problem for the combatants.
Pannett Art Gallery, Whitby

names but some of these seem to have been added by another hand. Plate 57 shows battle about to be joined, with *Victory* and *Temeraire* heading to break the Franco-Spanish line, while Plate 58 is from the opposing angle, after *Victory* has broken through. Plate 59 shows the van of the Franco-Spanish fleet turning to join the centre of the action. The approach to the enemy's line of Admiral Collingwood's *Royal Sovereign,* leading the leeward column, is depicted in Plate 60, while Plate 61 is an impressive study of *Britannia* entering the engagement. It is noteworthy that Chambers surrounded his vessels visually with more space than was customary in such portrayals, even that of Clarkson Stanfield, discussed below (Plate 62). More colour appears in a further, delightfully fresh study for the battle now in the Pannett Art Gallery, Whitby (Colour Plate 37).

These preliminary drawings were presumably formative in the production of two watercolours exhibited by Chambers at the OWS in 1837 and 1838. The former was entitled 'The Victory breaking the Line, Battle of Trafalgar' (No.

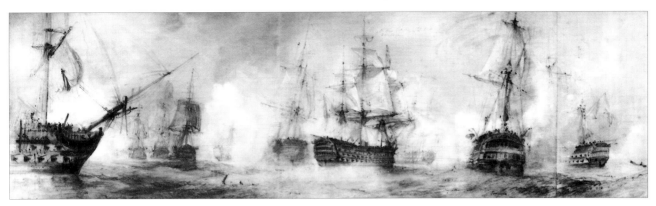

Plate 60. Study for the Battle of Trafalgar. Admiral Collingwood's Royal Sovereign, *followed by* Bellisle, *leading the leeward column to break the enemy line. Graphite and white bodycolour on grey paper 10½ x 34in. (27 x 87cm). By allowing plenty of space in his composition, Chambers conveys a strong impression of the tactical position before battle was joined. The inscriptions, in graphite, which may have been added by the artist himself, read, from the left:* Bellisle, Santissima Trinidad, Bucentaure, Redoutable, San Leandro, St. Ana, Royal Sovereign, Indomptable, Fougueux, Monarca. *Near* Royal Sovereign's *topmast, another inscription reads: 'St. Ana lost main top mast, 3 [illegible] join'.* Private collection: photograph National Maritime Museum, London

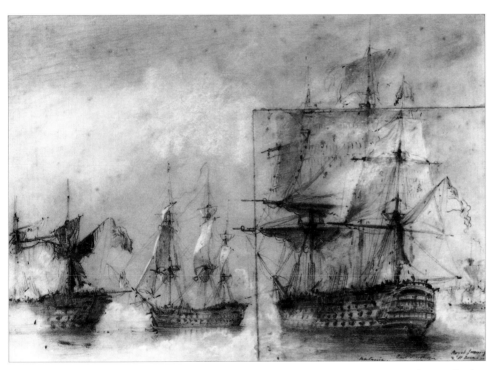

Plate 61. Study for the Battle of Trafalgar. Britannia *entering the action. Graphite and white bodycolour on grey paper 11 x 14½in. (27.5 x 37cm). The collage shows the artist working to achieve a satisfactory composition.* Britannia *joined the battle at the centre, between* Victory *and* Royal Sovereign. *The drawing is annotated from the left, in ink:* Temeraire, Fougueux, Britannia Earl Northesque, Royal Sovereign & St. Ana. *Lord Northesk's name has, inexplicably, been given a French ending.* Private collection: photograph National Maritime Museum, London

230). It must have been an important drawing as it was priced at 30 guineas, the most expensive of his watercolours. The 1838 work was 'The Situation of HMS Victory, at the time when Lord Nelson was killed, Battle of Trafalgar' (No. 114). Unfortunately neither of these works has been traced.

Chambers had obviously been working on a Trafalgar picture as early as the

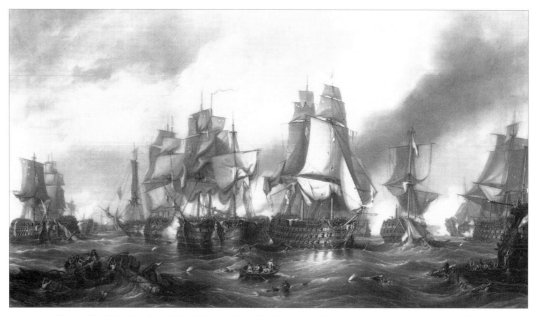

Plate 62. The Battle of Trafalgar, after Clarkson Stanfield. Oil on canvas 29 x 47½in. (73.5 x 120.5cm). The scene about an hour and a half after Lord Nelson was shot. A tablet on the frame of the original painting by Stanfield identifies the vessels, from left to right: Royal Sovereign, Santa Ana, Bellisle *(wrecks),* Mars, Fougueux, Temeraire, Redoutable, Victory, Bucentaure, Neptune, Santa Trinidad. National Maritime Museum, London

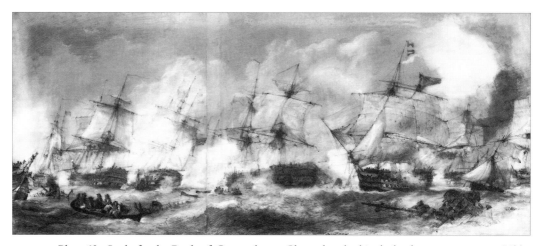

Plate 63. Study for the Battle of Camperdown. Charcoal and white bodycolour on grey paper 21½ x 48½in. (54.5 x 123cm). The drawing is a tour-de-force, *being almost the same size as the finished oil and fully as powerful and detailed.* Private collection: photograph National Maritime Museum, London

summer of 1835 when Watkins stayed with him in London. Writing to him on 27 January 1836 Watkins asked: 'How do St. Paul's and the Battle of Trafalgar proceed?' The St. Paul's (Colour Plate 30) was a substantial work in oil and it may be inferred that the Trafalgar was the same. If so, it was not exhibited and no further reference to it has been found.

Early in 1833 the United Service Club appointed a committee under the chairmanship of Earl de Grey and opened a subscription among members to acquire a pair of historical paintings of the Battles of Waterloo and Trafalgar. Clarkson Stanfield received the commission for the latter. The choice of Stanfield was attributed to the fact that he had been retained by King William IV to paint the official royal record of the opening of London Bridge, following the success of

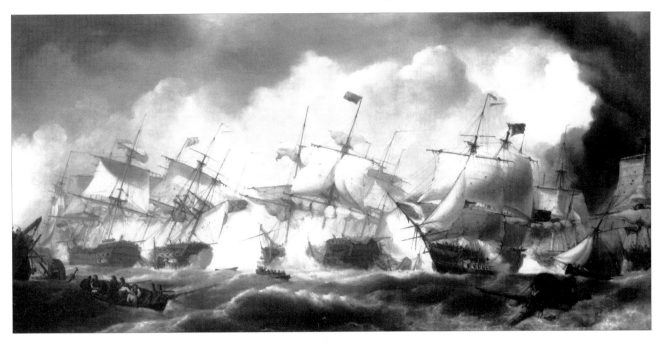

Plate 64. The Battle of Camperdown, 11 October 1797 Oil on canvas 24½ x 47½in. (62 x 120.5cm). A dynamic depiction of a naval engagement in rough weather, including the detail of Able Seaman Jack Crawford nailing Admiral Duncan's flag to the mainmast.

Private collection: photograph National Maritime, Museum London

his 'St. Michael's Mount', exhibited at the Royal Academy in 1830. Stanfield's painting is very large and was hung at the Academy in 1836 (No. 290). After having an additional eighteen inches added across the top in 1840, it measures about 100 x 180 inches (254 x 457 cm) and still hangs in the old United Service Club building in Pall Mall, now the headquarters of the Institute of Directors. It is not known how much the painting cost but it was insured in 1840 for £1,000.

There is no title on the picture but the frame carries a tablet giving a key to the vessels portrayed. The scene shows the centre of the action at 2.30 p.m., about an hour and a half after Nelson was shot. 'The sea was smooth with a long ground swell from the NNW – the precursor of the heavy gale which followed'.[6]

In 1839 Chambers made a smaller copy in oil of Stanfield's massive work (Plate 62) which is now in the National Maritime Museum collection. The painting was not commissioned for Greenwich Hospital and its origins are unclear. It is an accurate copy of the original, the long oily sea being the most immediately striking feature. There is an air of quiet about the scene which seems to reflect a period of exhaustion after the formidable intensity of the early stages of the battle as crews take stock of death and damage.

Chambers' other original painting of a comparable subject, 'The Battle of Camperdown, 11 October 1797', depicts a different scene: the battle fully engaged in heavier weather conditions (Plate 64). On this occasion the action took place in the turbulent lull between two gales. Admiral Adam Duncan (1731-1804) in the *Venerable* inflicted a crushing defeat on the Dutch fleet under Vice-Admiral Jan de Winter in the *Vrijheid,* off Camperdown and at the same time restored the morale of the Navy after the mutiny at the Nore. The origin of the commission is not clear but it seems to have come from the family of the victorious admiral who wished to commemorate the event. A finely finished preliminary drawing, almost the same size as the final oil and very similar to it, may have been produced for approval by the patrons (Plate 63).

The painting shows the heart of the action with the *Venerable* and the *Vrijheid*

6 Tyne and Wear No. 173

139

locked in combat. The long landscape format of the canvas helps to accommodate the extended linear view of the battle, where formal lines of approach soon disintegrated into mêlées between pairs of vessels, especially when the weather was rough. The result was visually irregular, if not chaotic, and always presented artists with difficult decisions when attempting a realistic depiction. However, Chambers' careful observation of sea and cloud effects, sails, rigging and seamen succeeds in creating a dramatic and credible image. It also includes the faithfully recorded detail of Able Seaman Jack Crawford nailing Admiral Duncan's flag to the mainmast after the mast-head had carried away, a feat of daring Chambers himself no doubt appreciated. Crawford's north country origins in Sunderland, where a statue was erected to commemorate his deed, would also have attracted the artist's fellow feeling.

It may be observed that Chambers' pictures were normally of limited dimensions. Only rare examples of commissioned and gallery paintings were on a large scale. Within these smaller sizes he was consummately successful and this may have been why he preferred them. It may also have been because they were more economical. A contemporary stated that, owing to his small stature, he needed a pair of steps or a stool to reach the upper parts of the canvas.[7] Since this was probably true it would provide a very practical explanation of his preference for medium and smaller-sized works.

This series of paintings of naval engagements represents the third principal grouping to be found in Chambers' *oeuvre*. It consisted of commissioned battle set-pieces mostly ordered for the gallery at Greenwich Hospital. Chambers' working life was a time of peace and, after the Battle of Navarino in 1827, there were no current naval actions to catch the public imagination and merit recording. The subjects were therefore, as noted above, usually commemorative. They made fresh demands on the artist in terms of structure as well as the handling of ships, fire and gun-smoke. Composition and detail both became more complex and more difficult to render in a manner both historically accurate and artistically appealing. Chambers rose to the challenge by diligently preparing drawn studies and sketches as well, on occasion, as oil sketches, in order to produce a final gallery version in oil. The resulting paintings achieve their effect through a brilliant restraint, quite different from the histrionic ebullience of de Loutherbourg and Turner. In terms of grandeur and dramatic impact, therefore, this group comprises some of his most imposing and memorable works.

7 Anderdon Collection 1829, British Museum

Chapter 13

HOLLAND AND YORKSHIRE 1837

While Chambers was working on the 'Bombardment of Algiers' for Greenwich Hospital, he maintained his output of the sea-paintings which allowed him to express more fully the closeness to nature which his Romantic sense dictated. Some of these were new versions of established works, such as sea-pieces set off Margate.

Early in 1837 he made his first visit abroad as an artist rather than as a seaman. While many artists were travelling through France to Switzerland and Italy, Chambers chose Holland. The long tradition of Dutch marine painting and the lasting influence of the van de Veldes on British marine art would have been a strong encouragement to go there. His own dedication to improving his technique of sea painting and broadening his knowledge of local conditions would also have prompted him to study the short steep seas produced on Holland's shallow waterways. The fresh wind and tall sky effects above an extensive flat landscape, captured by some of the greatest Dutch painters such as Jacob and Salomon van Ruysdael, would have offered him a challenge, as they did to his contemporary E.W. Cooke.

With continental travel so much the fashion and many of his contemporaries undertaking tours abroad, Chambers may well have felt the need to join in. The inclusion of overseas subjects in his portfolio would undoubtedly increase his appeal to potential purchasers. The results were to prove him right.

Even the build of Dutch vessels may have had a certain appeal to him and suited his style. Watkins had recorded in a letter to him of September 1835:

> Our mate, you may remember, was observing that your vessels are of a Baltic build. As we were going down the river he pointed a Norwegian out to me as an instance. I must confess there is some resemblance, but perhaps you design it should be so on account of the common look of our English ships. [He went on to advise:] Nevertheless, I would simply suggest, that a ship with a British flag should have the characteristic build of her country.

Whether or not this comment was justified, it is further illustration of the critical appraisal to which paintings were subjected by all types of viewer.

> Chambers was a very rapid and exact sketcher, and returned with a variety of choice material for pictures.

This material was worked up promptly for the 1837 exhibitions and lasted him until his next visit two and a half years later. Three of the six drawings hung at the OWS that year were of Dutch subjects and two of the three at the SBA. One of the latter, the large oil 'Dutch East Indiamen getting their anchors after a storm – coast of Holland' (No. 445, Plate 65), now at the Tate Gallery, London, is a spectacular example of his best exhibition work and the mastery he achieved after the stimulus of his Dutch visit. The characteristics of his style are rendered more

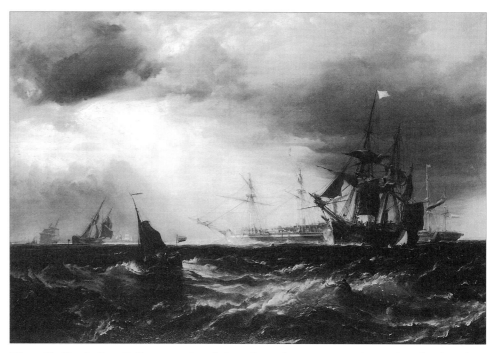

Plate 65. Dutch East Indiamen getting their anchors after a storm – Coast of Holland. Oil on canvas 37½ x 54in. (95 x 136.5cm). An impressive exhibition work produced after Chambers' first visit to Holland. The broad sweep and chiaroscuro handling of sea, sky and labouring shipping shows deep understanding and mastery of the medium. It was hung in the 1837 show of the Society of British Artists. Tate Gallery, London

dramatic by the chiaroscuro handling of the bright sunlight from the stormy sky and its clear but restricted play upon the water, ships and sails. All the urgency of the moment is caught as the Indiaman tacks up on a rising tide, into a fresh breeze, to break out its anchor, while the unfortunate barque, in the left middle-distance, heels to try and free itself from the bank on which it has run aground. Shadowy dolphins in the right foreground add a whimsical touch. The brushwork is fluent and accurate, achieving its effects, even in detailed areas, with limited but telling strokes.

An illustration of the fluency of Chambers' watercolours at this time is the drawing in the Whitworth Art Gallery, Manchester (Colour Plate 38). This was worked up into several versions in oils, of which Colour Plate 39 reproduces an example, also dated 1837. It was also later copied by Calvert Jones (see page 117).

On each of his two trips to Holland, Chambers was accompanied by pupils. This may have been a further incentive to travel. The company of other like-minded artists would have been appealing and the opportunity for them to experience a wider range of topography and subject-matter a valuable training. It may have been the company of pupils as well as the uniqueness of the opportunity which prompted Chambers to depart from his usual reluctance to copy the work of other artists. The sale of studio contents after his death included 'Sketch from the celebrated Backhuysen at the Hague' (Lot 60). Ludolf Bakhuysen (1631-1708), although in fact born a German, was one of the most influential of the great Dutch marine school.

Gooden-Chisholm is recorded by Roget as recounting:

> I was in Holland with him [Chambers] fifty one years ago and our life there was to be in a boat sketching all the morning and afternoon, and then at Amsterdam into the boat to sketch the great schuyts that were taking people away to the villages on the Zuyder Zee after their work of the day was over in the city.[1]

These sketches were to be the foundations for some of Chambers' most successful works: 'German Reapers leaving Amsterdam for the different Towns in Waterland

Plate 66. A windy day. Boats in a gale. Watercolour over pencil 10 x 14in. (25 x 35cm). Signed. Holland exhilarated Chambers and this typical view is interpreted with a responsive and dynamic fluency. Courtesy of the Board of Trustees of the V&A

– Evening' (Colour Plate 54 and page 176) and 'Dutch Passage Boat crossing the Maas' (Colour Plate 53 and page 169). Gooden-Chisholm continues:

> It was distinctive of him more than of any other artist that I have worked with, that on any impressive effect in sea or cloudland presenting itself, his plain little face would light up, and his hand become tremulous, and for the time he was raised. These would be the rare intervals when the poverty and discomfort of his life would be lost to him. He had ample of the miseries. [But he sums up:] Chambers was a lovable little fellow, entirely unaffected by the success which reached him.

Another sketching companion, and perhaps pupil, Alfred Clint recollected:

> Always on the look-out for subjects for his pencil, he one day, finding nothing that interested him, was seen to pull up suddenly before a formal row of leafless trees, with the exclamation 'Blow me! I *must* do *something*' and proceeded to make a careful study of the bare branches.[2]

Calvert Jones may have been another artist who accompanied Chambers to Holland but there is no conclusive evidence of this. It seems unlikely that James Harris, his other pupil from Swansea, went on the tour. Edward Duncan first exhibited Dutch scenes at the New Water-Colour Society in 1838, so he might also have joined the group in 1837. E.W. Cooke paid his first visit to Holland in 1837 but he and Chambers do not seem to have been together or to have met there.

'A Windy Day', a Dutch waterway scene, now at the Victoria and Albert Museum (Plate 66), shows Chambers at his most dynamic and dominant in the watercolour medium. There is great zest and atmosphere in the painting which

2 Roget II p.237

143

Plate 67. Dutch Barges Going to Market. Watercolour 12 x 16½in. (30.5 x 41.5cm). The use of light washes imparts an almost oriental atmosphere to the scene.
Seattle Art Museum, Washington

Plate 68. View of Amsterdam. Watercolour 10 x 14in. (25 x 35cm). Amsterdam, a city of canals on the river Amstel, had a strong appeal for the artist.
Courtauld Institute of Art, University of London

exemplifies his response to nature in the typically breezy Dutch landscape. In calmer mood, conveying the visual elegance of everyday Dutch life on the water, is another outstanding drawing of a boeier heading out, well laden and with passengers (Colour Plate 40). Similarly 'Dutch Barges Going to Market' (Plate 67), now in the Seattle Art Museum, Washington, where the use of delicate washes imparts an almost ethereal mood. Back in Amsterdam, Chambers could not resist a view of the city from the river Amstel, but still from a floating viewpoint (Plate 68). These examples of Chambers' watercolour technique employ a minimum of under-drawing, relying for their effect, including fine rigging lines,

Plate 69. Coast Scene. Watercolour over pencil 7 x 11in. (18 x 27.5cm). A commonplace scene handled with sensitivity. The Royal Watercolour Society Diploma Collection, housed at the British Museum

on light washes, fluent brushwork and detailed use of the slender point. There is some scratching out and use of bodycolour to heighten relief in the 'Windy Day'.

A small drawing in the collection of the Trustees of the Royal Society of Painters in Water-Colours called 'Coast Scene' (Plate 69) may also date from this tour in Holland.

But the Thames remained home territory for Chambers and the Nore light vessel at its mouth was an important mark for shipping navigating the river. Shortly after his return from the Low Countries Chambers was given official permission to visit it:

<div align="right">Trinity House, 14th.April 1837.</div>

Sir,
Permission has been granted for the bearer hereof, Mr. Chambers, to remain on board the Nore-light vessel, for some days, in order that he may take some views, (drawings) at the entrance of the Thames and Medway. You will, therefore, receive him on board, and provide him with accommodation *at his own expense.*
<div align="center">I am, Sir,
Your obedient servant,
J. Herbert, Sec.</div>
Mr. Thos. Fielder, Master of the Light-vessel, at the Nore.

The permission was apparently secured through the good offices of Mr. Aaron Chapman, a member of the same family of Whitby ship-owners and bankers, who was M.P. for the town and an Elder Brother of Trinity House.

Colour Plate 40. A Dutch boeier. Watercolour 13½ x 23½ in. (34 x 60cm). Signed and dated 1837. An outstanding example of Chambers' developed watercolour technique, stimulated by his Dutch visit. Private collection: courtesy of Agnew's, London

Although Chambers did not avail himself of the opportunity to stay on board, he drew the lightship, as he did many of the river landmarks (Colour Plate 41). It is characteristic in its authenticity and spirit. The low viewpoint, the fishing boat and barge in the foreground partly superimposed upon another barge and cutter behind, the stormy sky and wind-whipped water give a sense of the mundane urgency of life afloat. The patches of sunlight falling across the barge's bow and silhouetting the lightship in the background enhance and balance the composition.

Rather less congested is another watercolour of a Thames scene (Colour Plate 42). It shows a cutter in a stiff breeze, gaff peak dropped and foot clewed up to ease the mainsail, against the backdrop of a rank of laid-up men-of-war, with a Thames barge, head to wind, in the left middle distance. As in the previous example, the artist takes the viewer directly into the action by bringing the open deck of the cutter close to the picture plane.

The River Medway, a tributary at the mouth of the Thames, probably offered Chambers the opportunity to enjoy nature in a quieter, more rustic environment than the busy Thames highway. Perhaps it was something of a refuge where he could sit on the shore or take out a boat and sketch. His first work accepted by the Royal Academy was a sketch on the river and he returned often to the scene.

Colour Plate 38 (Opposite, above). Dutch shipping scene. Watercolour, bodycolour and surface scratching 7 x 9in. (17.5 x 23cm). Signed and dated 1837. Movement of light and water under the effect of wind and cloud delighted Chambers and stimulated him to make telling use of the watercolour medium. The Whitworth Art Gallery, The University of Manchester

Colour Plate 39 (Opposite, below). Dutch shipping scene. Oil on canvas 24 x 33in. (61 x 84cm). Signed and dated 1837. In oil the treatment of the subject is equally effective. Chambers' pupil, Calvert Jones, later copied the painting. Sotheby's

Plate 70. Shipping on the Medway. Oil on panel 14 x 20in. (35.5 x 50cm). Signed and dated 1838. The Medway was a favourite haunt of Chambers. He appreciated the pastoral quiet combined with the concerted activity of the Chatham naval dockyard, seen in the left background.

Ferens Art Gallery, City of Kingston upon Hull

Plate 71. Haybarges on the Medway. Watercolour 11 x 15in. (28 x 39cm). Signed and dated 1837. The heavy, laden barges take on a lightness and grace in the artist's deft use of wash and detailed point.

City of Birmingham Art Gallery

Plate 72. Haybarges on the Medway. Etching 6 x 9in. (15 x 23cm). Probably the only attempt by Chambers himself to enter the field of engraving and prints, practised by many of his contemporaries. Undertaken towards the end of his life, no evidence has been found that it was published.

National Maritime Museum, London

His views were usually calms or of benign weather conditions which seem to reflect the sense of peace he found there. 'Entrance to the Medway' (No. 211) was hung at the SBA in 1836. It may have been similar to the later oil illustrated as Plate 70, now in the Ferens Art Gallery, Hull. Although the mood is calm, there is ample activity on and around the nearest anchored vessel and Chatham naval dockyard fills the left middle distance.

'Hay-barges in the Medway', 1837, in the Birmingham Art Gallery (Plate 71), is in the typical Chambers format and totally convincing. The ungainly, lumbering, hay-laden barges are given grace and energy as a keen breeze drives them along, sprit and lug sails bulging under the load. A pile of darkening cloud silhouettes the sharp profile of the sails and enhances the colour tones of the sunlit canvas. The straining figures and smoking galley chimney bring personal involvement to the dynamic scene. The dark band of water beyond the barges frames the surging foreground waves and underlines the anchored man-of-war, which complements the off-centre barges without competing with them.

Two copies of an etching of this picture are known to exist in proof state, without lettering (Plate 72). Roget records Alfred Clint's account of Chambers etching this image,[3] so, although the state is unfinished and there is no further evidence of publication, it seems certain that this was the result of Chambers' own first effort at the technique. It was almost finished at the time of his death (see page 186) and was to have been printed and sold for the benefit of his family. The purity of line the etching displays is typical of his skill. The fact that Chambers tried his hand at etching suggests that he may have finally become persuaded of the value of mastering this technique, in order to be able to produce his own prints for publication. Many of his contemporaries had successfully done so, notably E.W. Cooke, copies of whose publications were among those owned by Chambers.

3 Roget II p.237

On 27 May 1837 Mary Ann gave birth to their third son. He was baptised Edwin Calcot Finucane on 25 June at St. Pancras Church, still their parish church while they were living at Park Village West. Once again the parents chose numerous and somewhat esoteric christian names. Calcot would have been after the distinguished painter, Augustus Wall Callcott (see page 92). Finucane is rare either as a Christian or surname. The only derivation found is from an Irish family name originating in County Clare, MacFionnmhachain. The Chambers' reasons for choosing the name have not been clarified.

In July Chambers was again at Whitby, staying at Aislaby Hall, Watkins' home just outside the town. His health was improved:

he looked like a jolly, chubby sailor-boy again.

As usual he was busy during his visit.

Colour Plate 41. At the Nore. Watercolour 13½ x 20in. (34 x 50.5cm). Although Chambers received permission to stay, at his own expense, on the Nore light vessel, he did not take up the offer. This view suggests that it was not necessary to be on board to portray the busy traffic on the river. Courtesy of the Board of Trustees of the V&A

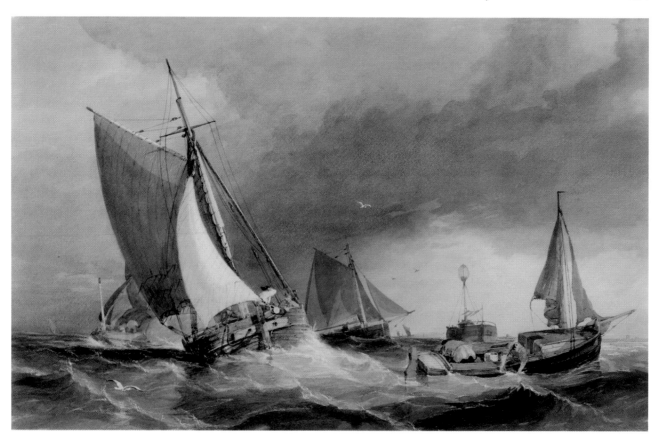

He wanted some rock subjects, and went upon the scar, where he found some bits to his liking, such as a huge rock, overgrown with sea weed, and reflected in the still pool around it, left by the receded tide. He invested these common objects with extraordinary power. In truth he could give sublimity to the simplest things; and some of his shore-pieces equal as paintings, Byron's poetry. 'There is a rapture on the lonely shore.'

The lonely shore sometimes had a more tragic aspect. Wrecks were frequent enough on this exposed rocky coast, with the entrance to Whitby harbour a narrow opening between the cliffs. The *Phoenix,* the pride of the Chapman fleet (see page 33), fully provisioned for a whaling voyage, was being towed out of port in April 1837 by the steamboat *Streonshalh,* which proved too light for the tow. The *Phoenix* was cast off and drove ashore on the Scar behind the East Pier. The crew were saved and she was later refloated. Repaired in dry dock and sold to a Scarborough owner, she was then used in the American timber trade.

Colour Plate 42. Old men-of-war at anchor: boats in a gale. Watercolour 9 x 13½in. (22 x 34cm). Signed and dated 1837. Another unpretentious scene, carefully structured and interpreted with restrained colour. The masterly handling of clouds is characteristic and complements both the form and the tone of the image. Courtesy of the Board of Trustees of the V&A

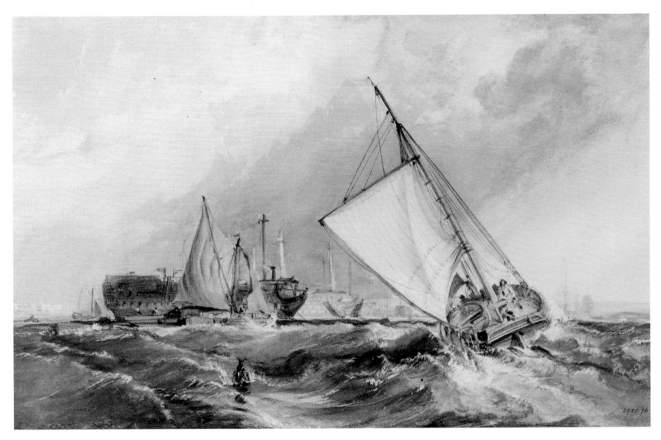

Plate 73. Vessel ashore, Whitby East Side. Watercolour 2 x 3¼ in. (5 x 8cm). Signed. A rough and very small sketch made on the spot at the time of the wreck. Royal Academy of Arts, London

Chambers made a small sketch of the vessel as she lay ashore. This was probably the small drawing now in the Jupp collection at the Royal Academy (Plate 73). Although the composition has been changed, the sketch was probably the basis for a larger watercolour in the Pannett Art Gallery at Whitby (Colour Plate 43). The prominence given to the cliff and rocks not only emphasises the threat always posed to shipping by an unfriendly coast but also exercises the artist's ability to tackle the complexities of their portrayal. The lesser role to which the wrecked hull is relegated, calm after the storm, high and dry by the safety of the harbour wall, so near and yet so far, re-echoes the subordination of men's efforts to the forces of nature. The mood of the scene is powerfully captured in the fluent handling of the watercolour medium.

A more direct derivation from the original sketch was a wood-cut made by W. King which was reproduced in the *Whitby Repository* on 1 January 1867 under the title 'The Phoenix Ashore' (Plate 74).[4] The debt to Chambers' original was acknowledged and, given the limitations of the medium, the wood-cut captures the drama and pathos of the scene. The illustration was accompanied by an article narrating the circumstances of the wreck.

Watkins continues:

He took coloured sketches in Aislaby stone-quarries. The wondering rustics regarded him with reverence. One man said, 'they tell me you earn a guinea an hour'. 'Aye', answered he, 'sometimes four'. When in the country he counted his time lost, if not spent in gaining sketches. A day's excursion was no recreation to him unless he could render it profitable. His ardent mind was immediately clouded when the sun was overcast, and the effect of light and shade withdrawn. He used at such times impatiently to exclaim, 'Shine out, fair sun'. A more industrious man never lived. He was always uneasy when he could not obey those impulses which were ever prompting him to paint. He did scraps in my sister's albums, and made a very pretty little drawing of Aislaby Hall, which he presented to my mother.

'Whitby Rocks – Study from Nature', hung at the OWS the following year (No. 261), must have been one of the results of this trip.

Chambers extended his stay to a month.

Plate 74. The Phoenix *ashore. Woodcut by W. King after George Chambers 6 x 8½in. (15 x 21.5cm). Derived from the small sketch (Plate 73), this was reproduced in the* Whitby Repository *on 1 January 1867.* Whitby Literary and Philosophical Society Library

> He then proceeded to Hartlepool for rock subjects – those at Whitby not being exactly to his mind. He wrote afterwards: 'I got some very fine rock subjects, which will be useful sometime.'

Geology was a subject in which Chambers was keenly interested, as were David Cox, Turner and Cooke, among others. Rocks and cliffs often formed part of coastal scenes, especially on the rugged North Yorkshire coast, which figured in his paintings. The tonal patterns of stone, particularly reflecting the light when wet from sea or rain, could be as challenging to the artist as the ever-changing face of the sea. The *Geological Survey of the Yorkshire Coast* by Young and Bird (see page 26) was in the artist's possession at the time of his death (Sale Lot 178). This detailed survey of the subject runs to 328 quarto pages with engraved maps and elevations, hand-coloured.

It was after Watkins' hospitality to Chambers on this visit in the summer of 1837 that he published his *Memoir of Chambers. The Marine Artist,* which gave much biographical information and extolled the merits of its subject. It was also critical of the attitude of Whitby people towards Chambers and therefore caused some resentment in the town. The timing of the publication seems to have been related to Queen Victoria's accession to the throne, for it contains the suggestion that Her Majesty should appoint Chambers her marine painter.

Chambers' return journey to London was by means of a new steam packet service. This new form of sea travel was, like the growing network of railways, a sign of the rapidly developing times. There are references in the correspondence, too, to the greater speed and efficiency of the public postal service, although both Watkins and Chambers still preferred to send letters by hand of friends at no cost.

On his arrival from the north that autumn, Chambers took new apartments at 7 Percy Street, Rathbone Place, back in the artists' quarter around Tottenham Court Road. John Constable (1776-1837) had lived and worked round the corner in Charlotte Street for fifteen years until his death in January this year, 1837. George Rowney, the artists' colour manufacturers, were in Rathbone Place.

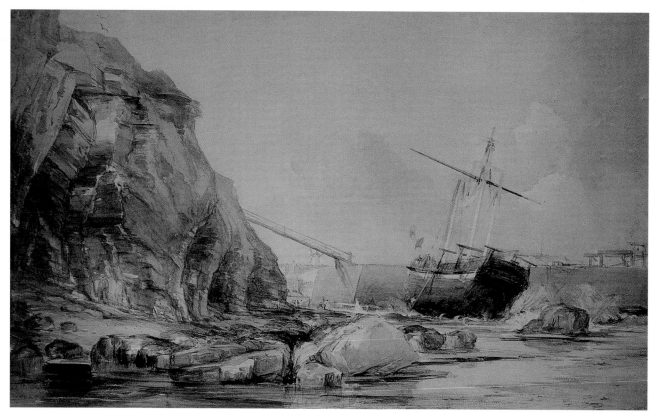

Colour Plate 43. Whitby East Side, Shipwreck. Watercolour 14 x 23in. (35 x 58cm). A finished drawing of a similar scene, where the cliffs play a dominant role. Chambers, like many other artists, was preoccupied by rocks and the problems of depicting them. On one visit, dissatisfied with the rocks at Whitby, he went to Hartlepool in search of others, more to his liking. Pannett Art Gallery, Whitby

He was too much out of the way in Park-village, and had cause to regret having left Alfred-street, the seat of his highest patronage.

The building is still there, now occupied as offices (Colour Plate 44). If the tall windows on the first floor were in place at that time and in Chambers' apartment, he would also have gained a light and airy north-facing studio.

It may have been at this address that the following encounter took place, illustrating

the enthusiastic respect of a gentleman for the fine arts and the unassuming demeanour of our artist

as well as his sense of humour!

Mr. Todd took apartments in the same house in which Chambers had apartments, purposely to cultivate his acquaintance. Mr. Todd asked the lady of whom he rented his rooms the way to Chambers' painting room, and, resolving to introduce himself, he knocked at the door. He heard a voice say 'Come in,' and in he went. There was a little, not a great man, standing at an easel, and busily engaged. Chambers seldom left work to attend to a visitor, but would talk as he painted, so that strangers have thought themselves not welcome. Mr Todd thought that he saw not Chambers, but one of his pupils. He asked if he had been long a painter? About ten years. 'You look young to have been a painter so long. Was that picture done by you?' – 'Yes' – 'and that?' 'Yes' – 'Gracious me! you have done them all – but what must your master's performances be? – can you introduce me to him?' 'Yes.' 'What kind of a man is he?' 'Oh, he's a decentish chap enough.' 'Is he accessible?' 'Yes'. – 'Well, I'll call again

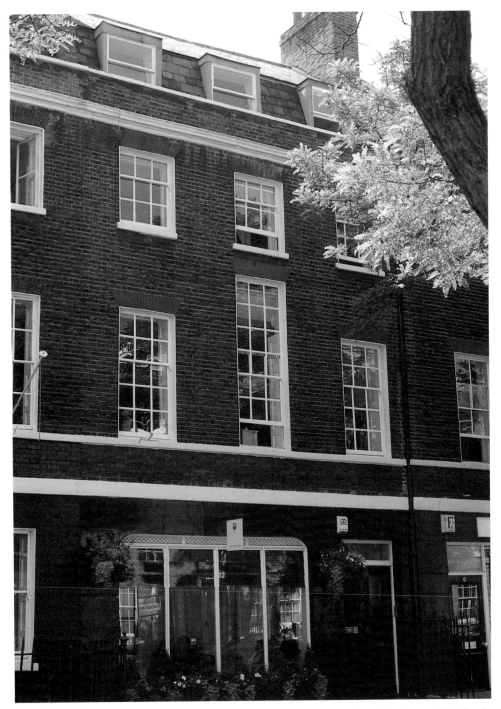

Colour Plate 44. 7 Percy Street, London. On his return from the north, Chambers and his family moved back to the artists' quarter near Tottenham Court Road, where they had lived before moving to Regent's Park.
Photograph Author

and see him when he's in the way' – and with that Mr. Todd went and told his landlady that he had been talking to one of Mr. Chamber's pupils. The landlady said that she did not know Mr. C. had any pupils at present. 'What kind of a looking man is Mr. C. then?' The landlady described him, and Mr. Todd exclaimed – 'Well! I have done it then – I shall never dare to speak to him again. – I don't know what I have been saying to him, but I have uttered a great deal of nonsense I am sure. You must go and make an apology for me – or stay, I'll go myself'.

After Mr. Todd's departure, Chambers had gone in to his wife, and, laughing, said, 'Blow me!' his usual expletive, 'if I hav'nt been taken for one of my own pupils.' He soon after saw Mr. Todd, and they spent many a pleasant evening together.

Something of a mystery emerges in the later correspondence between Watkins and Chambers. Watkins added a Sub P.S. to Mary Ann to his letter of 6 April 1836:

Dear Ma'am, – This is Lady-day, and as I was born on this day, I am by nativity a ladies' man, and therefore must write to a lady… I hope that George and Billy are good children, and good scholars, and that you have a good servant. Will you have the kindness to present my good wishes to — and to all good friends.

Only in this connection does Watkins resort to this anonymity and the inference is that it refers to a lady, a friend of Mary Ann's. The subject of the lady's suitability was evidently discussed during Chambers' 1837 visit to Whitby, for Watkins recounts:

Upon a subject relative to an important concern in life, upon which we had had a little difference of opinion, he writes me thus:- 'My dear friend, I trust my opinion on that subject will not lessen our friendship. If I did not think sincerely of your welfare and happiness, I should not take the liberty of advising you. You little know the experience I have had. I beg of you to be cautious.

Replying on 13 October 1837, Watkins wrote:

With reference to — I do assure you that anything you can say to me on that subject, in the spirit of friendship, receives my most respectful consideration. Your affection for me, and your knowledge of the world, makes me listen with deference to what you say.

There is no further explanation for Chambers' words except, perhaps, for a single line in Roget: 'Unhappily the after life of George Chambers was much embittered by his wife's frivolities.'[5] Watkins implied, writing after staying with Chambers in London in 1838, that they were both enduring distressing situations, but was not specific that these related to the opposite sex. Loyalty to the painter clearly deterred further comment. In his letter to his wife from Liverpool in June 1839 (see page 171), Chambers wrote: 'I will not forget you want some new Dresses'. One wonders if the plural indicates a certain extravagance in the wife of a struggling artist with four children. The evidence is slender, but it seems that Mary Ann became something of a trial to her husband.

5 Roget II p.230

Chapter 14

CONSOLIDATION: MATURE WORKS 1838

In the early months of 1838 Watkins again visited London and stayed with Chambers.

> He had at this time a view of St. Michael's Mount on the easel, with which he had much trouble. He could not keep the Mount back in the picture – it would overtop and come forward. At length, however, he contrived by a bold foreground, and by curling a mist round the sides of the Mount, to attain his object. The picture was exhibited in the National Gallery at the request of the gentleman who had commissioned him to paint it.

Illustrated as Colour Plate 45, it is a large painting, now in Bury Art Gallery and Museum.

If Chambers had ever actually seen St. Michael's Mount it is likely to have been during the voyage of the *Runswick* in 1826-27. He does not appear to have visited Cornwall afterwards. St. Michael's Mount was a well-known romantic subject at this period, Turner, Stanfield and Cooke all having painted pictures of it. Stanfield's was exhibited at the Royal Academy in 1830. Chambers' painting may have been commissioned by someone anxious to own a further version of the subject and his difficulty with it may have stemmed from his not having recently visited the location. The image creates a suitable aura of romantic drama and any shortcomings in the background view of the Mount have been amply redeemed by a characteristically strong foreground scene of sea, boats and fishermen. He painted a smaller version on panel in the same year, with the Mount set further in the background and the foreground occupied by a shipwreck.

The hanging of the picture in the National Gallery is something of a mystery. The Gallery, founded in 1824, moved to its new building on Trafalgar Square in 1838. At the same time the Royal Academy also moved from Somerset House to share the new premises and it is thus not always easy to separate the functions. Chambers had an exhibit at the Academy in 1838 but it was not this one (see page 106). All that can be said with assurance is that the gentleman who commissioned the painting must have been influential to have it hung at his request, either in the Gallery or by the Academy. It is tempting to think that it might have been William Seguier himself, although the picture was not among those from his collection sold in 1844 after his death.

Watkins records that he had

> nothing material to relate of his second visit to Chambers. By his advice I wrote a drama on the subject of Paul Jones, which was accepted by Mr. Farrell, of the Pavilion theatre; but his affairs becoming involved, he was compelled to quit the management before the piece could be brought out. Chambers had promised to paint a scene for it. A lawyer's clerk, named Garbutt, had come up to London to pass his examination – a fellow of Hogarthian humour, with whom Chambers, who was fond of farce, was highly amused.

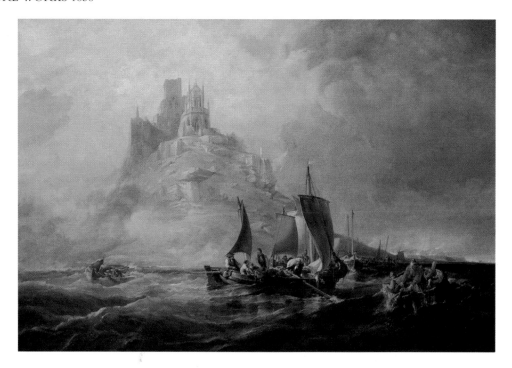

Colour Plate 45. Laying lobster pots, St. Michael's Mount. Oil on canvas 48 x 72in. (122 x 183cm). Signed and dated 1838. Watkins recounts that Chambers 'could not keep the Mount back in the picture… but by a bold foreground and curling a mist round the sides of the Mount' he achieved his purpose. The gentleman who commissioned the painting arranged for it to be hung in the National Gallery.
Bury Art Gallery and Museum

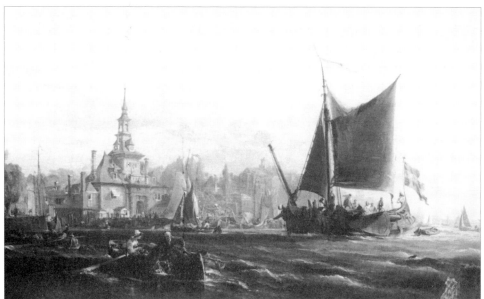

Plate 75. Rotterdam. Oil on canvas 34 x 52in. (86 x 132cm). Signed and dated 1838. This fine exhibition piece was probably the work accepted by the Royal Academy for its 1838 show.
Dowmunt, Cheam, Surrey

The Royal Academy accepted Chambers' 'Dutch vessels going out of harbour – Rotterdam in the distance' (No. 293) for its 1838 exhibition. The title of Plate 75 is not exactly the same, but is of a substantial canvas, signed and dated 1838, a fine exhibition piece, which could well have been hung at the Academy. He also had four watercolours at the Old Water-colour Society, including Trafalgar, and three works at the Society of British Artists. But he wrote to Watkins in May:

Nothing would give me greater pleasure than a visit to Whitby – only Yorkshire folks are not picture-fanciers. I have been very unlucky this year with exhibitions – altogether badly placed, and none sold. It will not do without getting more to nature. I wish we were living on the sea-coast for a year or two – which trip to take first I do not know. Mr. Gooding has a small yacht – we are going down the Thames for a week. Views from Gravesend to

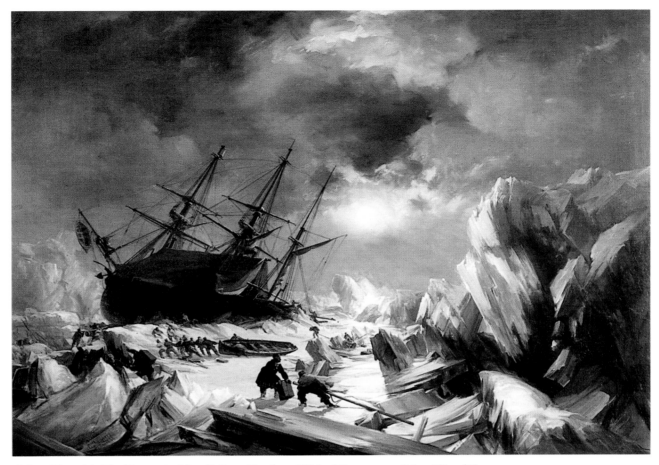

Colour Plate 46. The Terror *iced in off Cape Comfort, 1836. Oil on canvas 24 x 33in. (60 x 84cm). Signed and dated 1838. Depicting large ice masses presented difficulties for artists like Chambers who had not actually seen them. The painting none the less hauntingly captures the activity of the crew in their frozen fastness.*
Purchased with a Minister of Communications Cultural Property Grant and funds from Friends of the Beaverbrook Art Gallery; Beaverbrook Art Gallery, Fredericton, New Brunswick, Canada

London Bridge, with the immense variety of shipping, will be a good work to publish. You shall hear more when I get the sketches. You must not neglect to write every opportunity, as nothing gives me greater pleasure than your kind letters. We were at Crawford's yesterday – Garbutt was there. We had a most hearty laugh – he is a wonderful fellow – he desired his best respects to you. I have not been at Pyne's since you left. He called on me yesterday, wishing me to join him in getting up a Diorama for his friend Lewis to shew and give lectures on – the subjects the ancient prophecies in the Bible. You shall hear more in my next. My brother William has turned marine-painter, and has already painted five or six portraits of ships.

Gooden–Chisholm, recalled their trips:

Chambers and I were much about together on the river, on several yachting excursions, in which he accompanied me. We had very rough weather, so I doubt that very much came of them to him; but when it was impossible to use colour, his scrap-book was always in his hand, and any accident in the arrangement of a vessel's sails and notes of colour of clouds were at once recorded. Failing any particular object, he would be studying black and white in a little jet mirror, probably come from his early days at Whitby. This occupation would seem always to afford him great contentment.[1]

1 Roget II p.234

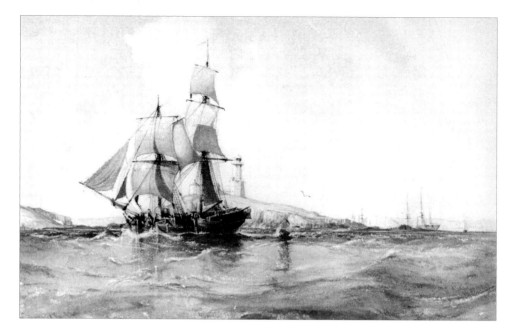

Plate 76. Shipping off the Mumbles. Pencil and watercolour. 7½ x 11½in. (19 x 29cm). Signed and dated 1838. At the entrance to Swansea bay, the Mumbles headland and its lighthouse have always been important navigational marks for shipping.
Private collection

Replying on 4 June, Watkins commiserates:

> I am sorry to hear of your ill-luck this year – politics engross so much of the public attention, that the arts suffer. You need not be discouraged, however, and you will not. Your genius is an estate to you, and will always procure you fame. Time is still in your favour, and fortune will recompense you at last.

Apart from an active time in politics, Queen Victoria's coronation was to take place on 28 June. Watkins writes of people who were going up to London for the event and, encouragingly, who would then have the opportunity of seeing Chambers' pictures in the galleries. He goes on to advocate the currently popular topographical views often published in book form:

> The hint you give of views on the Thames has roused my expectations. The best subjects for displaying your skill, and for exciting public interest, may be had there; and, by a popular publication, you would advance your claims to national honour as speedily and as efectually as by anything you could do. It would do you more good than mere exhibiting – when you exhibit, you are one in a crowd – if you publish a successful work, you stand as it were alone; and the success of your work would be a public recommendation to the higher powers. Stanfield got into the Academy, not so much by the judgement of the R.A.'s as by the noise made in public about him. His scenes at Drury Lane, and his published views, got him the public voice in his favour, and it is in the interest of the Academy always to listen to that.

Clarkson Stanfield's *Coast Scenery* had been published in 1836.

The publication of a series of views on the Thames, very much in mind at this time, evidently became a firm project, for Watkins, writing again on 10 December said: 'I am glad to hear that you are publishing views on the Thames, and hope to have the pleasure of seing them soon.' Carpenter presumably made a proposal to Chambers, or gave him a commission, which was later rescinded in the correspondence quoted above (see page 96).

> Captain Back employed our artist to paint him a picture from sketches representing the Captain's situation amid the ice, when sent to ascertain the fate of Capt. Ross [Colour Plate 46]. If Chambers could have taken a voyage to Greenland in one of the fishing ships, what a noble picture he might have painted.

Captain George Back (1796-1878) had been with Franklin on two earlier Arctic expeditions and had gone in search of Captain James Clark Ross, assumed lost, in

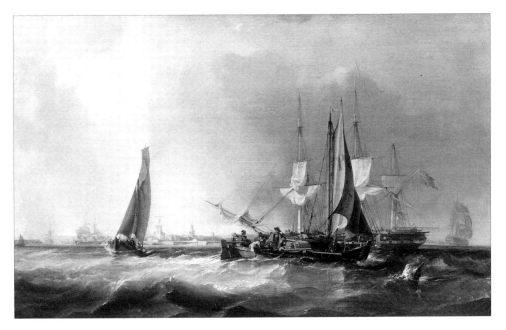

Plate 77. Portsmouth. Oil on canvas 18 x 30in. (46.5 x 76cm). Signed and dated 1839. A characteristic Chambers sea-piece handling sea, sky and shipping with consummate mastery and including accomplished figure painting of the occupants of the foreground ferry boat.
Southampton City Art Gallery

1834-35. In 1836 he was commissioned, at his own suggestion, to complete the mapping of the Canadian coastline between Regent's Inlet and Cape Turnagain and sailed in the *Terror* on 14 June. The ship became iced in off Cape Comfort, the predicament Chambers was called upon to depict. The *Terror* broke free in December. Ravaged by storms and drifting powerless among the icebergs, she survived a capsize and finally reached Lough Swilly in Northern Ireland on 3 September 1837. The picture remained in Captain, later Admiral, Back's family until recently. It is now in the Beaverbrook Art Gallery, Fredericton, New Brunswick.

William Henry Smyth was Captain Back's senior lieutenant in the *Terror* and an accomplished artist. His eye-witness line drawings of the *Terror's* situation in the ice and the efforts of her crew to free her were subsequently published as prints. Certain resemblances between these and Chambers' painting suggest that he may have had access to them while preparing his work. Captain Back, knowing of Smyth's drawings, probably recommended them to Chambers for authenticity. Although he had had some early experience in Whitby of depicting ice for whaler captains, Chambers had never visited arctic regions and would have had some difficulty envisaging the appearance of great ice masses. A preliminary drawing for Captain Back's oil was in the sale of studio contents after the artist's death (Lot 130). Another version of the final painting, larger but unsigned, is at Greenwich. It is very similar to Chambers' and may also have been painted by him.

Ice appears in another 1838 painting 'The barque *Auriga*, 231 tons, Master F.E. Chalmers. From Sydney, N.S.W., to London. 60 miles S.W. Cape Horn (Diego Ramirez) 59S 67W, 1836' (Colour Plate 47). Built in 1825 and owned by Richardson of London, *Auriga* regularly made runs to and from Australia. The preliminary drawing, sold with the studio contents, Lot 63, was entitled 'Homeward-bound from Sydney, surrounded by icebergs'. The painting vividly captures the terrifying uncertainty of navigating in waters strewn with icebergs and, again, illustrates the difficulty of depicting icebergs with realistic accuracy.

In August-September 1838 Chambers was again in the West Country and Wales. His sea paintings of this period show great maturity. 'Shipping off the Mumbles' (Plate 76), portrays the scene off the well-known headland and lighthouse at the entrance to Swansea Bay.

South coast scenes also figure prominently in his output at this time, suggesting that he may have re-visited the Portsmouth area and his favourite views from Spithead. 'Portsmouth' (Plate 77), now in the Southampton Art Gallery

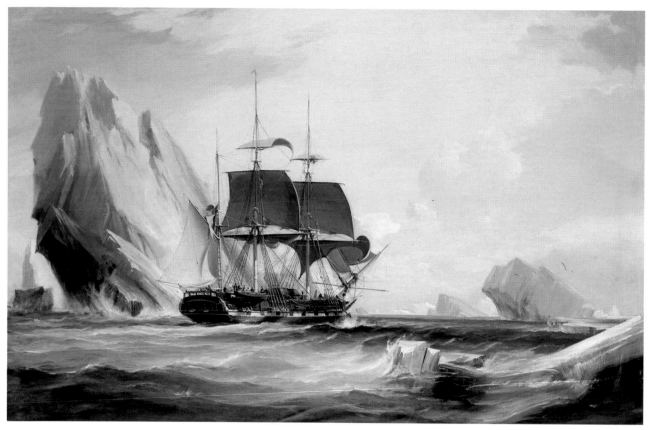

Colour Plate 47. The Barque Auriga, *231 tons, Master F.E. Chalmers, from Sydney to London, 60 miles S.W. of Cape Horn (Diego Ramirez) 59 South 67 West 1836. Oil on canvas 28½ x 42½in. (72 x 108cm). Signed and dated 1838. Even a daylight view conveys the terrifying uncertainty of navigating in waters strewn with icebergs.* Private collection

collection, and 'Off Portsmouth' (Plate 78), in the Harris Art Gallery, Preston, further illustrate his ability to treat this thematic material with vigour and spontaneity. The topography is identifiable but understated. The strength of the painting lies in its sense of light and movement.

This is, therefore, a suitable juncture at which to review the fourth main theme found in Chambers' *oeuvre,* the central core of his artistic inspiration. He was always fascinated by the challenges of conveying the movement and light of the elements over water in the medium of both oils and watercolours. This was no slavish attempt at reproduction. He sought to capture the mood of the moment, to interpret the state of the sea, sun, sky, cloud and wind with the aid of ships, small boats and the people in them pursuing their everyday vocations afloat. His handling was always fluent and his brushwork masterly. This group of sea-pieces is the largest and most significant in his output, spanning the entire period of his maturity. The sensibility of the works is romantic in being derived directly from nature, interpreting its freedom and freshness, and giving the individual, however humble his role, a place in the greater scheme of things. The location was usually specified and topographical detail still accurately observed, but now relegated to a subordinate function. The ships were rarely identified. The power of the portrayal is concentrated in the play of light and shade, sun and cloud, wind and waves, heeling vessels and bulging sails, attentive helmsman and straining oarsmen. The location was not critical, it could be on the Thames, off Whitby or on a Dutch waterway. It was sometimes used repeatedly as, for example, Spithead off Portsmouth. The intent and force of the image are self-sustaining. Thus, although

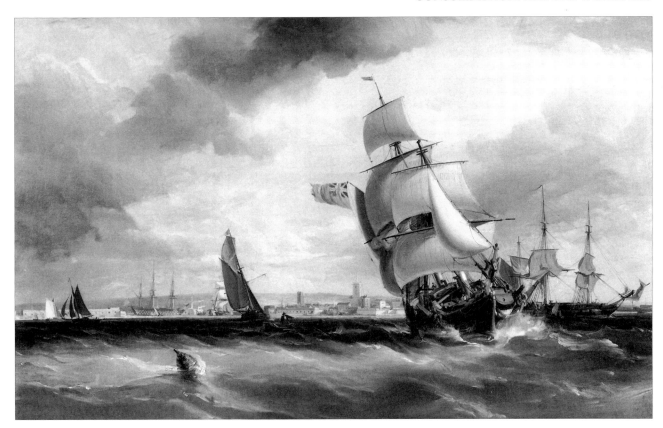

Plate 78. Off Portsmouth, in the distance, Nelson's flagship Victory. *Oil on canvas 17½ x 27½in. (44.5 x 68.5cm). Signed and dated 1839. The view of Portsmouth and Southsea from seaward was a favourite of Chambers, the shoreline accurately delineated but not intruding on the dynamic balance of the sea and sky. In this case the surging brig, emerging from the shadow, adds exhilaration and immediacy for the viewer.* Harris Museum and Art Gallery, Preston

Chambers' visit to Holland in 1837 resulted in a renewed zest and broadening of geographical horizons, the conception and execution of the works remained consistently within this thematic range.

It is noteworthy that Chambers was characteristically restrained in his choice of

Colour Plate 48. Typical signatures by Chambers. Above: Oil, detail of Colour Plate 36; below: Watercolour, detail of Colour Plate 38.

weather patterns for these pieces. The conditions ranged from the sunny and calm to the windy and rough but he rarely ventured into the depiction of gales, storms and shipwrecks. Lord Mark Kerr's commissioned painting of the *Cormorant* (Colour Plate 9) is one of few exceptions. The scene after the gale, the wreck, damaged rigging, the poignant and romantic, was more to his taste. Perhaps he had too many traumatic recollections of real gales in his sea-going days.

In October 1838 a group of Whitby residents, undoubtedly encouraged by Watkins, initiated an effort to have Chambers appointed Marine Painter to HM Queen Victoria, the new sovereign. The chosen route was through the Marquis of Normanby (1797-1863), the son of Lord Mulgrave (see page 127). He had succeeded his father in 1831, was appointed Lord Lieutenant of Ireland in 1835 and raised to the Marquisate in 1838. Lord Normanby was thus now the head of the Phipps family, Lords Mulgrave, of Mulgrave Castle, under whose aristocratic influence Whitby came. The Memorial forwarded by the Marquis to the Lord Chamberlain, read:

> To the Queen's most gracious Majesty.
> May it please your Majesty, – We the undersigned inhabitants of Whitby, in Yorkshire, humbly entreat your Majesty, graciously to patronise George Chambers, Esq., Marine Artist. The appointment of 'Marine Painter to Her Majesty', or any other mark of your royal favour, which your Majesty may be best pleased to confer, will be thankfully acknowledged with every sentiment of duty and gratitude, by us, your Majesty's loyal subjects, as well as by him.
>
> Mr. Chambers is a native of Whitby, now residing at No.7, Percy Street, Rathbone Place, London. From humble origin, by no other means than his merits he attained such public estimation, that your Majesty's Kingly predecessor, and his Queen consort, were both graciously pleased, personally, to bespeak a pair of subjects from his pencil. He has painted many pictures for titled and talented gentlemen, and two of his productions are to be seen in the celebrated Painted Hall, at Greenwich Hospital. He has lately been commissioned to paint a third.
>
> We, the inhabitants of Whitby, having a high sense of the honour which his genius confers upon his country, as well as upon his native town, would be extremely gratified to hear that our beloved Sovereign had conferred some mark of honour upon him. That your Majesty may long live to be the munificent patron of English merit and the arts, and reign over a free and devoted people, is the ardent wish of,
> > May it please your Majesty,
> > > Your Majesty's Loyal Subjects,

There followed a list of fifty-three signatories. John Taylerson, a young surgeon and pamphleteer, was the person charged with collecting the names and carrying on the correspondence.

In spite of various reminders to the Marquis and hopefulness on the grounds also that his wife was Lady-in-Waiting to the Queen, no reply had been received by April 1839. Watkins, aggrieved, noted in a letter to Chambers on 11 April that the Memorial had been mentioned to the Marquis when he visited Yorkshire

and he promised to look after it. Another Memorial, on the subject of making Whitby a bonding port, was entrusted to him, and he soon got that favourably settled.

Chambers in reply advised Watkins not to write to the Marquis again (see page 167) and the matter lapsed. J.C. Schetky, who had been Marine Painter to William IV, was reappointed to that role in 1844. On his death in 1874, Queen Victoria appointed Oswald Walters Brierly (1817-1894) in his place. Brierly was knighted in 1885.

Watkins continually endeavoured to obtain a major commission for Chambers from Whitby but without success. Even a scheme for Chambers to send a painting for display in a shop window, in the hope of finding a purchaser, seems to have come to nothing. It appears from the correspondence that although Watkins came from a family of ship-owners which was therefore, one assumes, reasonably wealthy, he did not himself possess the means to purchase a picture for display in or presentation to the town.

The confirmation of attributions of work to Chambers can sometimes be difficult. He usually signed and dated important oils and watercolours but there are exceptions, as, on occasion, when drawings were to be taken from the original for print production. His customary signature is illustrated in Colour Plate 48a. When he signed watercolours it was in a similar form in watercolour (Colour Plate 48b). Occasional instances occur of a signature or inscription in pencil or ink on watercolours. Some of these may have been in Chambers' own hand but others seem to have been added by another hand. With the large number of drawings and sketches made available by the studio sale after his death, there may be cases where an inscription made as a record is genuine. Other such attributions may be less reliable. Considerations of style and technique are therefore the main determinants.

The situation is complicated by George Chambers, Junior, the elder son, who became a painter of some note, exhibiting at the Royal Academy and elsewhere between 1848 and 1862 (see Epilogue). He frequently used a signature very similar to his father's, which might indeed often be judged an imitation of it. Since he also sometimes painted subjects with which his father had been successful, or copied them, the difficulty is increased. Furthermore, George Junior quite often failed to add a date after his signature or painted an illegible one. The different technique of the two painters, however, usually makes a distinction possible. George Junior's paintings were usually larger and his handling of paint more free, the attention to detail and figures being less rigorous. His watercolours can be of sufficient quality to be confused with those of his father, but subject matter or other non-stylistic criteria usually provide the key.

Chapter 15

'NOBODY'S PAINTER BUT NATURE'S' 1839

Early in 1839 'Rotterdam' was exhibited at the British Institution (No. 413, Colour Plate 49). This oil, now in the Pannett Art Gallery, Whitby, is a more conventional image of a busy port. The interest of people in the foreground is maintained and the solid mass of tightly-packed boats behind is relieved by the lighter buildings and church tower on the skyline. The formation of the clouds complements the strong diagonal recession in the harbour, reminiscent of the Capture of Portobello (Colour Plate 36), leading the eye to the distant sun-lit bridge.

Writing to Watkins a few months later, in April, Chambers says:

> I have nothing in the Academy this year, but have been very successful in the Water-colour Gallery. My drawing – A Broadstairs anchorboat, going off – is hung as the centre drawing, and has been very highly spoken of. Mr. Harding bought it before the private view, which is a great honour; but in spite of all, I do not find the encouragement that I strive for. Artists are all alike for that. There is no selling a picture but through dealers.

James Duffield Harding (1798-1863) was a precocious and prolific artist during Chambers' lifetime. He was a traveller and produced drawings of views, such as

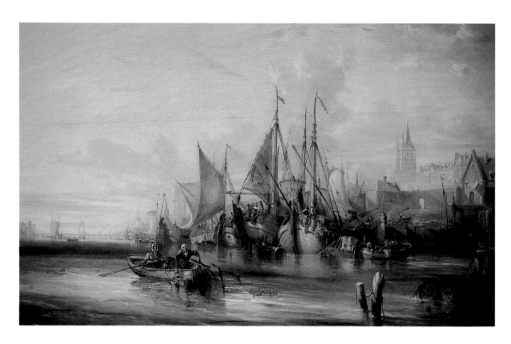

Colour Plate 49. Rotterdam Harbour. Oil on canvas 30 x 45in. (76 x 114cm). Signed and dated 1839. A major exhibition work, resulting from the artist's first visit to Holland, hung at the British Institution in 1839. Although a more conventional harbour view, Chambers has succeeded in keeping the composition open by strong recession in line and colour to the distant bridge in the left background.
Pannett Art Gallery, Whitby

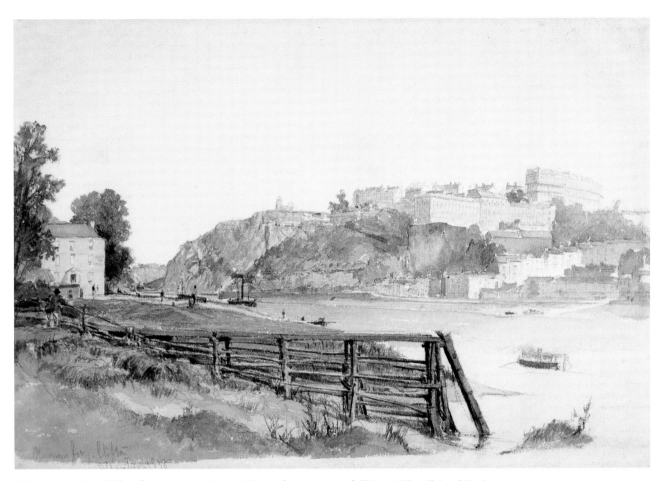

Colour Plate 50. Clifton from Rownam Ferry. Watercolour over pencil 9½ x 14½in. (24 x 37cm). Signed and dated 1838 and inscribed Rownam Ferry, Clifton. A popular viewpoint which contrasts the Avon Gorge and Clifton terraces with the pastoral river bank.

his *Sketches at Home and Abroad,* published by Tilt in 1836, of which Chambers owned a copy at the time of this death (Appendix 3). Copies of this book to the value of £3,000 were reportedly sold within four days of its publication, which explains the contemporary interest in such enterprises. Apart from watercolours Harding was a busy lithographer, engraving Bonington's works for James Carpenter's edition published in 1829-30, of which Chambers also had a copy. A member of the OWS and of Chambers' wider circle, even if not a close friend, Harding was influential among his contemporaries and advised Sydney Cooper to resist Carpenter's blandishments to paint a series of pictures for him (see page 94). Always a teacher, Harding also produced a series of instructional drawing books.

Chambers continued:

I have been at Liverpool since Christmas to take a view of it to publish. I shall go to finish it on the spot about the first week next month. I should not advise you to write to the Marquis any more – we must never depend on great men's promises. I hope the time will come – once make a hit, then no thanks to them. I expect to have a large lithograph finished in about a week or two. If it turns out well I will send you a copy – it is Stranded Shipping. You will think I have quite forgot your little picture. I shall be a large one in your debt, for the trouble you take in my interest.

Chambers' original watercolour for 'Stranded Shipping', dated 1838, and a

Plate 79. Stranded Shipping. Lithograph by W. Gauci after George Chambers 12½ x 19½in. (31 x 49cm). The original watercolour for this dominating example of Chambers' concern with space and tone is also in the Victoria and Albert Museum. The customary viewer's perspective enhances the bulk of both wreck and rocks. Courtesy of the Trustees of the V&A

lithograph print of it, are both in the Victoria and Albert Museum (Plate 79). It is an imposing work. The wrecked hull is an intimidating monolith dominating the viewer and diminishing the men at its foot who are hauling flotsam from the sea. The rocks which balance the composition left of centre are an eloquent tribute to Chambers' protracted studies on his trips to the North Yorkshire coast. The distant view of ships at sea eases the tension by taking the eye to the horizon but, at the same time, emphasises the ambivalence of the sea: storm and calm. It is a powerful image which transfers with equal force from the watercolour to the lithograph. William Daniell's 'Wreck of an Indiaman', of which Chambers possessed an image (see page 183), may well have been his inspiration for this work.

The print at the V & A has no lettering and could have been produced, as Chambers expected, in 1839. However, a magnificent full-size print, heightened in facsimile with white, complete with lettering, at the British Museum appears to be from the same block. This is No. 7 of a series of *Landscapes by Eminent English Artists,* drawn on stone by W. Gauci, published by E. Gambart and Co. in 1852 (Appendix 4). This edition could have used an earlier block but as it was drawn by W. Gauci, Paul's brother, it seems more likely that it was a fresh production for the 1852 series.

Besides the Broadstairs anchorboat (No. 337), Chambers had six drawings at the OWS in 1839 (Appendix 2). Among them was 'Grace Darling and her Father going out the Wreck' (No. 225). It was unnecessary to give more detail in the title, as the heroic rescue of survivors from the new steam packet *Forfarshire* on 7 September 1838 by the Keeper of the Longstone lighthouse and his daughter was already famous. The event immediately became headline news and the family was besieged by artists wishing to paint Grace's portrait and the scene of the wreck on the Farne Islands off the coast of Northumberland. Chambers would not have been among them for he could well envisage the location and the circumstances of the drama, but the level of public interest was such that he clearly could not resist producing a version of his own.

'Clifton from Rownam Ferry' (No. 2, Colour Plate 50), was another exhibit. A traveller's topographical view, this was probably a product of his journey to the West Country the previous summer. It chooses a favourite viewpoint, previously used, for example, by Francis Danby (1793-1861) in about 1821, and by J.B.

Pyne, which combines the foreground meadows and the sweep of the Avon at Hotwells with the Gorge, high slopes and towering terraces of Clifton behind. The abutments for I.K. Brunel's suspension bridge had been started but the span had not yet been thrown across the Gorge.

'Marines going off to an Indiaman – Northfleet' (No. 109) was a subject which Chambers used several times and was later copied by his son, George. Colour Plate 51 is reproduced from a drawing in the Ferens Art Gallery, Hull and there are similar versions in the Paul Mellon Collection and the V & A (Colour Plate 52). The shipping at anchor gives Chambers the opportunity to demonstrate his ability to catch the feel of wind and water. The open boat taking off the Marines, whose tunics allow him to put his characteristic touch of red in the foreground, provide human interest and associate the viewer with the emotional tension of departure. It was a compositional formula he used frequently. Northfleet is not strongly depicted. The message of the picture is the timelessness of the scene and the situation. A picture with the same title was shown at the British Institution in 1840 but it is not clear whether it was one of these or another version.

Also at the OWS was 'Dutch Passage Boat Crossing the Maas, Holland' (No. 324). A picture with this title had been submitted to the Royal Academy this year but had not been accepted.

> It is well for artists that a taste for the arts is extending itself through the country as well as in town – that there are exhibitions of paintings in Liverpool, Birmingham, Newcastle, Glasgow, &c., as well as in London. Chambers received circulars from all the country associations, inviting him to send pictures for exhibition – he complied with several – the carriage of his pictures was paid, and the pictures themselves sold. The picture rejected by the Royal Academicians was sent to the Manchester exhibition, and, was declared the best marine painting there. Chambers was rewarded by a prize of twenty guineas, and honoured by a present of the Heywood silver medal.

The picture hung at the Royal Manchester Institution Annual Exhibition of Modern Artists (No. 108) was in oil, which suggests that the watercolour at the OWS may have been a study from which the oil was developed for submission to the Academy. Chambers sent a second painting to Manchester, 'Off the Isle of Wight', which was hung in the same exhibition (No. 159).

Watkins described 'Dutch passage boat crossing the Maas' thus:

> the sail flapping in the wind, and the waters slapping the sides of the boat – a thing of life and motion.

Signed and dated 1839 is an oil, 'A Dutch boeier in a fresh breeze' (Colour Plate 53), at the National Maritime Museum, which could be the painting in question, having lost its original title. It is a substantial exhibition work of outstanding directness and vitality and would have merited the accolades it received. The composition is simple and open, the subdued radiance of the pigments concentrating on the sense of movement from the wind. The placing of the boeier close to the picture plane takes the viewer directly into the activity on board and the exhilaration of the stiff breeze.

Closer study of the painting reveals some elements of Chambers' technique. The underpainting is a warm pink or biscuit colour, somewhat similar to the light brown grounds favoured by the Dutch painters. Chambers used a fluid, buttery consistency of paint which was applied on open areas with a wide, fat, stiff brush

Colour Plate 51. Marines going off to an Indiaman – Northfleet. Watercolour 8½ x 13in. (22 x 32cm). Signed and dated 1839. The uniforms of the Marines provide the foreground touch of red which the artist liked so much. The work catches the poignant emotion of departure as the skiff rows out to the waiting ship.
Ferens Art Gallery, City of Kingston upon Hull

Colour Plate 52. Seascape. Watercolour 8 x 10½ in. (20 x 27cm). Another version of a frequent sight on the Thames, handled with feeling and delicacy.
Courtesy of the Trustees of the V&A

in strong strokes creating tones and forms. One result was accentuated brush strokes in which grime could accumulate over time. White was applied where needed and quite heavy impasto in dense areas such as the wave breaking on the bow. This has become less evident with the surface smoothing caused by the process of re-lining the canvas. The figures are deftly painted with a few assured strokes of a finer brush, including touches of red to enliven the clothing. Several 'pentimenti' are apparent where Chambers changed his mind, as he often did. A painted-out hat over the bow-sprit is an example. The shoreline in the background was painted before the boat on the left-hand side and is seen to run through the hull and figures on board.

One wonders whether it was Chambers' visit to Liverpool at the beginning of the year which prompted him to send the rejected picture to Manchester, a

Colour Plate 53. Dutch boeier in a fresh breeze. Oil on canvas 35 x 52in. (89 x 132cm). Signed and dated 1839. Probably the painting rejected by the Royal Academy which was then sent to Manchester, where it won the Heywood silver medal and a prize of twenty guineas.
National Maritime Museum, London

neighbouring city with, perhaps, a convenient submission date for its exhibition.

Family affairs rarely figure in Chambers' letters, or at least in Watkins' quotations from them. On 6 April 1839 Mary Ann had produced a sister for the three boys. She was baptised at St. Pancras Church on 6 May and given the names Emily Gooding Harriet Rossetta Hamerton. Her parents' penchant for original and eclectic first names seems here to have been carried to excess. Gooding was after Chambers' pupil and friend with whom he had toured in Holland in 1837 and sailed on the Thames. Otherwise there is no immediate explanation for the names chosen, unless the Rosetta stone, discovered in 1799 and still a source of much interest, suggested an appealing name. The choice of names leaves the impression that there was a certain affectation or flamboyance about George or, quite possibly, his wife.

Chambers returned to Liverpool in June in order to finish the picture of that city. While there he wrote to his wife on 25 June 1839. The manuscript letter has survived.[1]

Dear Wife,
I hope this will find you all well. you would have heard from me before only waited to see how I got on with the picture. I have got a room over in chesshire, and hope to get the picture finished in two or three days. I have had a letter from Mr. Jas. Harris he will leave swansea this day week for London and stop a day or two in Bristol. I hope to return myself by that time if I am not dissapointed by getting pay for the picture. wright and let me know if Mr. Edwards ever called, in my hurry I came away without the leather waistcoat if I do not get cold & reumatism should I make any stay I would have it sent. Mr. Henry Watkeys is going to Holland with Mr. Harris they will come to town together I expect it will not suit me very well to go yet on acount of the Exhibition. wright per return and let me know how you have arranged about the rooms hope George an William are good Boys give a kiss to my Dear Edwin & Baby and Believe me to remain your affectionate Husband
G.Chambers
p.s. I have not wrighten to Mr. Crawford's until I get pay from the Picture, he said he would try to come while I was here you must manage has well as you can for a bit until I get Back I will not forget you want some new Dresses and will bring you a present if I see anything to please me
40 Duncan Street, St. James, Liverpool

1 Anderdon Collection 1838, British Museum

171

In spite of this second visit, the Liverpool picture seems to have had a protracted history. The engraving was apparently still unfinished at the time of Chambers' death over a year later. Watkins' letter on behalf of his widow to thank Clarkson Stanfield for promising to correct a proof is dated 22 February 1841 and still only expected the proof to be ready in five weeks' time (see page 186). The delay could, of course, have been due to any number of reasons, Chambers' ill-health and delay in the engraving being only two. Engraved by James Carter, it was finally published by Thomas Hague on 1 December 1841 (Plate 80). The print is an impressive work in both scale and detail. The subject and composition appear to relate back to 'Emigrants going off to an American Ship, Rock Fort, Liverpool' of 1835 (see page 98), exhibited at the British Institution that year. That also was a large picture, frame size 48 x 60 inches (122 x 152.5cm), and evidently depicted a similar scene. In the picture for Hague the foreground boat is pulling away from the American vessel rather than towards it. The background Liverpool shoreline is portrayed with detailed accuracy as one would expect since Chambers had taken a room across the Mersey for that purpose.

It is curious that, since Chambers made two visits to Liverpool expressly to paint the scene, he should apparently have come out with a formula so close to that of the earlier painting, which itself suggests a previous visit. The former work may have been so successful that he felt he would be safer to retain a similar structure. It is equally possible that while there he felt the local influence of the Walters. Liverpool and the Mersey were at this time very much the preserve of Miles Walters (1773-1855) and his son Samuel (1811-1882) who both painted a wide range of ships' portraits against the background of the city's waterfront and other locations on the Mersey. Influenced by W.J. Huggins, whose marine paintings were being reproduced as aquatints, they were talented painters and Samuel in particular achieved significant success with his accomplished portrayal of a broad spectrum of nautical incidents on the busy river and its approaches.[2] Indeed, with such local talent available it says much for Chambers' national standing that Hague considered it worth bringing him from London.

The tour Chambers made in Holland early in 1837 had provided him with an ample supply of material upon which he was able to draw for paintings produced and exhibited in 1837, 1838 and 1839. These had been some of his most successful works at exhibition.

It seems from the letter quoted above that James Harris had written to Chambers to propose that they should undertake a tour in the summer of 1839, in company with Mr. Henry Watkeys, whose identity has not been established. Chambers liked Holland and would have been eager to replenish his stock of sketches from nature. The proposal would have been particularly appealing if he were to receive payment for lessons and have his expenses covered. It is not clear which Exhibition he feared would conflict with the timing since all the major London shows had already opened and the picture sent to Manchester had been prepared earlier for the Royal Academy. At all events, Chambers was in southern Holland in the late summer and it seems safe to assume, therefore, that Harris and Watkeys accompanied him with, perhaps, also other companions.

Watkins recorded that Chambers

was at home in Holland. Nature was his Academy, he was nobody's painter but nature's.

2 Davidson. Samuel Walters

He was as busy as ever during the tour and assembled another portfolio of Dutch

Plate 80. The Port of Liverpool taken from Seacombe, Cheshire Dedicated with Permission to H.R.H. Prince Albert K.G. Engraving by James Carter after George Chambers 1841. Plate size 19 x 33in. (47.5 x 83.5cm). Chambers was commissioned by Thomas Hague, the publisher, to go to Liverpool in order to make the original for the print. He rented a room on the Cheshire shore of the Mersey to ensure that he depicted the opposite shoreline accurately. A letter written to his wife while there has survived and is reproduced on page 171. National Maritime Museum, London

sketches. When he returned to London these stood him in good stead for the 1840 exhibitions for which, in the event, he was to have little opportunity to prepare.

The anguish of Chambers' own unremitting struggle against ill-health was aggravated towards the end of the year when he and his wife suffered the sadness of the loss of their third son, Edwin, at the age of two years and six months. He died on 22 October 1839 of whooping cough at 26 Percy Street. Chambers had referred to arrangements about their rooms in his letter to his wife. In the autumn they moved across the road from No. 7 to No. 26. The house no longer exists, having given way to a modern block fronting the Tottenham Court Road.

John Watkins, who was a liberal or radical, depending on the point of view, had been supporting the Chartists, giving public lectures drawing attention to the plight of the working classes. For this he was imprisoned but, on coming to trial, was released with, it may be added, the help of the Marquis of Normanby. Chambers wrote to him in late 1839:

> I have been very uneasy about you, hearing that you had got into trouble about the Chartists. I hope you have got it all settled. I did not think you would be so foolish as to have anything to do with them.

Chambers' own politics were very moderate, being

> guided by his personal feelings in favour of the tories, who are better patrons of art than the whigs. Yet he mixed himself up with neither party, and left London during a contested election that he might escape being canvassed for his vote.

The artist was always willing to help his friends with art-work.

> Lord Byron was indignant at the supposition that he wrote poetry to puff Warren's jet blacking – Chambers disdained not to make a sketch of his friend West the optician's house, in Fleet-street, just as it appeared when bedecked in honour of her Majesty's visit to the city; and he did a little drawing of St. James's Stairs, for the corner of Crawford's bills. I remember hearing him say, that a candlestick would make a good picture – and, in illustration of the art of colouring, he observed that though the colour of brass was yellow, not a particle of yellow would be used in painting a brass candlestick – black and white would picture it more truly.

LAST MONTHS 1840

For the earliest of the London exhibitions, which opened at the British Institution on 3 February 1840, Chambers drew for material on his recent visit to Holland. Two of his three paintings were of Scheveling (now Scheveningen) beach on the Dutch coast near The Hague (Appendix 2). The flat North Sea beaches and the long breaking waves had always attracted Dutch painters and became a favourite site for visiting artists. Watkins described one of these paintings, owned by Dr. Roupell, which was later lithographed by Gauci. It is probably 'Scheveling beach at flood tide' (No. 240), referred to in the *Literary Gazette* as 'an admirable specimen of coast scenery'. The larger of the two, it measured 34 x 60 inches (86 x 152.5cm.) frame size.

Colour Plate 54. Amsterdam. Watercolour 10 x 13½in. (24 x 34cm). Signed and dated 1839 and inscribed Amsterdam. This may be the work exhibited at the Old Water-colour Society's show in 1840 and purchased by W.L. Leitch with his Art-Union prize. It is a scene which Chambers and his companions would have witnessed frequently during their sketching trips outside Amsterdam, rendered with quiet restraint of colour and sentiment. Trustees of the British Museum

Colour Plate 55. Dordrecht from the River. Watercolour 4¾ x 14in. (12 x 35cm). This was a popular stopping place for artist-travellers in the Low Countries. The wide landscape format of the drawing responds well to the expansive views over the flat Dutch countryside.

Dutch fishing boats are stranded amid the surf that tumbles on the sands, where the crews, men and women, are engaged in their rough toils. Nothing is more difficult than to paint a wave: not as in the poet's line, where it

> Heaves like a long swept wave about to break,
> And in the curl hangs pausing;

But where it is actually broken and dashing up; yet Chambers has achieved this: how successfully, the patrons of the art will have an opportunity of judging when they see the lithograph.

No image either of the original or lithograph has been traced but well-known paintings of a similar scene by J.M.W. Turner 'A Coast Scene with Fishermen hauling a Boat Ashore' (The Iveagh Bequest, Kenwood) and E.W. Cooke, who had also first visited Holland in 1837, probably give a good idea of Chambers' pictures. The latter is entitled 'Beaching a Pink in heavy weather at Scheveningen' and is in the National Maritime Museum, Greenwich.

The third painting at the British Institution was 'Marines going off to an Indiaman – Northfleet' (No. 307). It is not clear if this was the same work as that shown at the OWS the previous year (Colour Plate 51), where it was, apparently, unsold, or another version. The outside dimensions of the frame, 28 x 38 inches (71x 96.5cm), were sufficient to contain the watercolour if it was the same. The short period before this early exhibition could have prompted Chambers to submit the picture to a second show.

On 28 March 1840 George Chambers wrote to John Watkins:

Dear Friend,
I am very glad to be able to write you once again. I must tell you I have had a very severe fit of illness. Have been confined to my room nearly four weeks; but, thank God, feel myself fast recovering. It has entirely put a stop to my getting ready for exhibitions this year. I received yours, dated Jan. 24th., with the etching and the brooch for Mrs. C. which was all in pieces. I do not like your portrait ; but think Weatherill would soon be very clever at etching if he kept to it. There are sad disasters at Mr. Pyne's – he is in the Queen's Bench — everything seized — he had better never have known such friends as we met the night you and I were there. He has been in the Bench four or five weeks. Cooper is going sadly off. Manufacturing pictures will not last long. Do write and let me know if you have got over your chartist troubles. I am

Plate 81. The Dover Pilot-boat in a rough sea. Watercolour over pencil 20 x 27½in. (50.5 x 70cm). Queen Dowager Adelaide bought a watercolour of similar title at the OWS exhibition in 1840 which could have been this one. It is a powerful example of the artist's developed style of sea painting but very different from the calm beach scene she had commissioned from him nine years earlier (Colour Plate 15).
National Gallery of Ireland

very anxious to hear. I have some notion of a call at Whitby before long. My doctors say I must get out of town as soon as well enough. Indeed, I am determined to be as much by the waterside this summer as possible.

It is impossible to study marine subjects living in London. I think of a voyage down to Stockton or Shields with some of my friends, among the collier captains – if so, will return by the way of Whitby, and hope to have the pleasure of seeing you. Give my respects to all enquiring friends, and believe me to remain,

Yours ever truly,
G. Chambers.

Excuse this hasty scrawl, and do write as soon as possible. We do not make much use of the cheap postage. Mrs. C.'s kind respects.

The brooch mentioned in the letter was of jet, a typical local product of Whitby, which, being black, was used in ornaments of mourning. Watkins had sent it to Mrs. Chambers on the death of her son, Edwin, at the end of the previous year. Replying on 1 April., Watkins says 'My kind respects to Mrs. C., if the jet brooch was broken, it is a sign that she is not to wear mourning long'. These cheerful words of comfort were sadly not to be justified by the events which befell the family within a few more months.

In spite of his renewed attack of illness Chambers assembled five paintings for the OWS which opened on 27 April (Appendix 2). 'German Reapers leaving Amsterdam for the different towns in Waterland – Evening' (No. 90) was chosen by W.L. Leitch for purchase with his Art-Union prize. A watercolour signed and dated 1839 and inscribed 'Amsterdam', now in the British Museum, is probably this picture (Colour Plate 54). It is a portrayal of the sight Chambers would have witnessed, perhaps with Chisholm-Gooden, on his visits to Holland and captures the scene with atmosphere and feeling.

The Art-Union of London, started in 1837, was a monthly arts magazine supported by subscribers. Its purpose was to encourage the arts as well as to provide news about art and artists. Each year therefore a ballot was held and monetary prizes allotted to winning subscribers, whose participation was in relation to the level of their subscription. In 1840, the forty-three prizes ranged in

*Plate 82. Ships at Anchor in
the Downs riding out a Gale.
Watercolour over pencil
10 x 15in. (24.5 x 39cm).
Chambers' delight in capturing
the movement of ships and the
sea is evident, handled at speed
with sure skill.*
The Royal Watercolour Society
Diploma Collection, housed at the
British Museum

value from one for £200 to ten for £10 and totalled £1,400. They were to be applied by the prize-winner to the purchase of a work of art from a current exhibition. Leitch's prize was of £25 and he paid £26.5.0. for Chambers' watercolour. This was a typical gesture of generosity and support by Leitch who had long been a friend and admirer of Chambers and who was to be helpful to his widow after the artist's death. The Art-Union was to carry a notice of Chambers' death in its November 1840 number and an obituary in the December issue

A watercolour sketch, also in the British Museum, may have been a preliminary drawing for 'Dutch River Scene, near Dort' (No. 179) at the same exhibition (Colour Plate 55).

The Queen Dowager's purchase of 'Dover Pilot-Lugger returning to Harbour' at the OWS exhibition has been mentioned earlier (see page 85). The painting has not been traced and the price paid is unknown, since the OWS Sales books for 1838 and 1840, among others, are missing. Queen Adelaide's accounts in the Royal Archives show a payment of £5.0.0 to a Mr. Chambers on 1 May 1840.[1] On the assumption that this was George, the amount is likely to have been for the frame and glass, the painting perhaps having been paid for previously. A watercolour of a similar subject is at the National Gallery of Ireland, 'The Dover Pilot Boat in a rough sea' (Plate 81). This demonstrates Chambers' customary mastery of movement and light and if Queen Adelaide's was similar, its appeal is understandable. Perhaps she remembered the artist, his Windsor visit over eight years before and his painting of Dover for her (Colour Plate 15). But this is a very different scene. The calm sea-side view has been replaced by Chambers' developed style of sea painting.

The report on the OWS show in the 'The Athenaeum' on 2 May was critical of most exhibits but concluded:

> One word in praise of certain marine drawings by Mr. Chambers, which, save for a monotonous chillness of temperature, would be excellent – and our notice of the Thirty-sixth Exhibition of this prosperous Society is closed.

Showing some of the same qualities as those of the Queen's drawing is another in the collection of the Trustees of the Royal Society of Painters in Water-Colours entitled 'Ships at Anchor in the Downs' (Plate 82). It does not appear to have been exhibited and it is not known how it came into the permanent collection of the Society.

The artist wrote to Watkins on 30 May 1840, to say:

1 in litt. Royal Archives –
author 21 April 1994

You must have expected me at Whitby before this, from what I said in my last to you. The reason is my health. I have been to Ramsgate; and have returned no better. My doctor wishes me to take a voyage up the Mediterranean. I should like to see you, and if the weather keep fine and you are at Whitby, to come down for a week or so by way of recreation. I am not well enough to sketch. I will get you to take a lodging for me, as I should like to be near the water. Is Cockburn at Whitby yet? Write per return, and let me know what you are doing, and if I stand a chance of having your company if I get so far. Give my kind respects to all enquiring friends. I will give you all news if I get to see you, although I cannot talk much, having nearly lost my voice for the last two months. I have been very successful with my drawings this year, and am glad to tell the Queen Dowager bought one, (a view of Dover, with pilot lugger).

Watkins wrote of this period, Chambers' last summer:

Ill-health and anxieties were gathering faster and thicker over Chambers, glooming his brow and clouding his genius. It was observed that his style of painting was becoming heavy and hard – there was not that clearness of atmosphere, that light expansive distance, which characterised his happier efforts. His hand was losing its cunning in the magic of colours. Too much of a grey tone pervaded his pictures. He was conscious of this, and saw the necessity of getting more out to nature. But alas! the cloud of death was appearing above the horizon – it was as yet small, indeed, as a man's hand, but was gradually rising, and was soon to overwhelm the sky with black pall. I have heard Chambers say that he painted best under distress of mind – doubtless difficulties whetted his genius, but then they were not so immoderate as to overpower it. Now mind and body were yielding together. He used to complain that the friends of his more successful days had forsaken him – 'but,' said he, 'only let me get better, and make another hit, and I shall bring them all round me again.'

He went to Ramsgate to be near the sea-side, for sake of health and fresh sketches. One was as eagerly sought as the other; But his voice was now hoarse as if with cold, and his arm too weak to hold his palette.

He returned, and his kind friend Gauci who went to see him was so shocked at his altered appearance, which plainly indicated the hand of death, that he fainted. Chambers resorted to his old friend Crawford, his counsellor, and his banker. With tears in his eyes, he said, 'I am afraid my serious indisposition will bring me and my family to live in a garret. All going out, and nothing coming in. I am almost reduced to poverty.' 'Never mind,' said Crawford, 'make yourself comfortable on that head – it shall never be the case, as long as I can hold my head above water.' 'I am advised to go up the Mediterranean,' said Chambers, 'but should I die on the voyage, what will become of my wife and family?' 'Do not give them a thought,' said Crawford, 'leave all that to my management, only you make preparation for the voyage.' 'But I have not the means,' said Chambers. 'That's my look out,' said Crawford, 'only promise to go and I will arrange all for your passage.' 'Well, please God, then, I'll make the attempt.'

In the event it was to Madeira that Chambers went to seek restoration of his health in a sea voyage and a warmer climate. This may have been the first con- venient ship Crawford could find and the shorter passage may have seemed more suitable than a trip into the Mediterranean. Chambers boarded the *Dart* packet, Captain Airth, at Gravesend and they dropped down the Thames, setting sail for Madeira from Deal on 20 June, having a fine run out.

Whenever he was able to sit on deck, Chambers occupied his time in sketching, and when he went below it was to make coloured drawings from his pencil sketches. In

Plate 83. The Dart. Lithograph by Augustus Butler after George Chambers reproduced in John Watkins' Life of George Chambers 1841. From a sketch made by the artist on his voyage to Madeira just before his death. The authenticity of the vessel's motion prompted a mariner to observe: 'Now she'll roll after that'.

this manner he executed a most beautiful sunset at sea — the level rays from the red luminary dancing across the waves in one gorgeous path of beauty, reminding us of the lines of Moore:-

> 'And we can almost think we gaze
> Through golden vistas into heaven'.

This romantically beautiful drawing is now in the possession of Dr. Roupell. Chambers likewise made a most spirited drawing of the packet in which he sailed, just as she performed the passage [Plate 83]. She is represented in full sail before the wind, running upon the top of a sea; and no sailor that looks at the picture but can fancy himself on board. 'Now she'll roll after that,' said one. The porpoises are playing like dolphins in the water, and a distant vessel — a cloud — a speck — will shortly fade into air.

When Chambers arrived at Madeira, he delivered letters of recommendation, and was well received by the principal merchants in the Island. He took sketches, with the intent of painting a large picture, and the last work of his hands was on this subject. [Lot 135 at the sale was 'Slight sketches of Madeira — the last picture painted by the Artist'.] He also began a drawing of Mr. Gordon's house, where he had met with much hospitable treatment. Mr. Gordon had commissioned him to paint a picture from this drawing, but he did not live to finish even the drawing, and it was forwarded by his widow to the gentleman who had bespoken it.

Chambers returned with the packet in which he had sailed out, after a stay of only ten days in the Island. In vain was he recommended to give the air of the place a longer trial. He ever felt uneasy when from home — like Sir Walter Scott, at Malta, he missed his own hearth, and yearned for his household gods. He returned, regretted by his friends in the Island, and beloved by the crew of the packet.

The *Dart* was back off Deal on 28 July and at Gravesend the following day. Chambers wrote, on 23 September 1840, what was to be his last letter to Watkins:

My dear Friend,
I have often attempted to write, and still waited to, in hopes to give you a better account of my health. It appears now beyond the power of medicine. Everything has been tried, and still no better. I have had two or three different doctors at a great expense, and I have not been able to touch a pencil since last March. Indeed, since my return from Madeira I have not been able to write a letter. The least movement now almost chokes me. I am to have the first of advice in the course of a day or two — we think Dr. Chambers. My

best friend, Dr. Roupell, thinks my only chance left is a warm climate, and wishes me to go to Malta, which must be decided soon. I know not how it will be done, for I can neither walk nor bear to ride in a carriage. You must excuse me not writing a long letter – it is with the greatest pain I write this. Cooper nor Pyne I never see. Not being able to talk obliges me to keep to myself. Master William has come home from school – he has had the scarlet fever. George and Mrs. C. are well, and send their best respects to you.

I was in hopes to have got to see you this summer – that is now quite impossible. Accept my best thanks for your kind invitation, and believe me to remain,

<div align="center">Yours most sincerely,
G. Chambers</div>

Do write again, and do not be offended at my not answering yours sooner. I wish I was well enough to come and take a country cottage near you. I almost long to live out of London.

Chambers often spoke of moving to the country. He was tempted by an offer of a cottage near Whitby at a rent of £5.10.0 a year.

Dr. Roupell, not more his physician than friend, had always advised him to seek restoration from nature, but Chambers had a kind of superstitious faith in physic; all the more dangerous in him, as his disease could not be ascertained, and, therefore, might be treated, and, in some instances, was so, very wrongly.

But on about 14 October he went to Brighton to seek the benefit of sea air.

The two boys were at the boarding Academy at Southgate; his infant daughter was at nurse.

His physician's advice was thus kindly communicated: -

My dear Chambers,

I am determined to make you well, and feel that while you are exerting the best of your art for me, at least you may claim a corresponding effort of mine.

Sea air, I thought, would have done all we wished, but, if disappointed in our expectations, we must combine with it other resources.

Your diet should be light, and easy of digestion. Toast, without or with very little butter; tea or coffee as best agrees with you, for breakfast. A mutton-chop about two for dinner, with potatoes, if floury; avoid all pastry – for drink, soda-water and a table spoonful of brandy. A very light supper about seven, and a walk afterwards, if fine. The warm bath can do no harm – you will not find the temperature of 98 too hot – it may be repeated three times a week should you feel the benefit – the sea water the best. You may smoke a cigar – the sarsaparilla might be well taken out of soda-water. These instructions will, I trust, be sufficient, but if not, do not hesitate to write, or consider that I have any other feeling than a sincere desire to see you reap the reward of a long and anxious application to your profession.

Do not hurry up to town on mine or on any one else's account, should you find yourself improving. Although you have not yet felt the advantage, that will, I trust, be soon manifest, – Mrs. Chambers and the children at least will be benefitted.

At Brighton,

> he would rest on the sands, and view the scene so familiar to him, expressing his
> rapture at every effect of the changeful atmosphere visible upon the sky and waters.
> Time was, when he could not see a fine sky without an impulse to sketch it, for he
> could make it fit some future subject. He used to call on his wife to bring him his
> colours before the rack had flown and become indistinct as water is in water. His
> sketching books were filled with bits of this description – with directions for the
> various colours – and slight as his stenographic sketches were, his recollections always
> aided him in painting up to the scene as it had appeared.
>
> His wife, now his only companion in his last hours, nursed him with great
> dilligence; rested not, to procure him rest; and endangered her own health to bring
> back his. She read to him to beguile his sickness; and, ever grateful to her for her
> attentions, and desirous to repay them more abundantly, he spoke of the rewards he
> would give her when well again.

None the less, they soon returned to London, to their home at 26 Percy Street.

> Nature relieved the pain of his surcharged heart by the bursting of a vessel, and
> reduced him to still greater weakness, till, at length, on the morning of the 29th of
> October, 1840, having risen from mere restlessness, he said, as he sat in his easy chair,
> 'I am faint,' and died like one falling asleep.
>
> A post mortem examination took place to ascertain the cause of his long disease,
> when it was found that like Sir Thomas Lawrence, he had been the victim of an
> affection of the heart.

The death certificate gives the cause of death as Aneurysm of the Aorta. Modern
medical opinion suggests that Chambers' illness may have been what is now known
as a collagen disease. Identified only within the last fifty years and still not totally
defined, this attacks the connective tissues of the body, affecting their strength and
elasticity and causing inflammation and pain. The manner in which the pain and
incapacity manifested itself intermittently in different parts of the body, the loss of
voice and the patient's increasing difficulty in holding palette and brush, would be
consistent with this diagnosis. In a form of scleroderma, in which the tissues dry up,
it could also account for the skin falling off Chambers' face and his grossly changed
appearance which so shocked Paul Gauci that he fainted. A collagen disease affecting
the tissues around the walls of blood-vessels would also be in conformity with the
post-mortem finding of 'aneurysm of the aorta'.

> In truth he had struggled with much sorrow and difficulty, and disappointment; indeed
> he had suffered much, and though he overcame all, it was not without being vanquished,
> even by his own victories. He was followed to the grave by Mr. Crawford, as chief-
> mourner, and buried in the church-yard of St. James' Chapel, Pentonville, aged 37.
>
> I remember once hearing him say, as we walked past this chapel, that Bonington
> was buried there, and that it was a quiet place. Morland, too, I believe, rests there.
> Chambers sleeps near his little son, Edwin Calcott,
> > 'With not a stone to mark the spot'.

The chapel has now been deconsecrated and is an office. The churchyard has
become a park and playground. The only preserved and cherished tombstone,
against the south wall of the church, is that of J.S. Grimaldi (1778-1837), the famous
clown. The artist George Morland (1763-1804) was buried there together with his
wife, who died only three days after him. Bonington's body had been removed in
June 1837 and reinterred alongside his parents' at Kensal Green Cemetery.

Chapter 17

AFTERMATH 1841 AND POSTERITY

Chambers had been so industrious, even during his last illness, that he left few debts, and a sufficient quantity of sketches, drawings, and pictures to discharge all, and leave a surplus. The most inferior of these, together with his colours and painting materials, should have been selected for sale, but the chief was chosen and the refuse left. It may be urged that the public would not attend a sale, unless attracted by superior articles, but at the sale of Chambers' works, the lowest lots, such as the pencil sketches, fetched comparatively the highest prices. It was unfortunate for the interests of the family that a picture-dealer had the management of the sale, and that picture-dealers reaped the greatest benefit from it. The auction was precipitated with injurious and indecent haste – and the whole proceeds did not amount to a sum equal to the worth of one of the pictures, and what one of them will one day realise.

I did get up to London, however, before the sale took place, and in time to induce Mrs. Chambers to put a reserve bid on several of the best lots, though she had been strongly advised to the contrary. I was glad to hear that her woman's wit had availed her to secure several of the best drawings, and thus she possesses a little stock of her late husband's genuine productions, which are rising in value every day. The sale, which had not been sufficiently advertised, took place in February, instead of in May.

The sale was conducted by Messrs Christie & Manson on 10 February 1841 at their King Street premises (Plate 84). It consisted of 180 lots comprising 693 items. Of these 658 were drawings, sketches and oil paintings, the remainder being studio equipment and material, books and prints (Appendix 3). While Watkins' customary partisanship and views on dealers seem to have coloured his judgement, some of his criticisms of the sale may have been justified. The arrangement of the lots of sketches and drawings appears to have been arbitrary, showing little feeling for the artist's life and work. The impression is given that the subject-matter of each lot was varied so that at least one item might appeal to a potential purchaser. Among the successful bidders listed in Appendix 3, picture dealers, print and book publishers and sellers, indeed, figured largely. They included Allen, Carpenter, Tiffin, Rought, Graves and Ackermann and some others may also have been professionals.

The items in the sale clearly confirm that Chambers was a tireless taker of sketches from nature whenever he had the opportunity and was also painstaking in his preparatory studies for finished works. It is only tantalising that so few of the drawings are identifiable and have been traced.

The artists who comprise the section headed 'Drawings by Various Artists' are largely predictable given Chambers' group of close friends. Indeed, there are perhaps fewer by Pyne and Cooper than one would expect in the light of the exchange of drawings at their evening sessions (see page 115). Lot 118 'A very large drawing by Vandevelde, of a Naval Engagement' is the only explicit reference found during Chambers' life of a regard for his greatest fore-runner. It is likely that this was one of the elder van de Velde's large drawings of battle scenes.

CATALOGUE

OF THE

INTERESTING WORKS

OF

THAT HIGHLY TALENTED ARTIST,

GEORGE CHAMBERS, Esq., Deceased:

Late Member of the Society of Painters in Water-Colours;

Consisting of Works in Oils and Water-Colours; Views in England and on the Continent, representing chiefly those Coast and River-scenes by the delineation of which this Artist attained such distinguished reputation.

ALSO SOME BOOKS OF PRINTS, AND PAINTING MATERIALS.

WHICH

𝔚ill be 𝔖old by 𝔄uction, by

Messrs. CHRISTIE & MANSON,

AT THEIR GREAT ROOM,

8, KING STREET, ST. JAMES'S SQUARE,

On WEDNESDAY, FEBRUARY 10, 1841,

AT ONE O'CLOCK PRECISELY.

The Collection may be viewed two days preceding, and Catalogues had at Messrs. CHRISTIE and MANSON's Offices, *King Street, St. James's Square.*

Plate 84. Title page of Messrs. Christie and Manson sale catalogue for the contents of Chambers' studio, 10 February 1841. Watkins felt that the sale was held with precipitate haste after Chambers' death.

Christie's

Chambers clearly appreciated the importance and value of van de Velde's work. It may have been of specific help to him when working on his naval set-piece paintings such as the battles of Trafalgar and Camperdown.

Among the five lots in another section, 'Pictures by Other Artists', is Lot 145 'Wreck of an Indiaman, by W. Daniell R.A.' William Daniell typically produced aquatints from his own drawings, often in book form, initially of subjects in India and the East and later coastal views of the British Isles. 'The Wreck of the Clarendon, West Indiaman' was published in 1836 as a separate print. The inference of the title of this section is that the pictures were oils, as opposed to the 'drawings' included previously. Chambers may thus have owned Daniell's original

THE LATE GEORGE CHAMBERS.

It is proposed to publish by Subscription, in One Volume, small 8vo., price 7s.,

For the Benefit of the Widow and Children,

SOME ACCOUNT OF THE LIFE AND CAREER

OF

THE LATE MR. GEORGE CHAMBERS,

Marine Artist,

MEMBER OF THE SOCIETY OF PAINTERS IN WATER COLOURS;

WITH A PORTRAIT.

BY A FRIEND.

"As with many Professors of Art and Literature, the sunshine of life was either too brief, or came too late, to enable Mr. CHAMBERS to make provision against the day of rain. Death overtook him when the most wearisome part of a toilsome journey was passed; but too soon to have permitted him to taste the luxury of repose after labour, still less to enjoy the happy consciousness that those who depended upon his exertions for ease and comfort, were secured them after he was gone."—*Art-Union.*

All who feel interest in the struggles of genius, and who can sympathize with the sorrows of a bereaved Family, unprovided for, are respectfully invited to send their Names to the following Publishers :—

Messrs. How and PARSONS, Publishers of "The Art-Union," 132, Fleet Street;
Messrs. ACKERMANN and Co., 96, Strand;
Mr. CARPENTER, Old Bond Street;
Messrs. D. COLNAGHI and Co., 14, Pall Mall East;
Messrs. COLNAGHI and PUCKLE, Cockspur Street;
Messrs. HODGSON and GRAVES, Pall Mall;
Mr. MOON, Threadneedle Street.

Plate 85. Publication Notice for Watkins' Life of Chambers. *Art dealers and print publishers joined in sponsoring the book, which was sold for the benefit of Mrs. Chambers and the children.*

'When it was known at the auction that you had kindly lent your eminent pencil to complete it, the picture immediately rose to double the sum it was standing at, although it still was knocked down much below its value. And Mrs. C. feels additionally indebted to you for your great kindness in promising to correct a proof of the engraving of her late lamented husband's picture of Liverpool, which Mr. Carter, the engraver, says will be ready in about five weeks.'

Mr. Locker, of Greenwich Hospital, was solicited on behalf of George, the eldest son, and by virtue of his kind nomination, the boy was admitted into the upper school [of the Royal Hospital School at Greenwich].

Before I conclude this chapter, I must not omit to mention Mr. Gauci's disinterested efforts in behalf of his friend's family. He is at present engaged in lithographing a picture of Scheveling beach, now in the possession of Dr. Roupell, and one of Chambers' most surprising performances [see page 174]. The lithograph will be published for the benefit of the painter's orphans. Chambers had nearly finished an etching of Thames barges in a breeze – his first attempt – this will also be sold, together with other prints and this book, in the hope that a fund may be raised for the permanent support of the artist's widow, who has no expectations nor means of support save what her late husband's talents have furnished.

When John Watkins wrote to Mrs. Chambers on 5 November 1840, immediately after receiving the news of the artist's death, he suggested: 'Should Mr. Carpenter advise it, I could draw up a Memoir of my friend, which might be published for your benefit'. It is interesting to note in passing the deference to Mr. Carpenter's views, in spite of all his recriminations against dealers in general and in particular. Writing again on 21 November, Watkins was anxious to secure the material for the *Memoir:* 'you will take care of the letters and papers of poor Chambers.'

The publication notice for the book (Plate 85) shows Carpenter among the publishers as well as the Colnaghis, the noted art dealers, Ackermann and Hodgson & Graves, publishers of prints, and the Art-Union. The dedication, dated 1 June 1841, was to Christopher Crawford, and the book was published shortly afterwards (Plate 86). Watkins proved a staunch friend of Chambers, as he had been regarded in life by the artist. The *Memoir* is a winning biography in spite of its at times extravagant and virulent partisanship. Augustus Butler provided the lithograph illustrations. These comprised an embellishment of the title page, one of Chambers' early rock studies dated 1831, above a line from Byron: 'Where all

Plate 86. Title Page of Watkins'
*Memoir. Byron's line 'Where all
has foundered that was ever dear' is
the caption to Chambers' drawing
of a wave-swept rock, lithographed
for the book by Augustus Butler.*

Plate 87. Portrait of George Chambers. Lithograph by Augustus Butler reproduced in John Watkins' Memoir.

has foundered that was ever dear' (Plate 86), the reproduction of his sketch of the *Dart* (Plate 83) and a portrait of the artist (Plate 87).

Watkins' conclusion is a fair epitaph:

> Our sailor-artist resembled our sailor-poet, Falconer, in having learnt his art where arts are more likely to be unlearnt. He knew every rope in a ship, and where it should be placed. In viewing one of his vessels we are irresistibly reminded of Byron's description;-
>
> 'She walks the waters like a thing of life.'
>
> We almost expect to see her sail out of the canvas. 'Her fixture has motion in't.' His vessels always sit well – *in* the water – not *on* it – they have hold of the water, and their sails seem swelled with actual wind. The waves appear to be really an undulating liquid – not glass, not ice, far less new-mown hay. The local truth of his views makes them to all purposes of vision the places themselves. In painting buildings he was as skillful as in painting shipping, especially such classic fabrics as St. Paul's Cathedral and Greenwich Hospital.

The *Literary Gazette* of 21 November 1840 concluded a long obituary with a reference to his paintings for the Greenwich Hospital Gallery and the words:

> he will there be handed down to posterity by the nation which will be proud of the young sailor artist.

In the decades following his death, the quality of Chambers' works was acknowledged, even though not accorded a high profile, by their continuing appearance in representative exhibitions. Examples are the Manchester International Exhibition of 1862, the Royal Academy in 1875 and Edinburgh in 1886. Some of these were associated with Royal anniversaries and other celebrations and the works were then added to leading provincial collections. Two watercolours in the Whitworth Art Gallery, Manchester, for example, were purchased in 1887 with a grant from the Guarantors of the Manchester Royal Jubilee Exhibition (Colour Plates 22 and 38) and one in the National Museum of Wales was presented by the 1882 Cardiff Exhibition Committee. Chambers' paintings thus remained to a limited extent in the public view in galleries outside London as well as the permanent display at Greenwich. Many of his commissioned paintings inevitably remained in the private collections for which they were originally intended.

The four principal themes found in Chambers' output, apart from his periods at the Colosseum and Pavilion Theatre, have been reviewed in the course of the narrative. They are the early ships' portraits, waterside views and events, naval engagements and naturalistic sea-pieces. These correspond in some respects to periods of his life but the last and largest group continued throughout his working life. It may be remarked, therefore, that his thematic range was quite limited. At heart he remained a sea painter, committed to the search for perfection in the interpretation of nature as encountered in sea, sky and ships. He ventured into the other areas of marine painting in response to commissions and market demands and brought to them the same sensitivity, originality and painterly skill.

Throughout his works Chambers was restrained in his choice of subject matter and his handling of it. The inherent tensions are understated and the emotional content subdued. It is this restraint, a reflection of his personal reticence, which has hindered a true appraisal of his *oeuvre* and his place in nineteenth century marine painting. He has been overshadowed by contemporaries more flamboyant in both their work and life-style. Yet an unpretentious romantic spirit, expressing itself in a striving for visual truth and purity, pervades all his productions.

Landscape and coastal views were very popular at the time and English artists were among the earliest and best exponents of this form, particularly in watercolours. This was in part a result of the burgeoning vogue for travel, especially in Europe, which followed the ending of the Napoleonic wars. At a rough count Chambers had over fifty contemporaries active in these landscape views, many of them producing travel views for reproduction as prints in the 'Annuals' and other publications which began to flourish in the 1830s. He was himself successful when he ventured into this type of subject-matter. Several painters, such as Augustus Wall Callcott mentioned above, achieved renown as marine painters for their depiction of marine or coastal landscapes. The importance of Bonington in this respect has also been discussed. Few, however, sought to confine themselves to the study and interpretation of ships and the sea and thus merit consideration primarily as sea painters.

Fifty years after Chambers' death, T.S. Cooper wrote:
Then he became better known, and would certainly have made a great name
had he lived. As it is, his name is well enough known; but owing to the
struggles he had to go through to earn a living during the first years of his
artistic career, he had not time to devote himself entirely to the branch of art
for which he was so eminently fitted, and just when his circumstances would
have permitted his more exclusive devotion to the study of sea-painting, he
was taken from us, in the prime of his manhood.[1]

J.M.W. Turner (1775-1851) is usually considered the greatest marine painter of
the epoch. Some of his most magisterial and influential sea paintings were
produced early in his career, such as the Bridgewater sea-piece of 1803 now in
the National Gallery. With exceptional talent and versatility he explored various
areas within the 'genre' and continued until his later most sophisticated dramatic
and atmospheric effects. Marine works were, however, only a part of Turner's
output. Other leading practitioners of the period were: Copley Fielding, Clarkson
Stanfield, E.W. Cooke, J.W. Carmichael and J.C. Schetky, all of whom produced
outstanding and famous marine paintings in the course of their often long lives
and varied thematic output. Among those who concentrated primarily on sea
painting, some, such as Schetky, remained mainly in the more established stylistic
tradition inherited from the van de Veldes. Chambers, with his intense, if
modulated, romantic vision and the consummate skill of his execution, may
worthily be ranked with the other leading artists. By virtue of the quality of the
works in both oil and watercolour, produced as a result of his single-minded
pursuit of perfection, he may be considered pre-eminent.

In the decades following Chambers' death sea painting continued largely in the
mould he had established, concentrating on the interpretation of the sea and its
craft in a naturalistic manner. Painters such as Thomas Sewell Robins (1814-
1880), Henry Redmore (1820-1887) and Thomas Bush Hardy (1842-1897)
remained within a similar thematic range of working vessels and their people in
coastal waters. Others sought to engage the emotion of the viewer more directly
by introducing greater human activity and everyday incident, often on the shore
rather than at sea. Among these were James Clarke Hook R.A. (1819-1907) and
Charles Napier Hemy R.A., R.W.S. (1841-1917) who appealed to the Victorian
taste for sentimental themes and thereby achieved popularity and success. Moving
in the contrary direction, 'pure' sea painters achieved their appeal by seeking to
capture the mood of the sea and sky alone, with only vestigial reference to
shipping. Such were Henry Moore R.A., R.W.S. (1831-1895) and John Brett
A.R.A. (1830-1902). In addition to the work of these artists, marine painting
continued in full flood throughout the nineteenth century, embracing a wide
spectrum from ship portraits through stately events to waterside landscapes in both
oil and watercolour. Chambers' unpretentious development of fundamental
romantic values in all these spheres exercised a continuing influence on stylistic
and thematic evolution during the remaining years of the century.

As Chambers did not during his lifetime attain the high profile of some of his

1 Cooper I pp.222-3

contemporaries, his reputation and his place in nineteenth century painting have tended to be overlooked. The restrained romantic naturalism which Bonington had exemplified, and which Chambers emulated, itself became less appreciated as it was superseded by other modes of painting in the Victorian period. Modern attitudes to art and the reassessment of the contribution of individual artists such as George Chambers should, however, now assure him of an established place in the art history of his period and of British marine painting.

Plate 88. Dutch fisherman. Watercolour over pencil 9 x 6in. (23 x 15cm).
Royal Academy of Arts, London.

EPILOGUE

GEORGE CHAMBERS, JUNIOR (b.1829 fl.1848-62)

It is clear from Watkins' narrative that Chambers' sons were still young when they started to learn the skills of drawing and painting (see page 111). The elder, George William Crawford (b.14 June 1829), inherited his father's talents and became a professional painter.

On his father's death, when George, Junior, was eleven years of age, he entered

Colour Plate 56. Boating on the lake. St. James's Park, looking towards Horse Guards Parade by George Chambers, Junior. Pencil and watercolour heightened with white 14 x 21in. (36 x 53.5cm). Signed and dated 1871. The younger George showed skill comparable with that of his father as a watercolourist, often choosing landscape views such as this rather than seascapes.

Christie's Images

the Greenwich Hospital School on the recommendation of E.H. Locker. His artistic talent developed early, for his first painting accepted by the British Institution, 'A Brig running out of Margate Harbour', was hung at its 1848 exhibition (No. 46) when he was only eighteen. The Royal Academy accepted 'Hatch boat crossing the mouth of the River Thames' (No. 353) two years later and thereafter hung one or two of his paintings almost every year until 1861. He was, therefore, during that decade evidently considered a young painter of talent and promise by the authorities at the Academy. He also exhibited at the Society of British Artists and a total of fifty-four works were shown at these three institutions up to and including 1862. He did not exhibit at the watercolour societies and the inference is therefore that most, if not all, of these works were in oils. With this almost precocious level of immediate success in the major London exhibitions, it is strange that he disappeared so suddenly from view after 1863. At the age of thirty-four he was presumably in the prime of life and creative capacity.

Plate 89. Shipping off Whitby by George Chambers, Junior. Oil on canvas 33 x 60in. (84 x 154cm). Signed and dated 1874. George, Junior's technique in oil painting was looser than his father's, using a more fluid medium, with the result that his work lacked the same freshness and clarity.
Pannett Art Gallery, Whitby

Plate 90. Outside the Mansion House, London by George Chambers, Junior. Pencil with grey wash and bodycolour 9 x 15in. (23 x 38cm). c.1858-60. The busy street scene at the heart of the City of London, caught with admirable animation and atmosphere. This drawing was the original from which a print was later produced and published. Museum of London

E.H.H. Archibald in his *Dictionary of Sea Painters* states:

There is at Greenwich a watercolour by him of Cannon Street Station, so he was alive at least until 1867. The donor of this and another watercolour claimed that Chambers had given them to his father in settlement of a debt and that his aunt had been governess to the Chambers' children in Venezuela, where Chambers worked as an engineer. He further claimed that Chambers went to work for Val de Travers in Trinidad about 1900, and was killed in a riot. No substantiation of this statement has been forthcoming.[1]

A proposal for a new bridge in Whitby caused such amusement that George Chambers was prevailed upon to paint a picture of a high level bridge from the Old Church Yard to the West Cliff. This was for Mr. William Dawson, dated 1866 and publicly exhibited, which also suggests that George, Junior was still in this country or had returned from a tour abroad, and was well known in Whitby, his father's native town.[2] Various other works bearing his signature have passed through the London salerooms or otherwise come to light. Among them was a pair of watercolours of London views signed and dated 1871, one illustrated as Colour Plate 56, a Dutch scene and a shipwreck at Whitby, both dated '74. and a haybarge dated 1876, while a view of Barnard Castle, Co. Durham, on board, bore a signature and date '98. An undated but signed oil on board entitled 'The Lake of Managua, Nicaragua, Central America, showing the Volcano Momotombo' would support the information that he went to Latin America.

Judging by known examples and the titles of others, the subject-matter of many of George, Junior's works exhibited at the London shows was similar to that of his father, including eight pictures between 1855 and 1862 which were identified as views in Holland. This, together with the occasional problems in distinguishing between their signatures mentioned above (see page 165), adds to the difficulty of identifying a body of work which was clearly that of the son. Some of his output,

1 Archibald p.82
2 English II V1

Colour Plate 57. The launch of the Royal Albert *by Queen Victoria, with Prince Albert in attendance, at Woolwich on 13 May 1854, by George Chambers, Junior. Oil on canvas 25 x 41in. (63 x 104cm). Signed. The launch by the Queen of one the last warships to be built at Woolwich was the source of much pride and celebration, and merited commemoration.*

Greenwich Borough Museum

particularly of landscape views, was original but he seems very often to have been content to reproduce subjects with which his father had been successful.

One of his most successful sea pieces was a coastal view off Whitby, now in the Pannett Art Gallery, Whitby (Plate 89) which provides an opportunity to compare the two styles. Like his father, he also painted scenes of topical interest such as the opening of the Great Exhibition of 1851 by Queen Victoria, seen across the Serpentine, which was accepted by the Royal Academy in 1852 (No. 950), and the launch of the *Royal Albert* by Queen Victoria at Woolwich on 13 May 1854, illustrated as Colour Plate 57. A less formal occasion was depicted in a drawing, now in the Museum of London, of the busy street scene outside the Mansion House in the City in about 1859, from which a large print was also made (Plate 90). The painting of the Bellot Memorial, 'To the intrepid young Bellot of the French Navy who in the endeavour to rescue Franklin shared the fate and the glory of that illustrious navigator, from his British admirers 1853', is an evocative view of the waterfront at Greenwich Hospital with naval pensioners in the foreground (Colour Plate 58).

George, Junior's technique of painting in oils was much looser than that of his father, seeking to achieve a more impressionistic effect. The use of a fluid paint mix and often somewhat turgid pigments meant that his work lacked the truth and freshness which was his father's outstanding characteristic. Many of the younger's oil paintings are large and histrionic in effect and would have accorded well with the evolving taste of Victorian connoisseurs and collectors. This was probably the reason for his success. Although only a limited number of his

Colour Plate 58. The Bellot Memorial at Greenwich Hospital by George Chambers, Junior. Oil on canvas 30½ x 44in. (77.5 x 112cm). Signed and dated 1857. A successful painting by the younger George Chambers, which creates an evocative image of Greenwich Hospital, with naval pensioners in the foreground. National Maritime Museum, London

watercolours have been traced, they often have a quality approaching that of George, Senior.

One can only speculate on the reasons for George, Junior's sudden disappearance from the London scene when he seemed to be doing so well. It is notable that his address changed frequently, usually at least once a year. This may suggest that it was perhaps financial pressures which prompted him to go abroad to seek, at least temporarily, an outlet for his artistic talents. After such a promising start and early recognition, the loss to painting in Britain is to be deplored. Had he continued to maintain these high standards and become firmly established, he would also have furnished nineteenth century art history with a second George Chambers of outstanding achievement.

APPENDIX 1

WORKS BY GEORGE CHAMBERS
IN PUBLIC COLLECTIONS

Explanation: Details of works illustrated in this volume are given in the caption to the relevant plate, to which reference is made. In other cases, Oil indicates that the painting is in oil on canvas, panel or board; Watercolour is a watercolour or a pen or pencil and wash drawing; Drawing is a pencil or pen drawing; dimensions are in inches (centimetres in brackets), height before width; s&d indicates signed and dated and sgd. signed only.

UNITED KINGDOM

ABERYSTWYTH National Library of Wales
Pilot boats heading out of Swansea. Colour Plate 28

BIRMINGHAM City Museums and Art Gallery
On the Thames; Tilbury Fort. Oil 6 x 8½ (16.5 x 21.5)
Hay barges on the Medway. Plate 71

BRISTOL Museums and Art Gallery
Moonlight scene. Watercolour 7 x 10 (18 x 25.5)

BURY Art Gallery and Museum
Laying lobster pots St. Michael's Mount. Colour Plate 45

CARDIFF National Museum of Wales
Fishing boats. Watercolour 7 x 11 (18 x 28)

EXETER Royal Albert Memorial Museum & Art Gallery
On the Amstel. Watercolour 7 x 11½ (18.5 x 29)

HULL The Ferens Art Gallery
Shipping on the Medway. Plate 70
View of the port of Hull with the *Spartan*. Colour Plate 4
On the Medway. Colour Plate 51
Old harbour Hull. Watercolour 8½ x 12 (21.5 x 30.5)

LEEDS City Art Gallery
A frigate. Watercolour 8 x 11½ (20 x 29)
Dover. Watercolour 7 x 10.5 (18.5 x 27)

LONDON The British Museum
View near Gillingham. Plate 25
Waterside scene. Plate 24
Beached hulk with spritsail barge. Watercolour 4½ x 14 (11.5 x 34)
Amsterdam. Colour Plate 54
Dordrecht from the river. Colour Plate 55
Ships at anchor in the Downs riding out a gale. Plate 82
Harbour scene. Plate 69
'All grey slate and stone'. Plate 48
Rownam ferry, Clifton. Colour Plate 50

LONDON National Maritime Museum
The Battle of La Hogue 23 May 1692. Colour Plate 32
The capture of Puerto Bello 21 November 1739. Colour Plate 36
The Battle of Trafalgar 21 October 1805. Plate 62
The Bombardment of Algiers 27 August 1816. Colour Plate 33
The Bombardment of Algiers 27 August 1816. Colour Plate 34
A brig leaving Dover. Oil 28 x 36 (71 x 91.5) sgd.
A Dutch boeier in a fresh breeze. Colour Plate 53
A sailing boat in a fresh breeze off Cowes. Colour Plate 5

View of Greenwich Hospital. Colour Plate 18
HMS *Britannia* entering Portsmouth. Colour Plate 31
Frigate firing a gun. Colour Plate 20
Boat at St. Aubin. Plate 15
Waterside scene, Chatham. Plate 16
The launch of the *Royal George* from Chatham Dockyard. Plate 17
Off Ryde, Isle of Wight. Plate 27
Haybarge on the Thames above Greenwich. Plate 32
A 3-decker going into Portsmouth. Plate 49
Sketch of 3-decker and details. Plate 50
Sketch of hulk and details, inscribed Egmont. Plate 51
Ship's bow, bowsprit and figurehead. Plate 52
Studies for the Bombardment of Algiers. Plates 54 and 55
First thought for the Bombardment of Algiers. Plate 56
Haybarges on the Medway. Plate 72
Gaff cutter and other shipping. Drawing 9 x 12 (23.5 x 31)
Stern of warship and other details. Drawing 11 x 14½ (27 x 38)

LONDON Tate Gallery
Dutch East Indiamen weighing their anchors. Plate 65
The hay barge. Plate 26

LONDON Victoria and Albert Museum
Seascape. Plate 37
At the Nore. Colour Plate 41
Sunderland Harbour, moonlight. Colour Plate 27
Old men-of-war at anchor. Colour Plate 42
Seapiece. Colour Plate 52
View of Scarborough. Colour Plate 21
A windy day. Plate 66
On the Thames. Plate 33
Stranded shipping. Plate 79

MANCHESTER The Whitworth Art Gallery, The University of Manchester
Dutch shipping scene. Colour Plate 38
Herring fishing. Colour Plate 22
Taking a pilot on board off the port of Whitby, North Yorkshire. Colour Plate 26

MARGATE Old Town Hall Local History Museum
Anchor boat going into Margate. Oil 38 x 53 (97 x 135) s&d 1838

MERSEYSIDE Lady Lever Gallery, Port Sunlight
Fishing smack off Scarborough Castle. Oil
The barge. Oil
Man-of-war, fisher boats and other vessels off Portsmouth. Watercolour

MERSEYSIDE Walker Art Gallery, Liverpool
Greenwich Hospital. Watercolour 8 x 11 (20 x 28.5)

NEWCASTLE-UPON-TYNE Laing Art Gallery
View of Greenwich Hospital. Watercolour 17 x 23 (43 x 58)

NEWPORT Museum and Art Gallery
Seascape with ship and lighthouse. Watercolour 6½ x 12½ (17 x 31)

NORWICH Castle Museum
Sea piece with ships. Watercolour 3½ x 8 (9 x 20) s&d 1837

NOTTINGHAM Castle Museum
Whitby Harbour. Oil 40 x 52 (102 x 132) s&d 1836

PORTSMOUTH City Council
Entrance to Portsmouth Harbour. Oil 18 x 24 (45 x 60) s&d 1835
Shipping in Portsmouth. Watercolour 26 x 33 (66 x 84)

PRESTON Harris Museum and Art Gallery
Off Portsmouth. Plate 78

SHEFFIELD Graves Art Gallery
Coast scene. Oil 10 x 13 (25.5 x 33)
Sailing ships. Oil 23 x 27 (58 x 68.5) s&d 1836?
Sea Piece. Oil 24.5 x 33 (62 x 84) s&d 1834
Hay barges. Watercolour, 8 x 12 (21 x 31) sgd.

SOUTHAMPTON City Arts Services
Portsmouth. Plate 77

SWANSEA Glynn Vivian Art Gallery
The ruins of the Castle and Plas House, Swansea. Colour Plate 29

WHITBY Pannett Art Gallery
Rotterdam Harbour. Colour Plate 49
Brig offshore. Oil 9½ x 15½ (24 x 39)
Off Yarmouth. Oil 20 x 27 (51 x 69) s&d 1835
Whitby East side shipwreck. Watercolour. Colour Plate 43
The Battle of Trafalgar. Colour Plate 37

YORK City Art Gallery
Storm at sea. Oil 20 x 30 (51 x 76) sgd.

IRELAND

DUBLIN The National Gallery of Ireland
Boats at Blackwall Reach. Watercolour 6½ x 10 (17 x 24.5)
The Dover pilot boat in a rough sea, Plate 81
The Dover pilot boat in a rough sea (study for previous entry). Drawing 14½ x 20 (36.5 x 51)

CANADA

FREDERICTON, NEW BRUNSWICK Beaverbrook Art Gallery
HMS *Terror* iced in off Cape Comfort, 1836. Colour Plate 46

MUSEE DE L'AMERIQUE FRANCAISE
North Foreland, Plate 22

ONTARIO Art Gallery
Off Dover. Oil 11 x 16½ (28 x 42.5)

UNITED STATES OF AMERICA

NEW HAVEN Yale Center for British Art
A sailing boat entering a harbour. Plate 45
Two fishing boats on the banks of inland waters. Plate 35
Sailing barges and boats in a choppy sea. Watercolour 7 x 11 (17 x 28)
Fish porter in a straw hat. Watercolour 10 x 7 (25.5 x 17.5)
Soldiers being rowed out to an Indiaman at Northfleet. Watercolour 16 x 26 (40 x 66)
A lugger signalling a passing frigate. Drawing 6½ x 10½ (17 x 27)

SAN MARINO The Huntington
River scene. Watercolour 9 x 14 (23 x 35)
Riverside scene. Watercolour 7 x 11 (18 x 28) sgd.

SEATTLE Art Museum
Dutch barges going to market. Plate 67

TOLEDO The Toledo Museum of Art
North Foreland. Plate 23

APPENDIX 2

WORKS BY GEORGE CHAMBERS HUNG AT LONDON EXHIBITIONS

YEAR **NO.** **TITLE**

The Royal Academy (RA)

1828	81	Sketch on the River Medway
1829	336	Off Ryde, Isle of Wight
1838	293	Dutch vessels going out of harbour – Rotterdam in the distance

The British Institution (BI)

Outside size of frame (inches)

1827	77	A view of Whitby	42 x 56
1829	90	Sunderland from the Sea	23 x 27
1830	493	A fresh breeze, Portsmouth in the distance	45 x 60
1831	123	A view on the Thames near Limehouse	20 x 23
1832	566	Shipping on a lee shore	25 x 42
1833	389	A line-of-battle ship off Culver Cliff, Isle of Wight	39 x 48
1834	70	Dover Pier	33 x 42
	546	Smugglers creeping for gin off Dungeness	51 x 69
1835	88	Emigrants going off to an American ship, Rock Fort, Liverpool	48 x 60
1837	234	An American Packet running for Swansea Harbour	54 x 69
	261	The bombardment of Algiers, by Lord Exmouth. Painted for the Royal Hospital Greenwich	88 x 116
1839	13	Rotterdam	48 x 68
1840	240	Scheveling beach at flood tide	34 x 60
	307	Marines going off to an Indiaman, Northfleet	28 x 38
	330	On Scheveling beach, Holland	20 x 26

The Society of British Artists (SBA)

1829	97	Shipping on the Strand
1830	129	Yarmouth Herring Fishery
1831	42	Sunderland Pier
1832	94	A stiff breeze in the Downs, the Guard-Ship in the distance
	416	The Capture of *Le Furet,* 16 guns, by HMS *Hydra,* from a squadron of French frigates off Cadiz
	421	Coasters becalmed in Sea Reach
1833	361	A Portsmouth ferry-boat crossing to the Isle of Wight
1834	25	Off Bainbridge Point, Isle of Wight
	357	A view of Staiths, 'Yorkshire'
	463	Boats waiting for flood tide
	481	Boats in sea-reach
1834/5	314	Margate
1835	238	Shields Harbour – moonlight
	318	Margate Pier
	364	A merchant ship and colliers running into Shields Harbour
1836	209	Running into Port
	211	Entrance into the Medway
	387	Queensborough, on the Medway
	455	Greenwich Hospital
	459	Shipping, after a heavy storm, Queen's Channel
	506	Swansea Harbour

Year	No.	Title
1837	31	The *Camilies,* West Indiaman, leaving her Pilot off Bembridge, Isle of Wight
	144	Delft Haven, near Rotterdam
	445	Dutch East-Indiamen getting their anchors after a storm - coast of Holland
1838	25	Disabled shipping in a lee shore, coast of Yorkshire
	534	The mouth of the Thames
	577	Danish brig running into Helvoit Sluice, Holland

The Old Water-colour Society (OWS)

f & g = frame and glass

1834	14	At Lingfield, Sussex. 12 gns. Mr. D.T. White, Oxford Street
	31	A collier in stays, Tynemouth Castle. 14 gns Griffith Esq, Norwood
	41	A Kentish apple boat – passing shower -–River Thames. 25 gns.
	115	South Pier, Sunderland. 20 gns.
	194	The Tower -–boats leaving Billingsgate. 25 gns. Mr. Donnett, Balham Hill
	209	Peter Boats, Sea Reach. Sold.
	245	Staiths, Yorkshire. Sold
	381	Paying off the *Maidstone* frigate, Portsmouth, sketched in 1832. 10 gns.
1835	57	Purl boat and barges on the Thames – morning. 12 gns.
	67	Greenwich, from Blackwall Reach. 15 gns.
	194	Taking a pilot on board off the port of Whitby. 30 gns.
	220	Ship breaking, Rotherhithe. 15 gns.
	291	A ferry boat going into Portsmouth, passing Blockhouse Fort. 20 gns. Michael Hodgson Esq, Pall Mall.
	293	Fishing smack running foul of a peter boat. 18 gns.
1836	3	Running into harbour. 18 gns. f & g £4.4.0
	22	Colliers getting under way. 10 gns. f & g £2.10.0
	36	Pleasure boats, Southend. 20 gns. f & g £4.12.0
	59	Peter boats, Sheerness. 20 gns. f & g £4. 4.0
	204	Swansea Harbour. 10 gns. f & g £3.12.0
1837	29	Rotterdam
	11	Ship breaking, Devonport. 12 gns. f & g £4.0.0
	143	Saw-mill on the canal near Rotterdam. 15 gns. f & g £5.0.0
	164	Sketch from nature. 5 gns. Henry Ashlin Esq, Edward St., Hampstead Road
	204	Dutch Schuyts going out of port. 15 gns. f & g £6.0.0
	230	The *Victory* breaking the Line, Battle of Trafalgar. 30 gns. Charles Spencer Ricketts Esq., 2 Hyde Park Terrace, Cumberland Gate.
1838	75	West Indiaman and collier stranded – sailors clearing away the wreck
	114	The situation of HMS *Victory* at the time when Lord Nelson was killed, Battle of Trafalgar
	254	Fishing smacks getting their anchors.
	261	Whitby rocks – study from nature
1839	2	Clifton from Rownam ferry. 20 gns. f & g £5.0.0
	109	Marines going off to an Indiaman - Northfleet. 18 gns. f & g £5.0.0
	195	Swansea Castle -–sketch from nature. 7 gns. f & g £2.10.0.
	225	Grace Darling and her Father going out to the wreck. 10 gns. f & g £3.0.0.
	300	Delft Haven, Holland. 15 gns. Price Edwards Esq., Weston, nr. Bath f & g £3.10.0
	324	Dutch passage boat crossing the Maas, Holland. 10 gns. f & g £3.3.0.
	337	Broad Stairs – anchor boat going off. 25 gns W. Strachan Esq., 34 Hill St
1840	44	Greenlandman bearing up to leave the ice – full ship
	79	Indiaman laying-to for passengers, Dover Roads
	90	German reapers leaving Amsterdam for the different towns in Waterland – evening
	179	Dutch river scene, near Dort
	258	Dover pilot-lugger returning to the harbour

APPENDIX 3

Reproduced by courtesy of Christie's Archives

CATALOGUE
On WEDNESDAY, FEBRUARY 10, 1841

PENCIL SKETCHES

		£.	s.	d.	Purchaser	
1	Various designs for pictures &c.	16		10	0	Parry
2	Ditto	14	1	2	0	Webb
3	Views in Yorkshire, &c.	15		7	0	Hoare
4	Various	25		15	0	Allen
5	Ditto	23	1	5	0	ditto
6	Ditto	24		15	0	ditto
7	Ditto, &c.	24	1	3	0	Henderson
8	Shipping, &c.	18	1	18	0	Allen
9	Sketches from nature	15	1	8	0	Allen
10	Ditto, &c.	9		14	0	White
11	Views near Portsmouth – one coloured	16	1	16	0	Beckford
12	Sketches of Dutch shipping, &c.	16	1	18	0	Allen
13	Landscape views in Sussex	14	1	10	0	Gauci
14	Sketches of men-of-war, &c.	8	3	5	0	Allen
15	Sketches of figures	18	1	10	0	Gauci
16	Ditto	16		19	0	Roupel
17	Ditto	14	1	1	0	Gauci

COLOURED SKETCHES

		£.	s.	d.	Purchaser	
18	Studies of figures	7	1	11	0	Carpenter
19	Ditto	8	2	3	0	Sir M. Herries
20	Ditto	5	1	10	0	Beckford
21	Ditto	7	2	6	0	Gauci
22	Sketches from nature, Rotterdam, &c.	4	1	10	0	Carpenter
23	Fort Rouge, &c.	3	1	10	0	Tiffin
24	Shipping	3	1	9	0	Beckford
25	St. Michael's Mount, &c.	7	2	2	0	Shirley
26	India Arms, Northfleet, &c.	13	2	0	0	Rought
27	Sketches from nature, Portsmouth, &c	10	1	8	0	Tiffin
28	Views in Holland and Dutch boats	5	2	14	0	Beckford
29	Sketches of boats, &c.	12	2	14	0	Tiffin
30	Sketches of heads of City Barges, &c.	6	1	16	0	Carpenter
31	Sketches from nature, of Brambletye House, Sussex	3	1	10	0	Vacher
32	Sketches in Madeira	6		17	0	Mivant
33	Launch of the Royal George, &c.	8	2	12	0	Rev. C. Vale
34	Sketches for bombardment of Algiers and Trafalgar	16	2	8	0	Forster
35	Unfinished drawing of Greenwich Hospital and 6 pencil sketches of ditto	7	1	0	0	Hoare
36	Whitby Abbey, rocks at Hartlepool	3	3	10	0	Rought
37	Aislaby Quarry, Yorkshire and sunset between Margate and Ramsgate	2	1	10	0	Money
38	Market-place, Funchal, and view of Queenborough	2	2	16	0	Bale

		£.	s.	d.	Purchaser	
39	Whitby Rocks, Swansea pier, and Madeira	3	1	10	0	Thomas
40	Tilbury Fort, church at Rotterdam, and coming into harbour	3	1	18	0	Palser
41	Mont Albin's Tower, Amsterdam and Scheveling		2	0	0	Turner
42	Swansea Castle, Queenborough, &c.		2	2	0	Gauci
43	Spar ladder, Whitby and view near ditto	2	1	18	0	Rought
44	Sunset at sea, study of fish, and Swansea bay	3	3	5	0	Bale
45	Banks of a river in Holland, &c.	3	1	18	0	Thomas
46	Northfleet, Dort, Swansea light-house	3	2	15	0	Forster
47	Plymouth, Rotherhithe	2	2	0	0	Turner
48	Scheveling beach, and Whitby	2	1	18	0	ditto
49	Dutch pilot-boat and Whitby rocks	2	1	15	0	Thomas
50	Dutch boats, study for a picture, and Clifton	3	3	5	0	Bale
51	Scheveling church, Hartlepool rocks	2	2	13	0	
52	Swansea, Swansea pier and Erith	3	2	15	0	Tiffin
53	Whitby rocks, on the Medway, Blackwall reach	3	2	10	0	Fenton
54	Scheveling beach, Liverpool	2	2	15	0	Graves
55	Study near Swansea, Emigrants going off	2	4	14	6	Tiffin
56	Briton ferry, vessels becalmed, Madeira	3	2	17	0	Shirley
57	Night view, Hungerford market, interior, and marine subject	3	2	5	0	Carpenter
58	Views in Madeira	2	3	10	0	Money

WATER-COLOUR SKETCHES AND DRAWINGS

		£.	s.	d.	Purchaser	
59	Baths at Gravesend and Clifton	2	4	4	0	Rought
60	Sketch from the celebrated Backhuysen, at the Hague	1	2	0	0	Turner
61	Rochester, and Park Village, West, Regent's Park	4	3	10	0	Bale
62	Whitby, and sketch of buoys, &c.	4	1	14	0	Bell
63	Homeward-bound from Sydney, surrounded by icebergs, Swansea pilot boats, and Swansea rocks	2	1	10	0	Turner
64	Mill in Holland, and Scheveling beach	2	3	5	0	Rought
65	Liverpool – vessel going out of harbour	2	4	6	0	Halsted
66	Obusky, Rotterdam	1	2	5	0	Carpenter
67	Sunset at sea, Madeira – boats, Dover pier	3	4	4	0	Gauci
68	Scheveling, Marsh Dam at Swansea	2	2	4	0	Knighton
69	The Mumbles light-house, Swansea, and sunset at sea	2	3	5	0	Fenton
70	Ship's forecastle, Dutch boats &c	4	2	18	0	Thomas
71	Studies from Nature	4	3	13	0	H. & Graves
72	Madeira	3	1	11	6	Turner
73	Light-house, Liverpool, craft on the Thames	2	2	5	0	Rought
74	A mill near Rotterdam	1	1	15	0	Hogarth
75	Tilbury fort, view near Swansea, Blackwall	3	2	12	6	Tiffin
76	Study on the banks of a river, Amsterdam – boats	2	1	15	0	Shirley
77	Studies of skies	4	3	0	0	Fenton
78	View near Whitby, and a whaler	2	2	15	0	Shirley
79	View near Whitby – landscape, view of Dort	2	1	5	0	Earle
80	The Dart brig, in which Mr. Chambers sailed to Madeira	1	3	15	0	Smith

No.	Description		£.	s.	d.	Purchaser
81	St Michael's Mount, Cornwall	1	2	12	0	Paliser
82	Vessels off Calais harbour – finished drawing	1	3	3	0	ditto
83	Lutheran church at Amsterdam	1	3	10	0	Mivant
84	Swansea pier – low water	1	6	5	0	Gauci
85	Spar Ladder, Whitby	1	7	10	0	Tiffin
86	An Indiaman breaking up	1	5	15	0	Carpenter

COLOURED DRAWINGS

No.	Description		£.	s.	d.	Purchaser
87	Mulgrave castle, Whitby – moonlight	1	1	5	0	Turner
88	Marines embarking	1	3	13	6	Hoare
89	Vessels off Dover, and emigrants going off	2	6	6	0	Tiffin
90	Dover pilot-boat, fishing boats, sea-reach and shipping	3	2	0	0	Shirley
91	Skeivis tower, Amsterdam	1	6	2	6	Haughton
92	Lutheran church, Amsterdam	1	5	7	6	Paker
93	Pilot boat running into Dover – unfinished		3	11	0	ditto
94	Park Village, Regent's Park, Swansea – coast-scene	3	2	2	0	Fenton
95	Whitby sands	2	2	15	0	Mivant
96	Swansea castle, toll house Swansea and shipping	3	3	8	0	Gauci
97	Upnor, Margate	2	1	10	0	Patterson
98	Grace Darling and her father pulling off	1	6	10	0	Shirley
99	Gravesend, Plymouth	2	2	12	6	White
100	The Dart, off Madeira – sunset at sea	2	4	4	0	Hollaway
101	Sketches in coloured crayons	7		16	0	Bell
102	Sketchbook, filled with pencil sketches	1	4	4	0	Tiffin
103	Ditto, with views &c., in Holland	1	2	5	0	ditto
104	Various drawings	7	6	2	6	Hogarth

DRAWINGS BY VARIOUS ARTISTS

No.	Description		£.	s.	d.	Purchaser
105	Drawings by Pyne	2	1	19	0	Mr. Paternoster
106	Interior by Leach, study of an old woman, Poole	2	1	10	0	ditto
107	Pyne – sepia	2	1	16	0	R. Ackermann
108	Vickers, views in Russia – sepia	2	2	2	0	Ackerman Strand
109	Cintra, by Holland, summons to battle, by Jones	2	2	5	0	Allnutt
110	Boy learning his lesson, by W. Hunt	1	8	18	6	White
111	A sepia foreign view by Vickers, marine by Gooding, men-at-arms, Marshall	3	1	9	0	Turner
112	Russian village, Vickers, sepia landscape, colours Muller	2	1	13	0	Rought
113	Landscape and cattle, by Sidney Cooper	1	3	0	0	Turner
114	Miscellaneous	8	1	8	0	Allen
115	Vickers, and others	6	1	7	0	Price
116	Pyne, and others	5		17	0	Smith
117	Burgess, and others	8	2	2	0	Halsted
118	Sepia drawings, by Pyne and Tucker	2	1	13	0	Bale
118★	A very large drawing by Vandevelde, of a Naval Engagement		12	12	0	Allnutt

FRAMED DRAWINGS

No.	Description		£.	s.	d.	Purchaser
119	View of Clifton – plate glass		15	15	0	White
120	View off Dort, with boats		12	12	0	Forster

		£.	s.	d.	Purchaser
121	View off Whitby – plate glass	9	9	0	White
122	Running into harbour – ditto	15	15	0	Mrs. C's Mother
123	West Indiaman and collier on shore, getting out stores	6	6	0	White
124	Fishing-smacks getting their anchors, large drawing, not quite finished – plate glass	26	5	0	Vernon
125	View on the canal at Rotterdam – plate glass	9	19	6	Mrs. C's Mother
126	The Dart on her voyage to Madeira – ditto	7	17	6	ditto
127	A saw-mill on the canal at Rotterdam – ditto	12	1	6	ditto
128	Study on the bank of a river, near Swansea – plate glass	4	4	0	Turner
129	Battle of Trafalgar, the situation of the Victory at the time Lord Nelson was killed – plate glass	13	2	6	Paternoster
130	Situation of Captain Back in the ice	2	5	0	Hogarth

FRAMED PICTURES

		£.	s.	d.	Purchaser
131	Sketch off Broadstairs	7	17	6	Francklin
132	Sketch of St. Michael's Mount	2	0	0	Howard
133	Unfinished sketch on the Dutch coast	5	5	0	Colling
134	View off Broadstairs – unfinished	4	6	0	
135	Slight sketches of Madeira; *the last picture painted on by the Artist*	2	15	0	
136	View in the Harbour of Rotterdam	12	12	0	Paternoster
137	Unfinished view of Delft Haven, in Rotterdam	10	10	0	Gauci
138	Copy of the fish-market of Bonnington	5	15	6	Mr. Colling
139	Two small pictures, Broadstairs and one other	3	15	0	Money
140	A pair of long pictures, unfinished; unframed	2	7	6	Rought
141	A pair, Rochester, sunrise, and companion, sunset	7	7	0	Bale
142	Scheveling beach	15	15	0	Mrs. C's Mother
143	Dutch reapers preparing to leave – unfinished	3	3	0	Colling

PICTURES BY OTHER ARTISTS

		£.	s.	d.	Purchaser
144	Small wood-scene by Lee	2	0	0	Colling
145	Wreck of an Indiaman by W. Daniell, R.A.	1	8	0	Smith
146	Design from the Waterwitch, by Pickering		17	0	Money
147	Two sketches, view of Eton by moonlight, and Clifton, unframed, by Pyne	1	6	0	Howard
148	Sketch of Italian boys, by Edmondstone	1	13	0	Mivant

UNFRAMED PICTURES

		£.	s.	d.	Purchaser
149	A storm coming on with brig – unfinished		17	0	Money
150	Battle of Trafalgar – nearly finished	15	15	0	Paternoster
151	A pair, view off Greenwich, and view off the Dutch coast – unfinished	3	13	6	Colling
152	Sketch of the bombardment of Algiers	4	0	0	Henderson
153	View on the river – unfinished, and two sketches	2	10	0	Allen
154	Sunderland Pier, with vessels – commencement on large panel	3	0	0	Colling

		£.	s.	d.	Purchaser

OIL SKETCHES AND STUDIES

155	Two marine subjects on milled boards, and two on panel; view of Lingfield, and a marine subject	4	3	0	0	Money
156	Various sketches, bombardment of Algiers, &c.	10	3	5	0	Rought
157	Various studies of figures	7	2	10	0	Carpenter
158	Various landscape studies and skies	10	1	0	0	Perry
159	Various, Upnor Castle, &c.	6	1	10	0	Paternoster
160	Various, Greenwich, mill on Blackheath, &c.	6	3	10	0	Rought
161	Studies of figures	5	1	11	0	Neck
162	Sea-fight, from a sketch by W. Vandevelde, and Scheveling beach	2	3	5	0	Colling
163	View of Greenwich, and a landscape – unfinished	2	1	7	0	

MATERIALS, &c.

164	A capital mahogany easel, and a plate-glass slab for colour grinding		3	10	0	Gulvani
165	A large blank canvas, 6 ft. by 4 ft. [183 x 122cm], and seven others		1	0	0	Paternoster
166	Three-leaved skreen, with magnifying glass inserted		1	8	0	Thorpe
167	One oak easel, and a folding ditto with mahogany case, with grooves to insert pictures		1	11	6	Paternoster
168	Five mahogany straining frames, table easels, and various drawing boards		1	7	0	Fry
169	Three pallets, and three T-squares			13	0	Hogarth
170	Two prints on straining frames; Turner's wreck, proof; Stanfield's wreckers, proof; and the wreck of the Grosvenor – framed			14	0	Clint

BOOKS

171	Burnet on Painting, Burnet on the Education of the Eye, &c. 2 vols.		2	11	0	Jenkins
172	Field on the Powers of Colours in Painting, 4 vols.		1	1	0	Davis
173	Cooke's Shipping and Craft, and Phillips on Effect and Colour, 2 vols., 4to.		1	13	0	Allen
174	Cooke's Southern Coast, 2 vols. 4to. *h. bd. russia*		1	16	0	Money
175	Bonington's Works, lithographed by Harding, 4to.			17	0	Gauci
176	Stanfield's sketches on the Moselle, the Rhine, and the Meuse; folio		2	16	0	Money
177	Harding's Sketches at Home and Abroad		3	5	0	ditto
178	Young's Geological Survey of the Yorkshire coast, 4to.					
179	India proofs to Turner's Annual Tour of 1838			8	0	Money
180	Various prints, after Turner; *some proofs*	19	1	1	0	ditto

| | | 533 | 17 | 0 | |

FINIS

APPENDIX 4

PRINTS AFTER GEORGE CHAMBERS

SUBJECT	ENGRAVER	PUBLISHER	DATE
Phoenix and *Camden* running into Whitby	E. Fisher Aquatint	G. Chambers and E. Fisher	2 Jan. 1826
Hydra taking *Furet* and *Hydra* at Bagur	Paul Gauci Engraving	Printed by Graf and Soret, 1 Gt. Castle Street Publ. Ackermann	1833
Burlington Quay	J.C. Bentley Engraving	Simpkin & Marshall Publ. Virtue	1834
North Foreland	R. Brandard Engraving	Simpkin & Marshall Publ. Virtue	1834
Margate	J.T. Willmore Engraving	A.H. Bailey & Co. 83 Cornhill	1 Oct. 1838
Haybarges on the Medway	G.Chambers Etching		about 1839
The Port of Liverpool	J. Carter	T.Hague Engraving	1841
Scheveningen Beach	Paul Gauci Lithograph		? about 1841
Dart	Augustus Butler Lithograph	J. Watkins' *Memoir* of Chambers	1841
The Wreck	W. Gauci Lithograph	'Landscapes by Eminent English Masters' No.7 Printed by M.& N. Hanhart. Publ. E. Gambart & Co. 25 Berner Street	1852
Greenwich Hospital	J.B. Allen Engraving	Royal Gallery of Art. Publ. James S. Virtue. *Art Journal* Vol.V	1859
Dover	T.A. Prior Engraving	Ditto, Vol.VII	1861
Burning of Whitby Theatre 23 July 1823 and *Phoenix* ashore at Whitby	W. King Woodcut	*Whitby Repository* F.D. Forth Printer Flowergate, Whitby	1866
Bombardment of Algiers	E. Chavanne Engraving		
Windy Day	C.O. Murray Copper Plate Etching	'Portfolio' p.128	1888

BIBLIOGRAPHY

Antique Collectors' Club. *Works exhibited at the Royal Society of British Artists 1824-93.* Woodbridge 1975

Antique Collectors' Club. *The Royal Watercolour Society. The First Fifty Years 1805-1855.* Woodbridge 1992

Archibald, E.H.H. *Dictionary of Sea Painters.* Antique Collectors' Club, Woodbridge 1980

Art Sales Index

Art Union, Report of the Committee of Management. London 1840

Balston, Thomas. *John Martin 1789-1854.* London 1934

Bénézit, Emmanuel. *Dictionnaire des Peintres, Sculpteurs, Dessinateurs et Graveurs.* Saint-Ouen 1976 Ed.

Bicknell, Peter and Munro, Jane. *Gilpin to Ruskin Drawing Masters and their Manuals, 1800-1860.* Exhibition Catalogue. Cambridge and Grasmere 1988

Binyon, R.L., *English Watercolours.* London 1944

Blayney Brown, David. *Augustus Wall Callcott.* Exhibition Catalogue. Tate Gallery, London 1981

Brook-Hart, Denys. *British 19th Century Marine Painting.* Antique Collectors' Club, Woodbridge 1978

Bryan. *Dictionary of Artists and Engravers.* Bell, London 1904

Bullamore, Colin P. *Scarborough and Whitby Watercolourists.* Whitby 1975

Burlington Fine Arts Club. *Catalogue of Exhibition of Marine Art.* London 1929

Burnet, John. *Essay on the Education of the Eye.* London 1837

Burney, W. *Universal Dictionary of the Marine.* London 1815

Butlin, Martin and Wilton, Andrew. *Turner 1775-1851.* Exhibition Catalogue. Tate Gallery, London 1974

Callow, William RWS, ed Cundall H.M. *An Autobiography.* London 1908

Camperdown, Earl of. *Admiral Duncan.* London 1898

Child, Dennis. *Painters in the Northern Counties of England and Wales.* Leeds 1994

Clifford, D. *Watercolours of the Norwich School.* London 1965

Clowes, W.L. *The Royal Navy, A History from the Earliest Time to the Present.* London 1897-1903

Colosseum, Regent's Park, Description. London 1846

Cooper, Thomas Sydney. *My Life.* Bentley, London 1890

Cordingly, D. *Marine Painting in England 1700-1900.* Studio Vista, London 1974

Cordingly, David. *Nicholas Pocock 1740-1821.* Conway with the National Maritime Museum, London 1986

Credland, Arthur G. *Marine Painting in Hull Through Three Centuries.* Hull City Museums and Hutton Press, Hull 1993

Cundall, H.M. *History of British Watercolour Painting.* Batsford, London 1929

Dafforne, James. *Pictures by Augustus Wall Callcott.* London 1875

Davidson, A.S. *Marine Art & Liverpool.* Waine, Wolverhampton 1986

Davidson, A.S. *Samuel Walters – Marine Artist.* Jones-Sands, Coventry 1992

Dawe, G. and Foster, J.J. *Life of George Morland.* London 1904

Dictionary of National Biography

Dubuisson, A. and Hughes, C.E. *R.P.Bonington.* London 1924

Emanuel, Frank L. *Edward Duncan RWS 1803-82.*

English, T.H. *Whitby Prints.* 2 Vols. Horne, Whitby 1931

Erffa, Helmut von and Staley, Allen. *The Paintings of Benjamin West.* Yale U.P., New Haven 1986

Feaver, W. *The Art of John Martin.* London 1975

Finden's Views. *The Ports, Harbours, Watering-places and Coast Scenery of Great Britain.* Virtue, London 1842

Gaunt, William. Marine Painting – an Historical Survey. Secker and Warburg, London 1975

Graves, Algernon. *Dictionary of Artists.* London 1895

Graves, Algernon. *The British Institution 1806-67.* Bell, London 1908

Graves, Algernon. *A Century of Loan Exhibitions 1813-1912.* London 1913

Graves, Algernon. *Royal Academy Exhibitors 1769-1904.* London 1904

Greenwich Hospital. *Descriptive catalogue of the portraits etc. in the Painted Hall.* 1887

Grundy, C.R. and Roe, F.G. *Catalogue of Pictures in the Collection of F.J. Nettlefold.* London 1933-38

Hall, S.C. *Catalogue of the Vernon Collection.* London 1851

Hardie, M. *Watercolour Painting in England.* London 1966

Harland, Joyce. *George Weatherill 1810-1890.* Pannett Gallery, Whitby 1994

Howell, R.G. *Under Sail. Swansea Cutters, Tallships and Seascapes 1830-1880.* Exhibition catalogue. Glynn Vivian Art Gallery Swansea Museum Services, Swansea 1987

Hughes, C.E. ed Mayne, J. *Early English Watercolours.* London 1950

Hyde, Ralph. *Regent's Park Colosseum.* Ackermann, London 1982

Ingamells, John. *Richard Parkes Bonington.* The Wallace Collection, London 1979

Kemp, Peter and Ormond, Richard. *The Great Age of Sail.* Phaidon, Oxford 1986

Kingzett, Richard. *Catalogue of Paintings by Samuel Scott.* Walpole Society, London 1980-82

Kitson, S.D. *Life of John Sell Cotman.* Faber & Faber 1937

Lister, R. *British Romantic Painting.* Cambridge U.P. 1989

Lloyds Register of Shipping and Lloyds List

Locker, E.H. *The Gallery of Greenwich Hospital.* 1831

Lyon, David. *The Sailing Navy List.* Conway London 1993

Maas, Jeremy. *Victorian Painters.* London 1969

MacGeorge, A. *William Leighton Leitch: A Memoir.* London 1884

Millar, Sir Oliver. *Later Georgian Pictures in the Collection of H.M. The Queen.* Phaidon, London 1969

Monkhouse, William Cosmo. *The Earlier English Watercolour Painters.* London 1890

National Maritime Museum, Concise Catalogue of Oil Paintings. Antique Collectors' Club, Woodbridge 1988

O'Byrne, W.R. *Naval Biographical Dictionary.* London 1849

Old Water-colour Society's Club Annual, Vol.11. London 1934

Old Water-colour Society's Club Annual, Vol.18. London 1940

Parris, L., Fleming-Williams, I. and Shields, C. *Constable*. Exhibition catalogue. Tate Gallery, London 1976

Peacock, C. *R.P. Bonington*. Barrie and Jenkins, London 1979

Pointon M.R. *The Bonington Circle*. Brighton 1985

Pointon, Marcia. *Bonington, Francia & Wyld*. Batsford with the Victoria & Albert Museum 1985

Pyne, W.H. *Etchings of Rustic Figures*. Ackermann London 1815

Quarm, Roger and Wilcox, Scott. *Masters of the Sea*. British Marine Watercolours. Exhibition Catalogue. Phaidon, Oxford, with The National Maritime Museum, Greenwich, and The Yale Center for British Art, New Haven 1987

Redgrave, Samuel. *Dictionary of Artists of the English School*. London 1874

Roget, J.L. *History of the Old Watercolour Society*. London 1891

Ruskin, John. *Modern Painters*. London 1888

Sainsbury, A.B. *The Royal Navy Day by Day*. Ian Allan 1993

Saunders, Ann. *Regent's Park*. Bedford College, London 1981

Shellim, Maurice. *Oil Paintings of India etc.* by Thomas and William Daniell. London 1979

Smales, Gideon. *Whitby Authors*. Whitby

Smith, Thomas. *Recollections of the British Institution 1805-59*. London 1860

Sutton, T. *The Daniells: Artists and Travellers*. London 1954

Tatlock, R.R. *Record of Collections in the Lady Lever Art Gallery, Port Sunlight*. London 1928

Thieme, U. and Becker, F. *Kunstler Lexikon*. Seemann, Leipzig 1924

Turnbull, Harry. *Artists of Yorkshire*. Snape 1976

Tyne and Wear Museums. *The Spectacular Career of Clarkson Stanfield 1789-1867*. Exhibition Catalogue. Newcastle-upon-Tyne 1979

Villar, Diana. *John Wilson Carmichael 1799-1868*. C&S Portsmouth 1995

Ward-Jackson, C.H. *Ship Portrait Painters*. National Maritime Museum, London 1978

Warner, Sir Oliver. *Introduction to British Marine Painting*. London 1948

Watkins, John. *Memoir of Chambers, Marine Artist*. Whitby and London 1837

Watkins, John. *Life and Career of George Chambers*. London 1841

Weatherill, Richard. *The Ancient Port of Whitby and its Shipping*. Horne, Whitby 1908

Weinreb, B. and Hibbert, C. *The London Encyclopaedia*. Macmillan 1983

Whitley, T. *Art in England 1821-1837*. London 1930

Wilton, A. *British Watercolours 1750-1850*. Oxford 1977

Wood, Christopher. *Dictionary of Victorian Painters*. Woodbridge 1971

Young, G. and Bird, J. *A Geological Survey of the Yorkshire Coast*. Whitby 1822

INDEX

Page numbers of illustrations are shown in bold